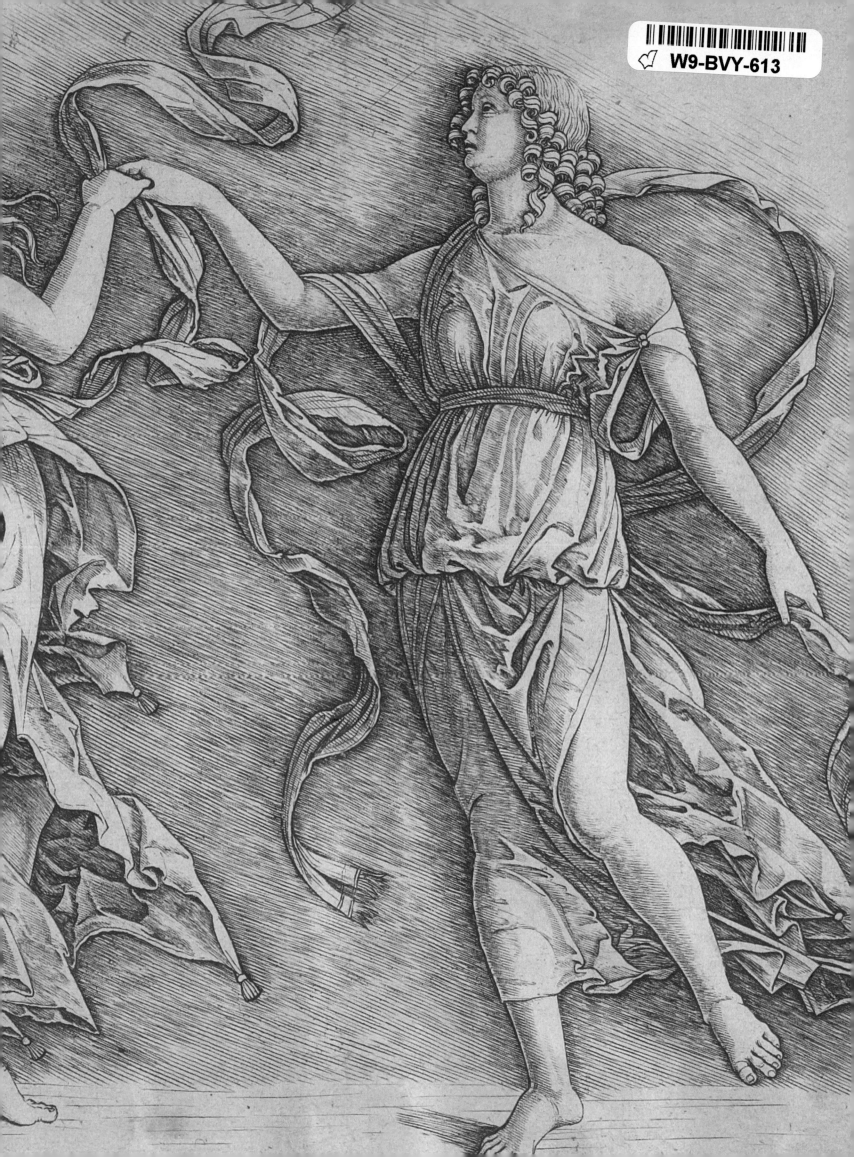

Herschel V. Jones

THE IMPRINT OF A GREAT COLLECTOR

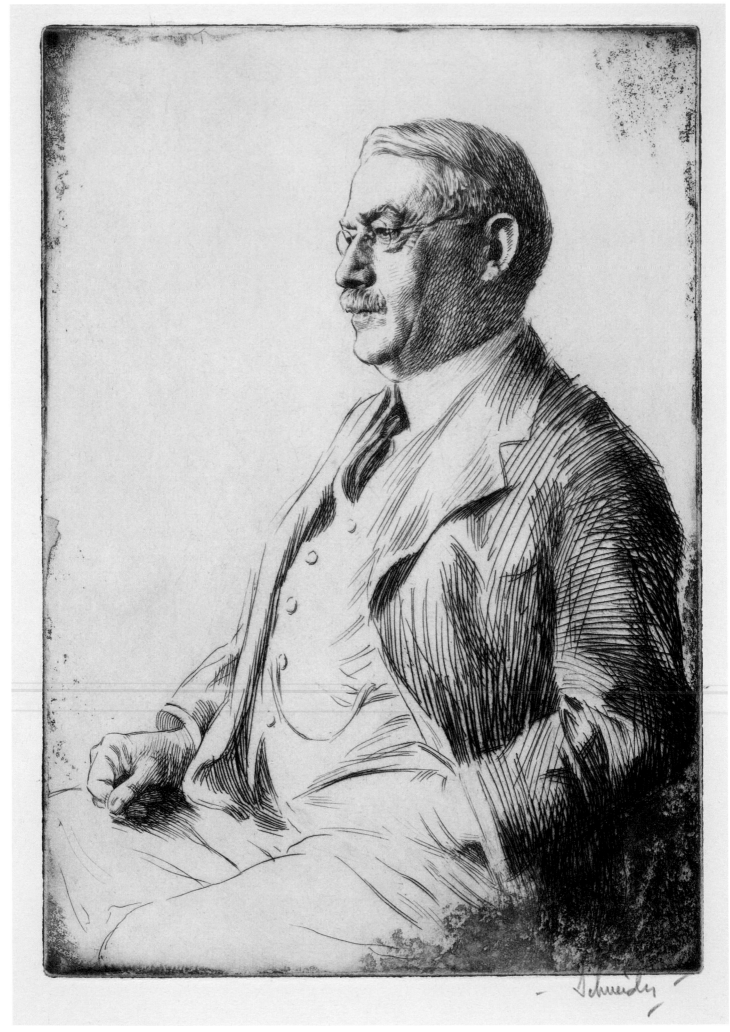

Otto J. Schneider, *Portrait of Herschel V. Jones*, c. 1920–25, etching and aquatint, 10 ¾ x 7 ½ in. (273:190 mm), gift of the Estate of Miss Tessie Jones, 2002.245

Herschel V. Jones

THE IMPRINT OF A GREAT COLLECTOR

LISA DICKINSON MICHAUX

with contributions by
MARLA J. KINNEY
JANE IMMLER SATKOWSKI

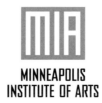

MINNEAPOLIS
INSTITUTE OF ARTS

This catalogue has been published in conjunction with the exhibition
"From Dürer to Cassatt: Five Centuries of Master Prints from the Jones Collection,"
held at The Minneapolis Institute of Arts, May 20–September 17, 2006.

Generous support for the exhibition and for this publication
has been provided by ANCHOR 🏦 BANK.

Published by The Minneapolis Institute of Arts
2400 Third Avenue South
Minneapolis, Minnesota 55404
www.artsmia.org

Distributed by the University of Minnesota Press
111 Third Avenue South, Suite 290
Minneapolis, Minnesota 55401-2520
www.upress.umn.edu

Library of Congress Control Number: 2006921635
ISBN: 0-8166-4904-9

Copyedited by Karen Jacobson
Designed by MartinRoss Design
Photography by Donna Kelly and Charles Walbridge
Publishing and production management by Jim Bindas—Book Productions LLC

All works reproduced in this catalogue are gifts from Herschel V. Jones
now in the permanent collection of The Minneapolis Institute of Arts unless otherwise noted.

Front cover: Albrecht Dürer, *Saint Jerome in His Study*, 1514, detail (cat. no. 30)

Back cover: Henri-Charles Guérard, *Elephant and Monkey*, c. 1888, etching and aquatint,
7 ¼ x 9 ⅟₁₆ in. (184:230 mm), P. 2,233

Endpapers: School of Mantegna, *Four Dancing Muses*, c. 1497, engraving,
8 ½ x 13 ⅝₆ in. (216:338 mm), P. 68.215

Printed in Singapore

Contents

Foreword

In 1916 Herschel V. Jones presented more than 5,300 woodcuts, engravings, etchings, and lithographs to The Minneapolis Institute of Arts, single-handedly creating one of the first great public print collections in the United States. His gift, still one of the largest donations of art in the history of the museum, consisted of almost the entirety of the collection of prints assembled beginning in 1885 by William M. Ladd of Portland, Oregon. Jones, an early trustee of the Institute, had recently purchased the collection in order to ensure that the museum would have a notable holding of works on paper. Between 1916 and his death in 1928 Jones continued to buy prints, both augmenting the Ladd collection and filling gaps in its holdings. Over time, these works too came to the museum.

This publication and the exhibition it accompanies document Jones's donation and provide an excellent overview of printmaking from the middle of the fifteenth century to the early 1900s. The collection assembled by Herschel V. Jones comprises superb impressions of some of the most important prints in the history of the medium. It includes a number of very rare colored woodcuts and metalcuts datable to the 1460s and 1470s; an impression of Antonio Pollaiuolo's magisterial and enormously influential engraving *Battle of the Nudes;* prints by the great German and Netherlandish masters Martin Schongauer, Albrecht Dürer, Lucas Cranach the Elder, and Lucas van Leyden; etchings by Rembrandt van Rijn and his innovative contemporaries Jacques Callot, of Nancy, and Giovanni Benedetto Castiglione, of Genoa; and works by such later artists as James McNeill Whistler, Mary Cassatt, Käthe Kollwitz, and Vasily Kandinsky, among many others.

The exhibition and catalogue grew out of the doctoral work of Lisa Dickinson Michaux, associate curator of prints and drawings at The Minneapolis Institute of Arts, whose Ph.D. dissertation focused upon Ladd and Jones as collectors. She organized the exhibition and wrote both the introductory essays and many of the entries in this publication. The remaining entries are by Marla J. Kinney and Jane Immler Satkowski. To all three of them, and to the many other members of the staff of the Institute who contributed to the show and the production of the catalogue, I would like to express my profound thanks.

There could be no better time to celebrate Jones's great benefaction. The exhibition coincides with the opening of the Institute's new wing, designed by architect Michael Graves, which includes, in addition to twenty-seven new galleries, a new Herschel V. Jones Print Study Room. We are deeply grateful to the family of the late Winton Jones for their generosity, as we are to Anchor Bank for its support of both the catalogue and the exhibition. The Herschel V. Jones Gift of Prints has enriched the lives of generations of museumgoers, and the present exhibition, together with this handsome publication, will introduce thousands more to the beauty and technical accomplishment of some of the very finest prints ever made.

William M. Griswold
Director and President

Acknowledgments

First and foremost, my profoundest appreciation goes to the Jones family for their continued support of the Department of Prints and Drawings at The Minneapolis Institute of Arts. The late Winton Jones in particular encouraged this project during his lifetime, and his family kindly set aside funds in his memory for this book and the related exhibition. I am also grateful to Dr. William M. Griswold, who was appointed director of the Institute while we were working on this project, for his immediate and gracious support. Dr. Evan M. Mauer, director emeritus, also played an instrumental role in making this publication and exhibition a reality.

The print collecting activities of William M. Ladd and Herschel V. Jones were the topic of my Ph.D. dissertation at the University of Minnesota. I continue to be indebted to Dr. Gabriel P. Weisberg for his steadfast guidance, his encouragement to explore the history of collections, and his belief that the study of prints should be treated with the same seriousness and methodology traditionally applied to paintings. My debt to Dr. Weisberg and his talented wife, Yvonne, is immense, and I thank them for many years of advice and inspiration.

Special recognition goes to Marla J. Kinney, as she was an invaluable contributor to both this publication and the related exhibition. Her catalogue entries reveal her love and knowledge of the material, and her inspired remarks regarding the essays greatly enriched their quality and significance. Her unflagging involvement at every stage of this project was a great help.

I must acknowledge the enthusiasm and positive attitude of Kristin Lenaburg, curatorial assistant in the Department of Prints and Drawings. Her ability and willingness to undertake any task made all aspects of this project run smoothly. My colleagues Dr. Richard J. Campbell and Dennis Michael Jon contributed their ideas and insights, and I owe special thanks to Edith Garmezy for her constant reassurance and wise counsel. Jane Immler Satkowski, research associate to the curatorial division, regularly lightens the load of our department, and her contributions to this catalogue are no exception.

I am deeply grateful to Jim Bindas for his skillful supervision of this publication. I am also indebted to Karen Jacobson for her patient and kind editing. Daniel Dennehy, Donna Kelly, and Charles Walbridge did an outstanding job of creating the stellar reproductions that do honor to the Jones Collection.

Numerous members of the Institute's staff lent their talents to this catalogue and the related exhibition. I am grateful to Julianne Amendola, Roxy Ballard, Philip Barber, Laura DeBiaso, Rurik Hover, Susan Jacobsen, Gayle Jorgens, Janice Lurie, Elizabeth Mullen, Lynette Nyman, Joan Grathwol Olson, Kristin Prestegaard, Elisabeth Sovik, AnneMarie Wagoner, Kaylen Whitmore, and Tom Jance and his excellent team of exhibition technicians.

I am also thankful for the contributions of my colleagues beyond this museum: Sue Welsh Reed and Maureen Melton at the Museum of Fine Arts, Boston; Ashley Carey at the Philadelphia Museum of Art; the knowledgeable staff in the Print Collection of the New York Public Library; Debra Royer, Prudence F. Roberts, and the late Gordon Gilkey at the Portland Art Museum; and the talented librarians at the Oregon Historical Society. In addition, we are extremely appreciative of Dr. Michael P. Gaudio of the University of Minnesota for his generous review of and insightful comments on the Renaissance and Baroque entries.

As a working mother, I am blessed to be surrounded by friends and relatives who constantly provide a helping hand. My heartfelt thanks go out to all those who welcomed my children into their homes, drove the carpool, and added one more plate at dinnertime, notably Lisa Prouty Gehrig, Becky Dieckmann, Marnie Brown, Lisa Nicholson, Diane Jablonski, and especially my mother, Ann Dickinson. I must particularly recognize the remarkable patience, love, and encouragement of my husband, Michael, and my children, Samuel and Maria. I hope they know that this accomplishment would mean nothing if I could not share it with them.

Lisa Dickinson Michaux
Associate Curator of Prints and Drawings

The Herschel V. Jones Print Study Room at midcentury. Courtesy of The Minneapolis Institute of Arts Archive

Preface

In the early twentieth century few American museums fully appreciated works on paper, and prints languished as secondary objects. Etchings, engravings, lithographs, and woodcuts did not attract precious acquisition funds; those were reserved for paintings and sculptures. The Minneapolis Institute of Arts was blessed with more foresight than most museums, and in 1916 it founded one of the nation's very first curatorial departments dedicated to prints. It was at this time that Herschel V. Jones purchased the William M. Ladd collection and its accompanying reference library, and presented them anonymously to the museum. The Ladd collection—formed between 1885 and 1916 in Portland, Oregon—attempted to trace the history of the graphic arts with works by masters from all periods. Remarkably, it contained nearly 120 woodcuts, engravings, and etchings by Albrecht Dürer; 150 etchings by Rembrandt van Rijn; and excellent examples by other venerated printmakers, such as Andrea Mantegna, Martin Schongauer, Hendrick Goltzius, Jacques Callot, Wenceslaus Hollar, and Giovanni Battista Piranesi.

As significant as these works were, however, the strength of the Ladd collection was the incredible richness of its nineteenth-century holdings. Ladd was an educated and dedicated collector who formed his collection in the wake of the etching revival; he owned superior prints by Charles Meryon, Jean-François Millet, Charles-Emile Jacque, Francis Seymour Haden, Félix Buhot, and many others. Testifying to the depth and quality of Ladd's holdings, the more than 100 etchings by James McNeill Whistler constituted one of the finest collections of the artist's work anywhere. Ladd also collected prints from the late nineteenth and early twentieth centuries by Mary Cassatt, Vasily Kandinsky, Käthe Kollwitz, Joseph Pennell, and Anders Zorn.

It was Minnesota's great fortune that, through Herschel V. Jones's foresight and generosity, this extraordinary collection made its way east and settled permanently at the Institute. Indeed, the prints were a windfall for Minneapolis and the newly established Institute of Arts. The Minneapolis Society of Fine Arts had moved into its new McKim, Mead, and White building only the year before, and the gift put the museum's collections on the map and propelled the institution into the national and international limelight. It was impressive that a newly established midwestern museum could display original works by such masters as Rembrandt and Dürer while also showcasing recent developments in the graphic arts.

Although Jones had a long history with print media, first as a reporter and later as owner and publisher of the *Minneapolis Journal*, he had barely collected prints before hearing about the Ladd sale. Rather, he was a celebrated collector of rare books and manuscripts. Calling on his well-developed collecting instincts and using the Ladd collection as his guide, Jones proceeded to acquire his own first-class print collection. He would not allow the Institute to reveal the source of the Ladd gift—nor that of scores of additional prints he gave in the years after his initial donation—until the week before his death in 1928. He made it known that he did not want his name attached to the gift until he had "secured a number of rare additional prints to fill in the gaps, making it a collection that represents with remarkable completeness the entire history of the graphic arts." The prints that remained in his collection at his death came to the Institute as part of his bequest in 1968, after the death of his daughter Tessie.

The Herschel V. Jones Gift of Prints remains the largest gift of artworks ever donated to The Minneapolis Institute of Arts and forms the nucleus of our Department of Prints and Drawings. Portions of the Jones gift are on display almost continuously in the numerous exhibitions held every year in our five galleries dedicated to the graphic arts. When not on display, the prints are available to view by appointment in the Herschel V. Jones Print Study Room. *Herschel V. Jones: The Imprint of a Great Collector* is being published in connection with the exhibition "From Dürer to Cassatt: Five Centuries of Master Prints from the Jones Collection." This catalogue also stands as an important tribute to the remarkable early development of the Department of Prints and Drawings at The Minneapolis Institute of Arts and the critical role that the graphic arts have played in the history of this museum.

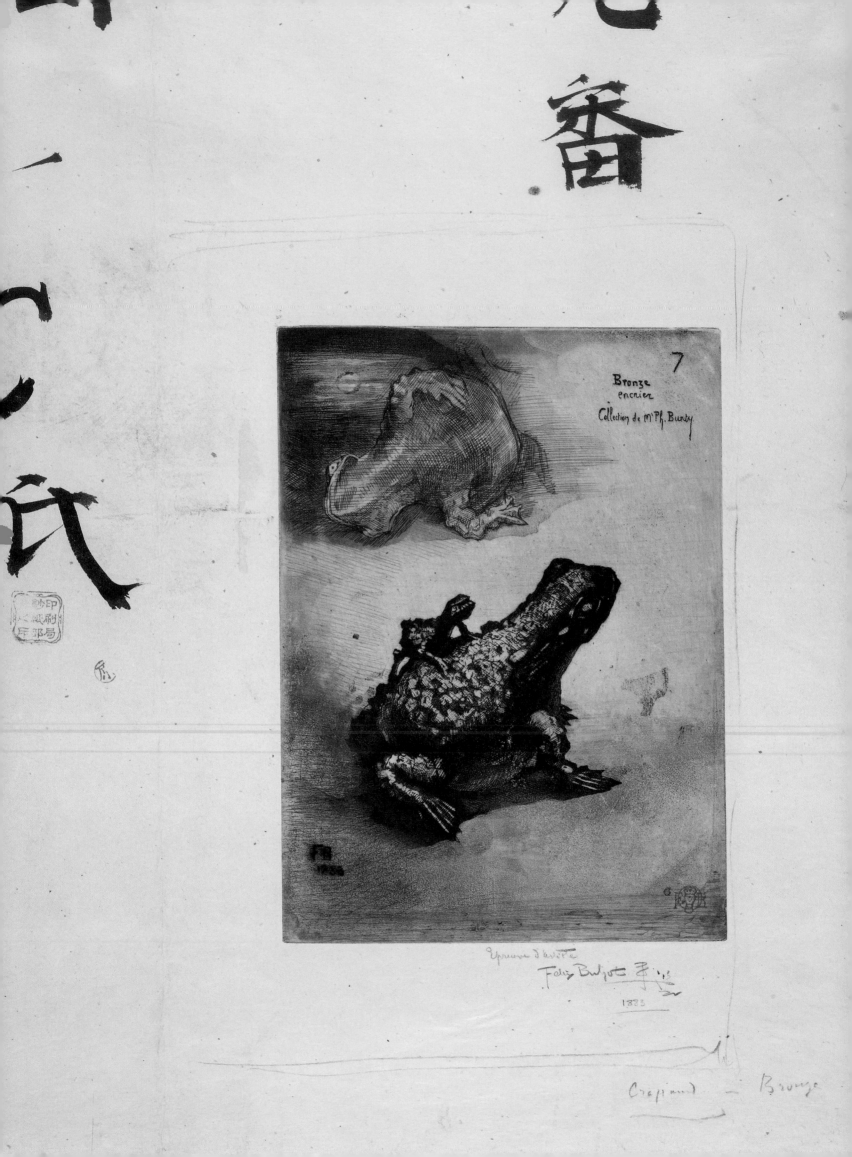

A Splendid Foundation

Lisa Dickinson Michaux

The history of The Minneapolis Institute of Arts' world-class collection of prints begins in Portland, Oregon, in 1885. This was the year when newlyweds William Mead Ladd (1855–1931) (fig. 2) and Mary Andrews Ladd (1859–1941) purchased their first etching, Francis Seymour Haden's *Shere Mill Pond* (fig. 3). The purchase marked the beginning of a collection that eventually consisted of more than 5,600 woodcuts, engravings, etchings, and lithographs that traced the history of the graphic arts in Western Europe and America.[1] The collection contained many rare impressions and unique proofs, including hundreds of prints by Rembrandt van Rijn and Albrecht Dürer alone, not to mention examples from contemporary artists such as Vasily Kandinsky and Mary Cassatt (fig. 7).

In Portland today the Ladd name conjures the achievements of William's father, William Sargent Ladd (1826–1893), one of the city's first political and financial leaders, rather than the extraordinary collection amassed by his son. One reason the young Will Ladd's accomplishments aren't better known may be that he did his collecting quietly in a place far removed from the traditional art centers of New York, Paris, and London. But the main reason is that in 1916 the entire collection was sold to Herschel Vespasian Jones (1861–1928) and whisked away intact to the city of Minneapolis, where Jones was publisher of the local newspaper. Jones quickly donated the prints to the fledgling Minneapolis Institute of Arts, and soon Ladd's connoisseurship was overshadowed as Jones made his own mark as an astute and knowledgeable print collector. Meanwhile in Portland the loss of such a valuable group of artworks was an unpopular subject, and the Ladd collection received little, if any, attention there as time went on. Jones clearly studied

the Ladd prints, however, because every subsequent print he acquired was a response to some deficiency he perceived in the original Ladd collection. Thus a consideration of Jones's accomplishments is incomplete without first examining the birth of the collection that inspired and eventually shaped his print-collecting activities in Minneapolis.

A Print Pioneer in Portland

Figure 2 William Mead Ladd. Courtesy of the Oregon Historical Society OrHi 50374

It is impossible to fully appreciate the significance and cultural role of the Ladd collection apart from its regional context. By the time Ladd came of age in the 1870s, Portland had made great strides since being incorporated in 1851. What began as a half-mile-long tract carved out of the dark forest and stretching to the Willamette River soon became a key trading center. By 1872 Portland was no longer just a rustic outpost but was reputed to be one of the wealthiest towns of its size in the United States.[2] Like the Ladds, many of the elite families of Portland originally came from the East Coast, and with them came eastern traditions. One was to create a private art collection as a reflection of one's affluence and culture. The elder Ladds and their wealthy friends collected Barbizon School paintings and decorated their homes with porcelains, textiles, and sculptures in an effort to bring both culture and prestige to their

Figure 1 Félix Buhot, *Bronze Frog*, from *Japonisme*, 1883, etching and aquatint, 8⅓₆ x 6 in. (211:152 mm), P.1,857

Figure 3 **Francis Seymour Haden**, *Shere Mill Pond (The Larger Plate)*, 1860, etching and drypoint, 7 x 13⅛ in. (178:333 mm), P.3,798

frontier city. Another tradition was to give children, especially boys, an East Coast education, and neither William nor his two younger brothers were exempt. He spent two years at Phillips Academy in Andover, Massachusetts, before entering Amherst College in 1874.[3] While in college, he would have had access to several important and early public print collections in the east. After 1876 he could have visited the Francis Calley Gray collection—at that time displayed at the Museum of Fine Arts, Boston, along with the museum's print collection—and the John S. Phillips collection of more than 60,000 European prints and drawings at the Pennsylvania Academy of the Fine Arts in Philadelphia.[4] These and other early collections certainly would have been models as Ladd defined his own areas of collecting.

After college Ladd returned to Portland to work as a clerk in his father's bank—Oregon's first private bank and the most powerful financial institution in Portland.[5] As the eldest son, Ladd inherited both money and social position, and he was expected to enter the family business.[6] In 1885, at the age of thirty, he married Mary Lyman Andrews, and they had three boys.[7] The couple played a leading role in the social, religious, and cultural activities of Portland; in 1892 Ladd's signature appeared on the letters of incorporation for the Portland Art Association. He was treasurer of the first

board of trustees, later serving as both president and vice president.[8] He devoted considerable time and resources to the association and to the museum that opened in 1895, not only contributing funds to pay for a curator but also placing his collection at the museum's disposal.[9] Early on, his prints were singled out as one of the most important sources of

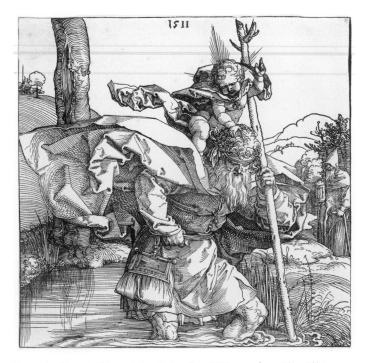

Figure 4 **Albrecht Dürer**, *Saint Christopher*, 1511, woodcut, 8¼ x 8¼ in. (210:210 mm), P.229

12

original art in the community.[10] Ladd believed that the museum and its school should appeal to the general public and that his own art should be accessible to a wide audience. This thinking informed his decision to focus on collecting prints, the most democratic art form. Although the Ladd home was furnished with paintings, sculptures, and decorative art objects, the emphasis was on the graphic arts.

Ladd certainly had other compelling reasons to amass prints. For one thing, while he could never have attempted to form an encyclopedic collection of paintings, that goal was actually attainable with prints, a much more affordable medium. Another reason to concentrate on prints had to do with cultural attitudes. The etching revival of the 1860s and 1870s contributed to a renewed appreciation of past achievements in the graphic arts, along with a frenzy of interest in printmaking techniques among contemporary artists.[11] Etching had gone out of fashion in the eighteenth century, when painting gained dominance, but in the mid-nineteenth century the medium was reborn, as artists took inspiration from Rembrandt and the landscape etchers of the seventeenth century.[12] Collectors and critics such as Philippe Burty, Charles Baudelaire, and Emile Zola promoted the concept of the *belle épreuve*, emphasizing the uniqueness and beauty of the individual print rather than the multiplicity of impressions.[13] The idea that a print could be a unique artistic entity and not just a reproduction of an existing artwork in another medium motivated both the making and the collecting of prints in France, England, and the United States. Nineteenth-century artists looked back to such masters as Rembrandt and Francisco de Goya and rediscovered the variety of effects that could be achieved

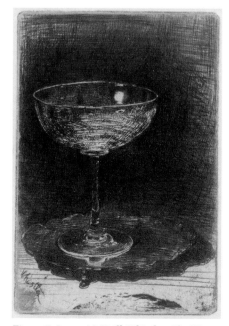

through the use of different types of papers and inks and through artistic printing techniques. Artists such as James McNeill Whistler (fig. 5), who was represented with nearly 150 prints in the Ladd collection, began to sign their works outside the plate to enhance their rarity and value. During the etching revival, connoisseurs such as Ladd became

Figure 5 **James McNeill Whistler**, *The Wine Glass*, 1858, etching, 3 3/16 x 2 3/16 in. (81:56 mm), P.4,527

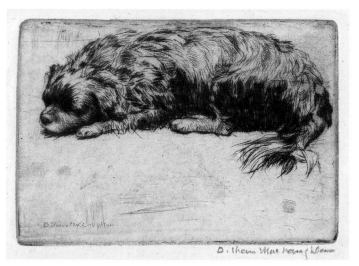

Figure 6 **Donald Shaw MacLaughlan**, *Jack*, 1902, drypoint, 2 1/2 x 3 9/16 in. (64:91 mm), P.4,993

interested in collecting different states of one print as well as unique proofs, or impressions that varied from the rest of the edition. This growing discernment in choosing impressions of nineteenth-century works extended to a collector's assessment of seventeenth- and eighteenth-century prints. For example, Ladd acquired a rare counterproof of Rembrandt's *The Goldweigher's Field* (cat. no. 46) and the only known impression of Thomas Gainsborough's aquatint *Wooded Landscape with Cows at a Watering Place, Figures and Cottage* (cat. no. 55).

From Coast to Coast: The Dealers Make Their Mark

One of the most interesting and extraordinary aspects of the Ladd collection is that it was assembled so far from any major art center. Although the Ladds traveled to the East Coast and San Francisco, they never made a single buying trip to Europe. It was thanks, then, to a few key dealers that this esteemed collection came together. New York dealer Frederick Paul Keppel Sr. (1844–1912) lent invaluable expertise from the start. While working as a bookseller, Keppel acquired a stock of sixty-two prints from a dealer who was going out of business, and he began trying to recoup the hundred dollars he had spent.[14] His first stop was Philadelphia, where he visited the knowledgeable collector John S. Phillips.[15] When Keppel confessed his ignorance of the prints' value and offered to sell Phillips the entire portfolio for what he had paid for it, Phillips told him that the works were quite valuable and that he would pay a hundred dollars for six of the pieces. Phillips then put Keppel to work identifying the remaining prints by making use of the collector's extensive research library. After marking the approximate value on each of the prints, Phillips

gave Keppel letters of introduction to other Philadelphia collectors. The money he earned in Philadelphia convinced Keppel to focus on selling prints, and he became the first dealer in the United States to concentrate solely on works on paper.

Keppel went to Europe to purchase additional stock and soon was making two or three trips abroad each year. He rarely purchased work that was not black and white, reputedly because he was color-blind. In 1905 he relocated his shop to a four-story building at 4 East Thirty-ninth Street in Manhattan and commissioned busts of Rembrandt and Whistler for the façade. He supposedly kept a small menagerie of animals in the shop, including a pet raccoon and the raven he took with him on his Atlantic crossings.[16] When Keppel died in 1912, his son David continued the business until the Depression. The Keppel Gallery is critical to the history of public print collections in America because several important museum specialists were trained there. David Keppel became an associate on a voluntary basis at the National Gallery of Art in Washington, D.C.; FitzRoy Carrington, who would later be instrumental in securing the Ladd collection for Minneapolis, became the print curator at the Museum of Fine Arts, Boston; and Carl Zigrosser went on to the Philadelphia Museum of Art.[17]

Ladd probably got to know Keppel through fellow Portland print collector Henry Failing. Failing purchased works from Keppel's gallery in New York and was sent prints on approval in Portland.[18] Failing was also working with Keppel's brother-in-law, William Kingston Vickery (1851–1925), another key source of the Ladd prints.[19] Vickery had contracted tuberculosis in his native Ireland, and his family had sent him to recover in America with his sister and her husband, Frederick Keppel. While working in his brother-in-law's New York gallery, Vickery became engaged to Keppel's sister Sarah. When Vickery's lung problems worsened in 1878, his doctor recommended a sea voyage to California. He headed to San Francisco with a portfolio of etchings and engravings from Keppel, who told him to "sell them if you can."[20] Once he was settled, Vickery sold his prints door to door all along the West Coast—including in Portland—and soon started a gallery based entirely on stock from Keppel.[21] Eventually Vickery was making his own buying trips to Europe as well, and the San Francisco gallery reflected his taste in art.

As the preeminent print dealer on the West Coast, Vickery had a national reputation. His San Francisco shop

became a gathering place for both intellectuals and students. A quiet man, Vickery had a unique selling style. Rather than covering the walls with works, he would hang one or two prints in his store window. When curious customers came in to see what he was selling, he would present thoughtfully selected works for their private approval.[22] This technique—which encouraged careful study of etchings and engravings by the likes of Dürer, Rembrandt, Haden, and Whistler—must have appealed to the studious Ladd.

Ultimately Vickery expanded his San Francisco gallery, taking as partners both his nephew, Henry Atkins, who had come from England to keep books for his uncle, and another associate, Frederic C. Torrey (1864–1935). Torrey visited Portland nearly every year to lecture for the Portland Art Association, and he developed strong ties to the city's museum and art patrons.[23] He was even responsible for bringing Marcel Duchamp's sensational *Nude Descending a Staircase [No. 2]*, which he had purchased for $324 from the New York

Figure 8 **Alphonse Legros**, *Head of a Model*, 1877, etching with pen and ink additions, 15 x 10¹¹⁄₁₆ in. (381:275 mm), P.2,720

Figure 7 **Mary Cassatt**, *The Mirror*, 1891, drypoint, 9 x 6¹¹⁄₁₆ in. (229:170 mm), P.4,959

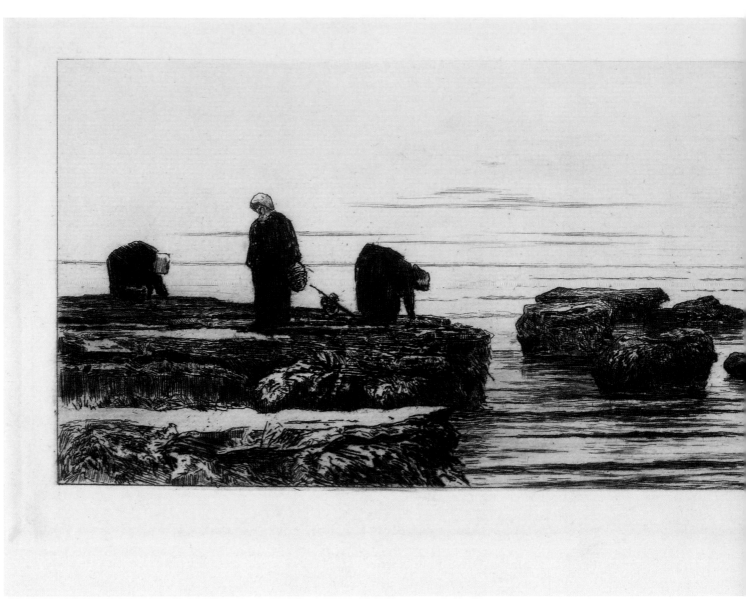

Figure 9 **Charles Storm van's Gravesande**, *The Seaweed Gatherers at Veules*, c. 1885, etching, 5¹³⁄₁₆ x 14⁷⁄₁₆ in. (148:367 mm), P.1,137

Armory Show, to Portland in 1913.[24] During his many visits, he brought prints for Ladd to examine and purchase. In addition to numerous European and American works, Torrey sold Ladd 750 prints representing the entire history of the Japanese woodblock tradition, including works by Ando Hiroshige, Katsushika Hokusai, and Kitagawa Utamaro.[25] These Asian prints formed a separate collection, which was given to the Portland Art Museum in 1932 and remained the most important public collection of Japanese prints on the West Coast for quite some time.[26] In 1916 Ladd turned to Torrey when it was time to sell the rest of his prints and the related reference library.

A Collection of Depth

One reason Ladd bought so enthusiastically during the nineteenth-century etching revival may have been Keppel's emphasis on the achievements of this period. The dealer worked hard to educate the American public about the joys of print collecting through numerous articles, lectures, and publications. His *Print-Collector's Bulletin* and the Keppel Booklets announced the prints available for purchase at his gallery.[27] Each series of Keppel Booklets was dedicated to particular artists he was featuring, including Haden, Whistler, Félix Buhot, Charles Daubigny, Paul Helleu, Charles Meryon, Jean-François Millet, and Joseph Pennell— all artists heavily represented in the Ladd collection. Through the description of specific impressions in the Keppel publications and the markings on the verso of the prints, many Ladd prints can be traced directly to Keppel.[28] With his help, Ladd acquired 260 etchings, mezzotints, and drypoints by Haden; 130 etchings by Buhot (fig. 1); more than 100 etchings and lithographs by Pennell, and more than 250 prints by Charles-Emile Jacque. When Ladd was collecting, many of the artists he chose had the respect of contemporary critics and success in the galleries; their work was in demand and garnered high prices.

Although many of the artists of the etching renaissance fell out of favor in the mid-twentieth century, the considerable

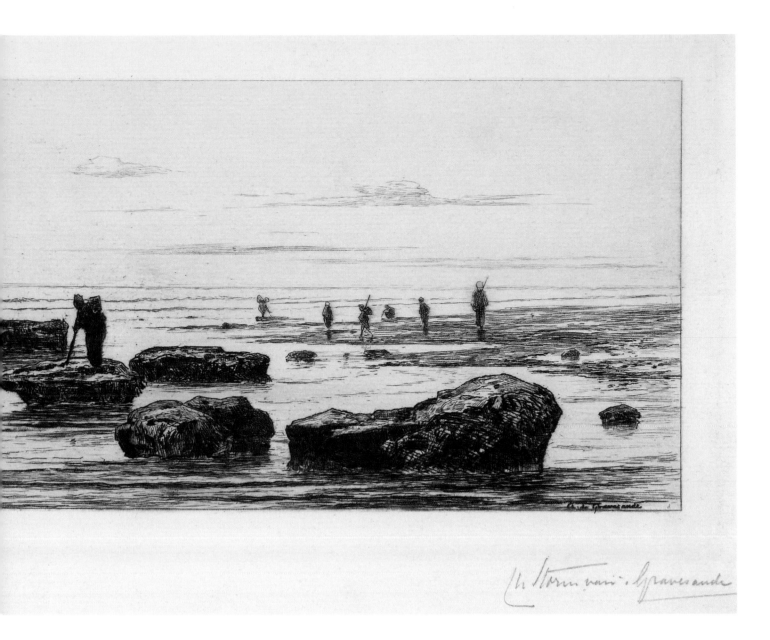

attention Ladd paid them provides important insight into the collecting preferences of the time. For example, Ladd brought together 72 works by D. Y. Cameron, 116 by Donald Shaw MacLaughlan (fig. 6), 116 prints by Alphonse Legros (fig. 8), 90 etchings and lithographs by Charles Storm van's Gravesande (fig. 9), and 153 etchings and lithographs and 6 drawings by the popular animal artist Evert van Muyden (cat. no. 66). Although these admirable works make up a significant portion of Ladd's holdings, they are not as well appreciated today as they once were. Ladd did secure major works by printmakers who have enjoyed renewed attention since the 1970s, however, including Buhot, Haden, Meryon (fig. 11), Félix Bracquemond, Henri-Charles Guérard, and Auguste-Louis Lepère (fig. 36). As research into the etching renaissance continues, the Ladd prints should receive even more attention and study from print scholars, activities that will surely reveal the untapped richness of this area of the collection.

Beyond the Etching Renaissance: The Quest for an Encyclopedic Collection

Ladd educated himself about the artists he admired and worked hard to make sure that his collection reflected the range of each artist's subject matter and technique. He consulted his extensive reference library for information about unique impressions and proof states that he could acquire, along with each artist's most important works. Since much of the work he was collecting was by living artists, he did not hesitate to contact them if he had a question regarding their prints. He was up to date on discussions about the authenticity of certain Rembrandts, for example, and the correct chronology of the artist's prints. His careful research, and consultation with some of the best dealers in the country, produced a print collection unequaled on the West Coast.

Clearly Ladd favored nineteenth-century prints, and by 1916 his nineteenth-century holdings were considered second in stature only to those of Samuel P. Avery

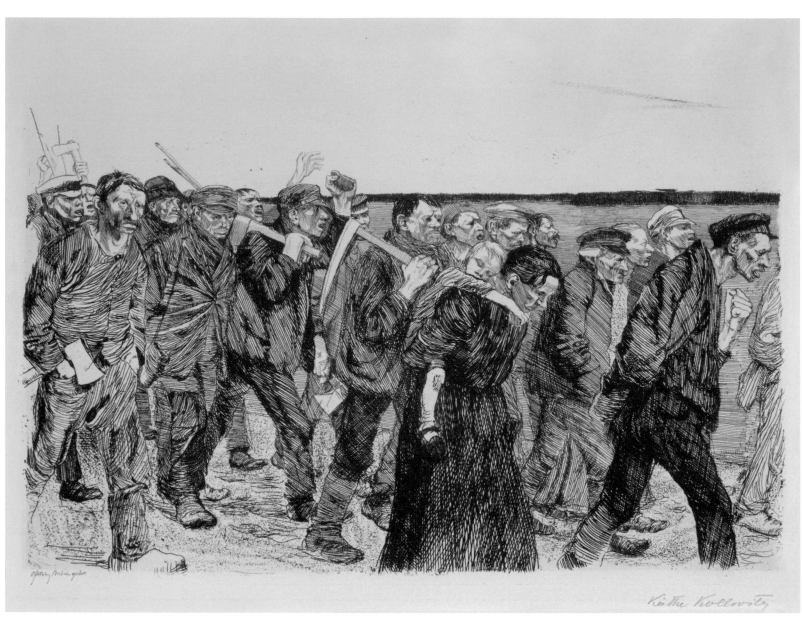

Figure 10 **Käthe Kollwitz**, *March of the Weavers*, 1897, from *A Weavers' Rebellion*, 1893–98, etching, 8½ x 11⅜ in. (216:295 mm), P.365

(1822–1904),[29] who gave his collection of 18,000 prints, regarded as the finest of its kind in the United States, to the New York Public Library in 1900.[30] Yet Ladd also persisted in his effort to form a collection that would represent the history of the graphic arts. He had seen how exhibitions of his prints had enriched the Portland Art Museum, and he felt the need for his isolated community to have a historical overview of original art. He added prints from the fifteenth century by such artists as Martin Schongauer and Andrea Mantegna while also seeking out contemporary examples by the likes of Vasily Kandinsky and Käthe Kollwitz (fig. 10). Ladd was similarly mindful of including a range of print-making techniques: woodcut, intaglio, lithography, monotype, even experimental methods such as cliché-verre. Again, the collection's encyclopedic aspirations, rendering it tailor-made for experts and amateurs alike, indicates that Ladd intended his prints to reside in a museum one day. Among

its many strengths, the Ladd collection stands out as a solid working collection—not focused on a single period, but rather endeavoring to encompass the whole of art history.

This goal often resulted in some unexpected concentrations. For example, Ladd amassed a premier group of more than 300 seventeenth- and eighteenth-century French portrait engravings. They range from large-scale works such as Charles-Clément Bervic's meticulous *Louis XVI* (cat. no. 54) to lively miniatures by Etienne Ficquet and experimental mixed-intaglio prints by Jean-Baptiste de Grateloup (fig. 13). Although interest in these portrait engravings has waned since Ladd's day, they again reveal the fashion among collectors of his era. In addition, Ladd bought nearly 150 English mezzotints, works that are of limited interest today but were extremely popular at the turn of the century and commanded high prices at auction. In fact, he would have paid more for these works than for most Italian and Dutch

old master prints.[31] That Ladd was able to acquire so many fine mezzotints at a time when they were highly sought after points to his standing among dealers and collectors. He was even able to secure important proof states of popular mezzotints, such as William Ward's portrait of Anthony Chamier after Sir Joshua Reynolds (fig. 12). In this unique impression, Reynolds himself used white paint and graphite to indicate where Ward needed to add extra highlights.

Like other collectors, Ladd became attracted to the great seventeenth-century Dutch artists as a result of the nineteenth-century etching revival. He owned prints by a number of these practitioners, among them Adriaen van Ostade and Cornelis Bega, but typically chose only a few from each one. The exception was Rembrandt, who was represented in the Ladd collection by 150 etchings. This quantity of Rembrandts would have been invaluable in any context, but they held special significance for Ladd because Rembrandt inspired so many of his favorite artists, including Haden, Whistler, Meryon, and Jacque. The enterprising Ladd tracked down examples from all stages of Rembrandt's career, including portraits, genre scenes, religious subjects, landscapes, and figure studies. The latter category includes a superb impression of *"Negress" Lying Down* (fig. 14), so named because of its dark tonalities. Rembrandt's cultlike

following in the late nineteenth century cannot be overestimated.[32] Considering the demand for the artist's work, the depth and quality of Ladd's Rembrandt impressions further attest to his status as a leading print collector of the day.

For all his attention to nineteenth-century printmaking (and its influences, such as Rembrandt), Ladd was still quite selective. He did not own any works by Théodore Gericault or Honoré Daumier, two of the most important artists in the early part of the century. Other crucial artists, such as Eugène Delacroix and Francisco de Goya, were significantly underrepresented. Among the early nineteenth-century works, Ladd did acquire a nearly complete set of J.M.W. Turner's *Liber Studiorum* (fig. 15), which today is quite rare and highly prized. Although unable to acquire an impression of the first state of every print (as was the goal of many nineteenth-century collectors of Turner's work), Ladd did purchase seventy of the seventy-one images produced in one state or another.[33]

Unfortunately, Ladd seems to have been blind to the achievements of artists working in a more modernist vein. He did not buy any prints by Pierre Bonnard, Edgar Degas, Paul Gauguin, Henri de Toulouse-Lautrec, or Edouard Vuillard. In Ladd's defense, however, most Americans did not know about these works until the 1913 Armory Show

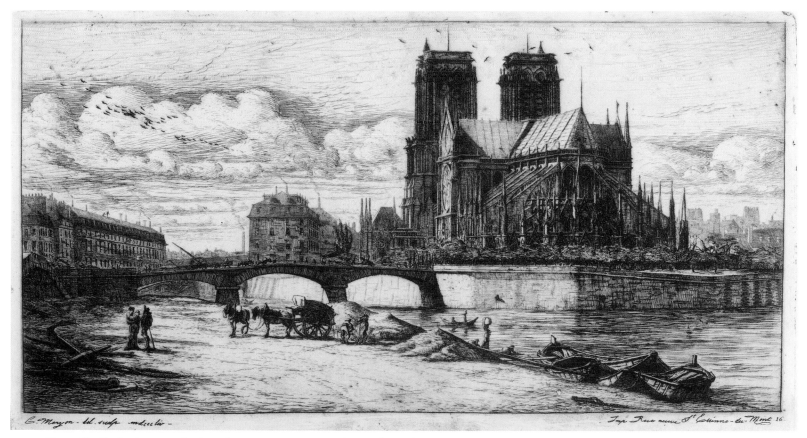

Figure 11 **Charles Meryon,** *The Apse of Notre Dame, Paris,* 1854, from *Etchings of Paris,* 1850–54, etching, 5 13/16 x 11 3/8 in. (148:289 mm), P. 3,019

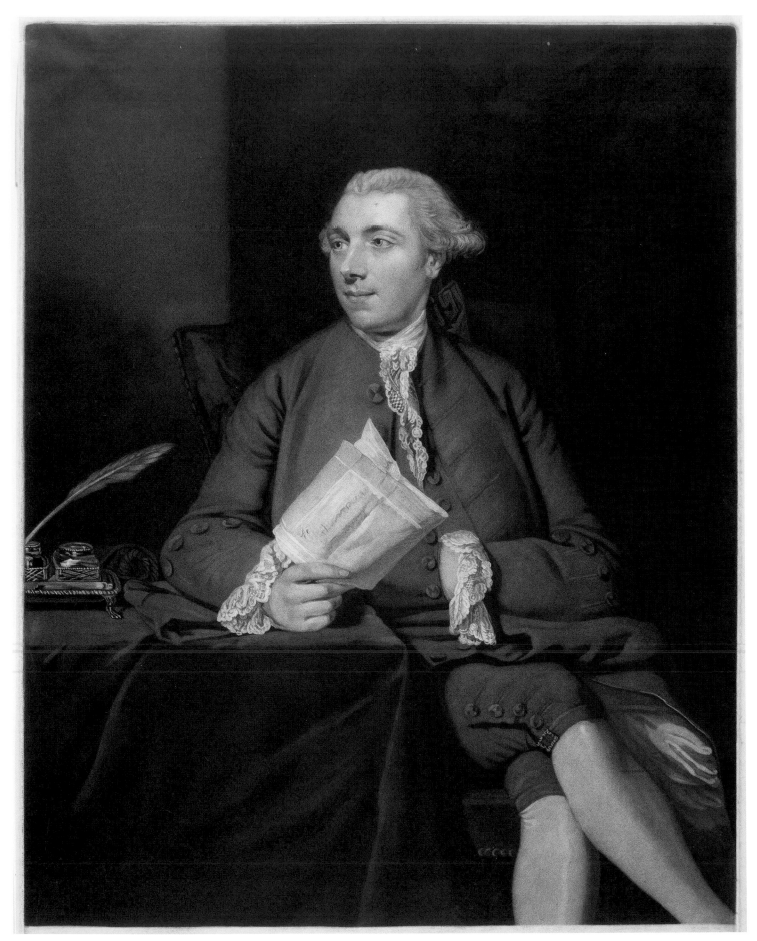

Figure 12 **William Ward** (after Sir Joshua Reynolds), *Anthony Chamier*, c. 1780, mezzotint, 17⁷⁄₁₀ x 13¾ in. (443:349 mm), P.3,457

in New York City, and the established Keppel Gallery did not associate with artists whose works were considered experimental.[34] Although there are some works by Kollwitz, Max Liebermann, and James Ensor to represent graphic activity outside the traditional centers of London and Paris, most were considered "realist" rather than modernist. Even the color woodcut by Kandinsky (cat. no. 76) was made before the artist began working with abstraction. Some of the collection's most interesting modernist prints came by way of the Viennese publication *Die graphischen Künste*, which Ladd subscribed to from 1900 until 1914. Through the supplements to this publication, sixty-four etchings, lithographs, and woodcuts entered the Institute's permanent collection. While most of the artists featured are less well known than their expressionist compatriots, the publication yielded some first-rate prints by August Brömse (fig. 16), Georg Jahn (fig. 17), and Robert Sterl (fig. 18). The Institute followed Ladd's precedent and subscribed to *Die graphischen Künste* until 1933.

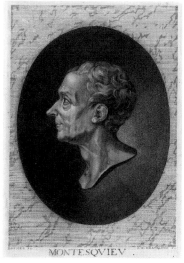

Figure 13 **Jean-Baptiste de Grateloup** *Montesquieu*, 1768, stipple etching with mezzotint, 4¼ x 2⅞ in. (107:73 mm), P.1,426

A Tale of Two Cities: The Ladd Collection Moves to Minneapolis

In 1916 the Portland Art Museum was hitting its stride as one of the most active institutions on the Pacific Coast.[35] When the Ladd collection sale was announced on October 18, 1916, it came as a huge blow to the local art community, especially considering that Ladd was one of the museum's founders and a longtime member of the board of trustees. Ladd prints had figured in numerous gallery exhibitions every year, and these loans, together with the broad scope of the collection and the philanthropic nature of the Ladd family, must have led many to believe that the collection would one day make its home at the Portland Art Museum. At the time of the sale, the collection was reportedly the third largest of its kind in America and the largest print collection on the West Coast.[36] It was a great boon to Minnesota's artistic standing when, in October 1916, the entire group of 5,608 prints and 7 drawings, along with a reference library of nearly 150 books, was sold to Herschel

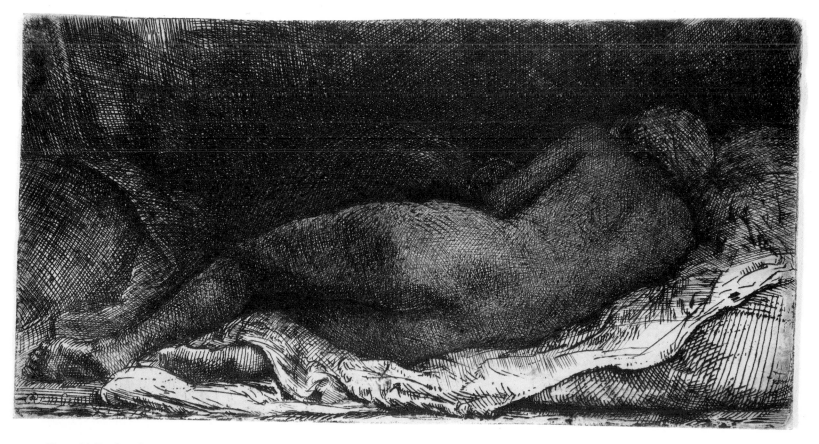

Figure 14 **Rembrandt van Rijn,** *"Negress" Lying Down*, 1658, etching, drypoint, and burin, 3¼ x 6³⁄₁₆ in. (82:157 mm), P.1,305

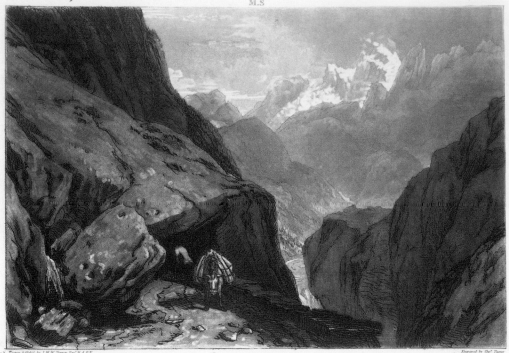

Figure 15 **J.M.W. Turner**, *Mount St. Gothard*, 1808, from *Liber Studiorum*, 1807–19, etching and mezzotint printed in sepia, 8⅛ x 11⅛ in. (205:209 mm), P.4,348

Minneapolis.[37] The opening of the Institute's McKim, Mead, and White building the previous year meant that there was room to store, catalogue, and exhibit the prints in a manner not possible in Portland. Although portions of the Ladd collection stayed behind—including paintings, the Japanese prints, and some engravings—there was concern that these could be lured to another city as well, prompting the city to seriously consider building a new museum of its own.[38]

It is doubtful, however, that the lack of gallery space had much to do with the Ladd collection leaving Portland. It is more likely that a financial reversal played a major role, forcing Ladd to sell the collection to raise needed funds.[39] It is also entirely possible that the prints would have brought much more money if they had been divided up and sold separately. It is to Ladd's credit that, as

V. Jones for $225,000. Almost immediately, Jones anonymously donated the vast majority of the collection to The Minneapolis Institute of Arts and set out to acquire a number of additional prints to augment the newly established Department of Prints and Drawings.

Commentators in Portland speculated that the city may have lost this important collection because it did not have a physical plant the size and quality of the one in

his dealers had no doubt urged, he kept the collection intact. The effort was made easier by Jones's quick actions and Ladd's long-standing ambition to see his collection in a public venue. We do not know whether any Portland collectors were approached about keeping this resource in the community, but we do know that many lamented its loss. It has taken years for Portland to regain a presence in the print-collecting world, but thanks to the actions of a

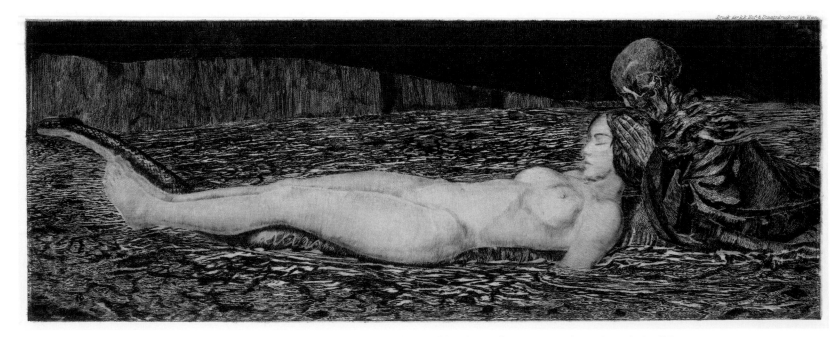

Figure 16 **August Brömse**, *A Death*, from *Death and the Maiden*, 1907, etching on blue chine collé, 4 x 10½ in. (102:267 mm), P.5,686

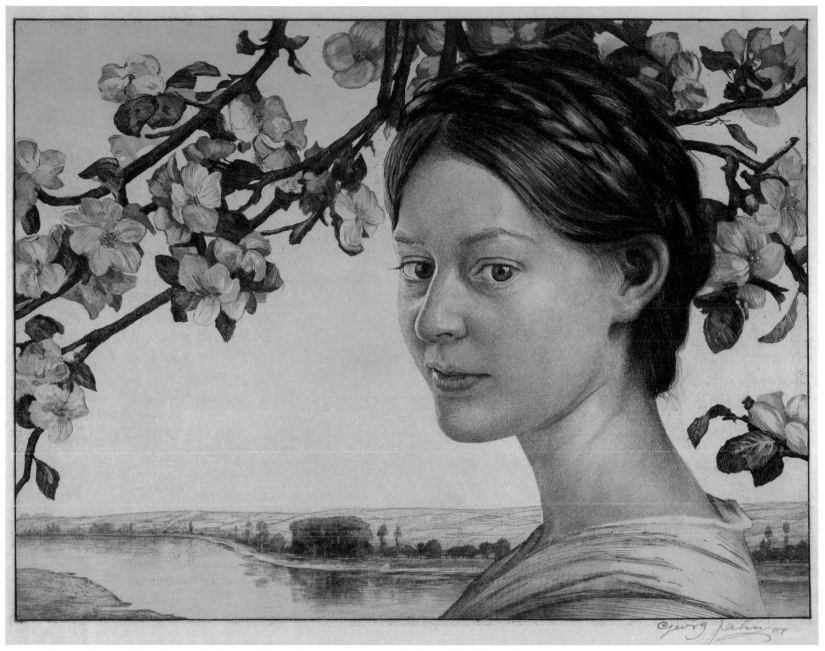

Figure 17 **Georg Jahn**, *Maiden with Flowers*, 1904, etching and mezzotint, 14¾ x 19 in. (375:483 mm), P. 340

dedicated collector and curator named Gordon Gilkey, the Portland Art Museum now has a significant collection.[40] Portland's loss was certainly Minneapolis's gain. The Ladd collection brought a new level of interest in works on paper to the Twin Cities, and its presence ignited in Jones and numerous other local collectors a passion for the graphic arts that continues to this day.

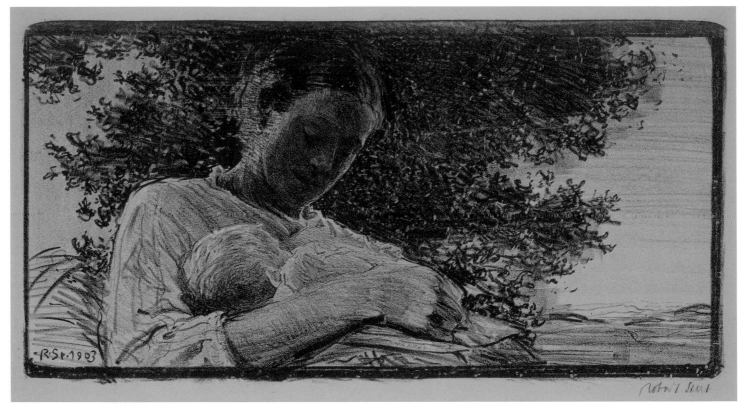

Figure 18 **Robert Sterl**, *Motherhood*, 1903, lithograph printed on hand-painted paper, 7 ¼ x 14 in. (184:356 mm), P.400

Notes

1. For an in-depth examination of the creation and use of the Ladd collection, see Lisa Dickinson Michaux, "A Tale of Two Cities: The Ladd Collection in the Context of Early Twentieth-Century Print Patronage in Portland, Oregon, and Minneapolis, Minnesota" (Ph.D. diss., University of Minnesota, Minneapolis, 2001).

2. Dorothy O. Johnson and Charles M. Gates, *Empire of the Columbia: A History of the Pacific Northwest* (New York: Harper & Brothers, 1957), 347.

3. Alumni biography file, William Mead Ladd, Amherst College, Amherst, Massachusetts.

4. For an in-depth study of Francis Calley Gray and the formation of his collection, see Marjorie Cohn, *Francis Calley Gray and Art Collecting for America* (Cambridge: Harvard University Art Museums, 1986). For more on John S. Phillips, see Frank H. Goodyear Jr., "History of the Pennsylvania Academy of the Fine Arts, 1805–1976," in *In This Academy: The Pennsylvania Academy of the Fine Arts, 1805–1976* (Philadelphia: Pennsylvania Academy of the Fine Arts, 1976).

5. E. Kimbark MacColl, with Harry H. Stein, *Merchants, Money, and Power: The Portland Establishment, 1843–1913* ([Portland, Ore.]: Georgian Press, 1988), 104–6.

6. Will had two brothers, Charles Elliott Ladd (1857–1920) and John Wesley Ladd (1870–1923), who were also bankers, and two sisters, Helen Ladd Corbett (1859–1936) and Caroline Ladd Pratt (1861–1946) (William S. Ladd Genealogy File, Oregon Historical Society). According to his biographer, Will wanted to become a physician, but his father had decided otherwise, and Will gave up his ambitions and took a job at the bank (William L. Brewster, *William Mead Ladd of Portland, Oregon* [Portland: Metropolitan Press, 1933], 18–19).

7. The Ladd children included William Sargent Ladd II (1887–1949), Charles Thornton Ladd (1890–1948), and Henry Andrews Ladd (1895–1941).

8. Brewster, *William Mead Ladd*, 57–58.

9. In 1895 the Portland Art Association opened with a gallery of plaster casts made after ancient sculptures in a space donated by the Library Association at Southwest Seventh and Stark Streets. In 1905 the Portland Art Association moved from the library into its own newly constructed building at Southwest Fifth and Taylor. Mrs. William S. Ladd (Will Ladd's mother) donated $30,000 for the construction of the building. For more on the history of the Portland Art Museum, see *Portland Art Museum: Selected Works* (Portland, Ore.: Portland Art Museum, 1996).

10. Henrietta Failing, the Portland Art Museum's first curator, referred to the Ladd collection in the following manner: "They [the prints] represent the greatest masters of these arts, and have provided exhibitions that in numbers and quality would be a source of pride in any community" (fragment of a published manuscript entitled "Portland Art Association" [1903–4], 3, Portland Art Association Catalogues, 1889–1910, file 1, Portland Art Museum Archives).

11. For more information on the etching revival, see Gabriel P. Weisberg, *The Etching Renaissance in France, 1850–1880* (Salt Lake City: Utah Museum of Fine Arts, 1971).

12. Some important artists were still devoted to etching during this period when it was "underground," including Francisco de Goya, Giovanni Battista Piranesi, William Hogarth, Thomas Rowlandson, James Gillray, Giovanni Battista Tiepolo, Jean-Antoine Watteau, François Boucher, and Gabriel de Saint-Aubin; see Gladys Engel Lang and Kurt Lang, *Etched in Memory: The Building and Survival of Artistic Reputation* (Chapel Hill: University of North Carolina Press, 1990), 24–25.

13. For more on Burty's ideas and life, see Gabriel P. Weisberg, *The Independent Critic: Philippe Burty and the Visual Arts of Mid-Nineteenth Century France* (New York: Peter Lang, 1993).

14. Frederick Keppel, *The Golden Age of Engraving: A Specialist's Story about Fine Prints* (New York: Baker and Taylor, [1910]), xxii.

15. At his death in 1876, John S. Phillips bequeathed his collection of more than 60,000 European prints and drawings to the Pennsylvania Academy of the Fine Arts in Philadelphia. The gift also included his extensive reference library and a bequest of $12,000 to maintain and increase the collection. Phillips had worked nearly thirty years to bring together the prints, which he arranged in volumes chronologically and according to school. It was certainly one of the most significant public collections at the time. For more on Phillips, see Goodyear, "History."

16. Charles T. Keppel, "Our Family History" (1981), Frederick Keppel Clipping File, New York Public Library.

17. Carl Zigrosser, *A World of Art and Museums* (Philadelphia: Art Alliance Press, 1975), 17.

18. Early in 1878 Failing purchased seventeen etchings for $244.20 from Keppel, including works by George Wille, Maxime Lalanne, Charles-Emile Jacque, and Eugène Blery (Frederick Keppel to Henry Failing, February 16, 1878, Henry Failing Papers, Mss. 650, box 4, Correspondence regarding Art Purchases, Oregon Historical Society).

19. In late August 1878 Keppel wrote to inform Failing that his brother-in-law (Vickery) "is a dealer in fine engravings in San Francisco and will be likely to call on you with some of my new stock, which I have just brought from Europe" (Frederick Keppel to Henry Failing, August 28, 1878, Henry Failing Papers, Mss. 650, box 4, Correspondence regarding Art Purchases, Oregon Historical Society).

20. Dr. Robert Vickery (grandson of W. K. Vickery), correspondence with the author, April 12, 2000.

21. Ruth Vickery Brydon (granddaughter of W. K. Vickery), Correspondence with the author, July 31, 2000.

22. Carol Green Wilson, *Gump's Treasure Trade: A Story of San Francisco* (New York: Thomas Y. Crowell Company, 1949), 32–33.

23. Portland Art Association Program Records, Mss. 1680, Oregon Historical Society.

24. In addition to organizing a two-week exhibition that included Duchamp's *Nude Descending a Staircase [No. 2]* (now in the collection of the Philadelphia Museum of Art) and reproductions of other artworks exhibited at the Armory Show, Torrey also presented a lecture entitled "Significance of Certain Tendencies in Recent Art" ("Cubist Art Is Viewed," *Oregonian*, November 27, 1913).

25. Vickery, Atkins & Torrey was the U.S. agent for Yamanaka, the largest distributor of Japanese art in the world (Wilson, *Gump's Treasure Trade*, 58).

26. Judson D. Metzgar, "Catalogue of the Mary Andrews Ladd Collection of Japanese Prints" (1948), manuscript, Archives of the Portland Art Museum. According to Metzgar, it is possible that noted Asian art specialist Ernest F. Fenollosa selected 100 of the 750 prints in the collection.

27. The *Print-Collector's Bulletin* was published from 1902 to 1911. The Keppel Booklets were often offshoots of this publication and were packaged in a series of small paperback catalogues meant to be stored together.

28. The Keppel Gallery marked the verso of prints in its inventory with a capital letter (A) followed by five numbers.

29. Marie C. Lehr, "The Print Collection," *Bulletin of the Minneapolis Institute of Arts* 5 (November 1916): 62.

30. For the contents of the Avery collection, see *A Handbook of the S. P. Avery Collection of Prints and Art Books in the New York Public Library* (New York: De Vinne Press, 1901).

31. For an analysis of the market for mezzotints at the turn of the century, see Sheila O'Connell, "William Second Baron Cheylesmore (1834–1902) and the Taste for Mezzotints," in *Landmarks in Print Collecting: Connoisseurs and Donors at the British Museum since 1753*, ed. Antony Griffiths (London: Trustees of the British Museum, 1996), 141.

32. For more on Rembrandt's role in the nineteenth century, see Alison McQueen, *The Rise of the Cult of Rembrandt: Reinventing an Old Master in Nineteenth-Century France* (Amsterdam: Amsterdam University Press, 2003).

33. Ladd acquired an impression of every plate in Turner's *Liber Studiorum* except *Ben Arthur, Scotland.*

34. Zigrosser, *World of Art,* 24.

35. "Portland, Oregon, Art Museum Has Many Activities," *Christian Science Monitor*, August 7, 1915.

36. "William M. Ladd's Big Art Collection Has Been Purchased," *Oregon Daily Journal*, October 18, 1916.

37. Edith Knight Holmes, "Portland Is Realized as Big Factor in World of Art," *Sunday Oregonian*, October 22, 1916.

38. Ibid.

39. This reversal probably goes back to the actions taken by Ladd during the financial panic of 1907 and the subsequent failure of the Ladd-owned Title Guarantee and Trust. It was the largest bank failure in Portland's history, and there were rumblings of scandal. To pacify the press and his customers, Ladd publicly announced that he would personally cover a portion of the lost savings accounts. He eventually assumed the entire debt, and this decision cost him more than $2.5 million. To repay this exorbitant amount of money, he relied on the financial resources of his sister Caroline Ladd Pratt (1861–1946) and her husband, Frederick Pratt (1865–1945). Pratt was Ladd's Amherst classmate and a New York banker whose father was one of the original investors with John D. Rockefeller in Standard Oil Company and whose family founded the art-oriented Pratt Institute. As a condition of the bailout, Ladd lost his controlling interest in the bank to the Pratts. Although he stayed on at the bank, his responsibilities were cut back considerably, and an individual brought in by the Pratts essentially ran the bank. Borrowing or taking money from his sister and brother-in-law probably also had the effect of limiting his print purchases. It is entirely possible that the bulk of the collection was formed before 1907 and that additions to it after this point were on a much smaller scale (MacColl, *Merchants, Money, and Power*, 407–14).

40. In 1978 Gordon Gilkey established the print department at the Portland Art Museum when he donated more than 7,000 prints and became the first curator of prints, drawings, and photographs. The Vivian and Gordon Gilkey Center for Graphic Arts was formed in 1993 and now has more than 25,000 works on paper. Gilkey remained curator until his death in 2000.

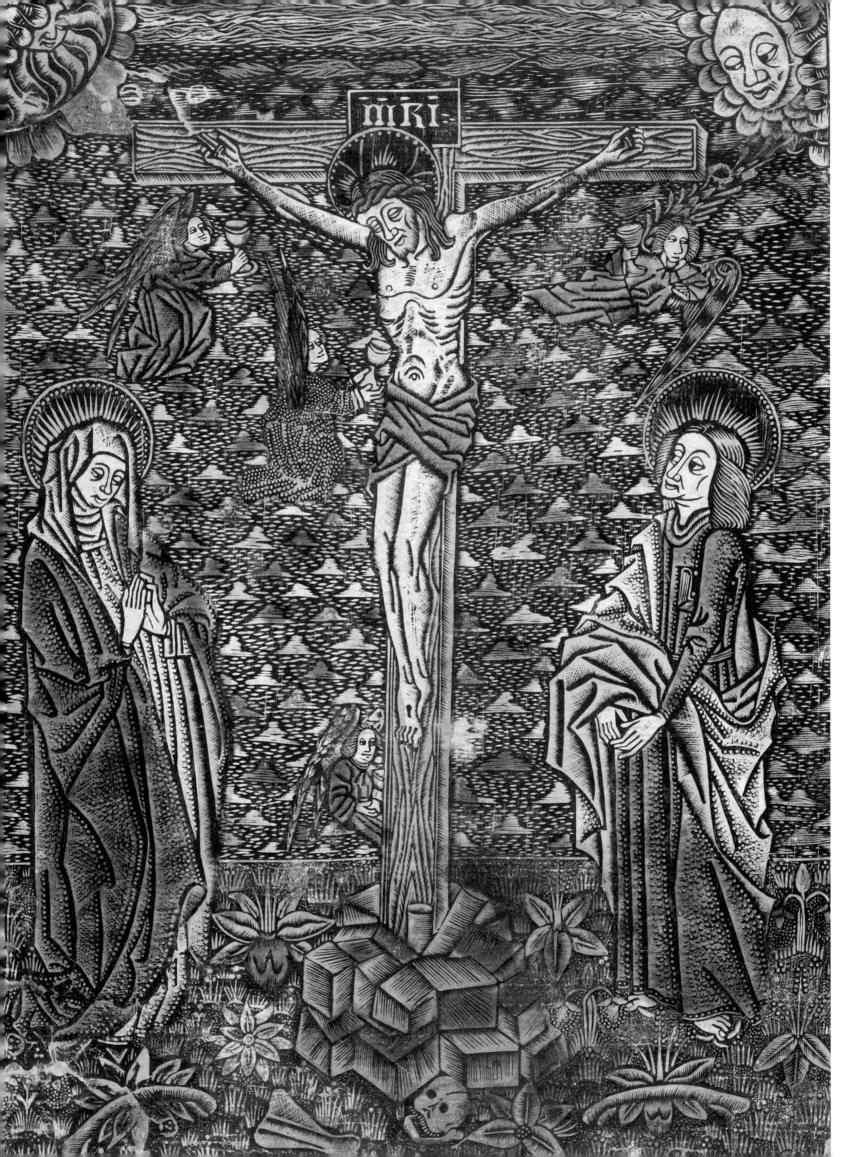

A Monumental Gesture

Lisa Dickinson Michaux

On January 7, 1915, The Minneapolis Institute of Arts was formally dedicated in a gala ceremony with some 3,000 members and their guests. The museum's first director, Joseph H. Breck (1885–1933), had come to Minneapolis from the Metropolitan Museum of Art in New York and had experience with large and varied collections. The opening was hailed as a great success, and the community was fully engaged; no fewer than 12,000 people went through the museum's doors the first Saturday it was open.[1] Yet Herschel Vespasian Jones (1861–1928) (fig. 20)—a museum trustee and the editor, publisher, and owner of the *Minneapolis Journal*—penned an editorial warning his fellow citizens of the dangers of elitism: "Art is not just something attractive in a stone building where it can be visited and tea served now and then by 'the better classes.' The Art Institute is for the people to make the fullest use of and to protect from false friends, if they ever arise, who would monopolize it or make it 'exclusive.'"[2] Jones knew of what he spoke. In his hometown of Jefferson, New York, he had to stop going to public school at age fifteen because the classes went no further. He then briefly attended the Delaware Literary Institute in the neighboring village of Franklin. Yet Jones did not let his lack of formal education stop him from succeeding at the highest levels of journalism and newspaper publishing. He was eager to help promote an open, accessible museum that would serve visitors from all social and educational backgrounds. Just a year later, in 1916, Jones would prove how deeply he believed in art "for the people" by investing in the most democratic of art forms—prints—and making them available to the inhabitants of his adopted city for all time.

The Institute's inaugural exhibition showcased art from the remote past to the present day and included a gallery earmarked for European and American prints and drawings. Breck envisioned a museum that would not specialize in any one area, but that would present the whole expanse of the visual arts. After the success of the inaugural exhibition, it was easy for the trustees to adopt this as the museum's mission, and Breck had permission to

Figure 20 Herschel V. Jones, 1923.
Photo: Lee Brothers, courtesy of the
Minnesota Historical Society

acquire a wide-ranging collection encompassing different media, including prints and drawings, and representing different parts of the world.

By November 1915 the Institute had acquired enough nineteenth-century etchings on its own to mount a show on the modern masters of printmaking. Works by French etchers Félix Bracquemond, Henri Fantin-Latour, Charles-Emile Jacque, Charles Meryon, and Jean-François Millet were displayed alongside prints by British and American artists Francis Seymour Haden, Samuel Palmer, and James McNeill Whistler. The exhibition also included prints by German artist Max Klinger and Swedish artist Anders Zorn. In the *Bulletin of the Minneapolis Institute of Arts*, Breck wrote: "It is planned to make the print department a permanent feature of the Institute's activities. Next year an attempt will be

Figure 19 **Unknown German artist**, *Christ on the Cross with Angels, Sun, and Moon*, c. 1460–70, hand-colored metalcut, 10¼ x 7⅛ in. (260:181 mm), P.68.87

27

made to develop the collection beginning with the earliest examples and working up to the present day."[3] Upon hearing this news, Paul J. Sachs, curator of the Fogg Art Museum in Cambridge, Massachusetts, wrote to his former Harvard University student to congratulate him. He encouraged Breck not to wait too long to acquire old master prints, as they grew increasingly scarce every year. Sachs also offered two prints as gifts to the Institute, including a rare impression on parchment of Bracquemond's portrait of Edmond de Goncourt. At this point Breck had no idea how prophetic his plans for a print department would be, for Jones's acquisition of William M. Ladd's esteemed print collection was just a year away.

The Pursuit of the Ladd Collection

On January 3, 1916, almost exactly one year after the museum's opening, Jones discovered that the Ladd collection was for sale, and he had some of the works shipped to the Institute for inspection and appraisal. The collection, formed over thirty years by William M. Ladd of Portland, Oregon, contained more than 5,600 woodcuts, engravings, etchings, and lithographs that ambitiously endeavored to

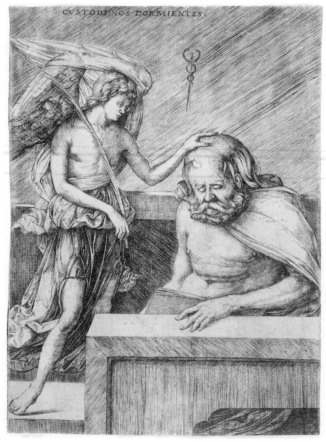

Figure 21 **Jacopo de' Barbari**, *The Guardian Angel*, c. 1509, engraving, 8½ x 6⅟₁₆ in. (216:157 mm), P.68.116

trace the history of the graphic arts. Ladd's agent for the sale, Frederic C. Torrey of the San Francisco firm Vickery, Atkins & Torrey, sent three shipments of prints to Minneapolis, representing the collection's range and depth.[4] Torrey also sent a two-volume catalogue of the collection and a list of the books in the accompanying library.[5] Jones and Breck were impressed by the high quality of the prints, and it was obvious that the variety of artists, countries of origin, themes, and mediums would provide for a multitude of future exhibitions and opportunities for study by museum visitors as well as print specialists. Jones and Breck began working to acquire the collection.

In January 1916, while staying outside Boston, Breck received a series of letters from FitzRoy Carrington (1869–1954), then curator of prints at the Museum of Fine Arts, Boston. Coincidentally, Carrington had come to the United States from England in 1886 and had settled in Minnesota, where he was an art dealer at the Harrington Beard Art Gallery in Minneapolis. In 1892 he moved to New York and was soon working for the print dealer Frederick Keppel. Carrington was director and general manager of the Keppel Gallery until 1912, when the trustees of the Museum of Fine Arts, Boston, lured him there to build up the old master print collection.[6] In a letter dated January 12, 1916, Carrington expressed excitement about the possibility of his former home of Minneapolis buying the Ladd collection, and he offered his services to Breck as a print expert. Carrington noted: "The Ladd Collection is important, and would be a splendid foundation upon which to build a really significant Department of Prints. I am quite excited to think of your getting such a 'nest egg' of Prints! It would be splendid."[7]

Carrington relentlessly urged Breck to do anything possible to acquire the Ladd collection for Minneapolis. He believed strongly in the importance of public print departments, and he wanted to get as many departments started in as many cities as possible.[8] As editor and founder of the *Print Collector's Quarterly*, the only journal of the time dedicated exclusively to works on paper, Carrington published a series of articles highlighting print departments in public collections across the country to further his cause.[9] His experience in Boston had proven to him that a print department was "the most useful of all" to a local community, and he did not want to see this museum-quality collection divided up and sold on the open market.[10]

Carrington had reason to feel proprietary about the Ladd prints, as he informed Breck: "My old firm, Messrs. Frederick Keppel & Company, either directly or, in later

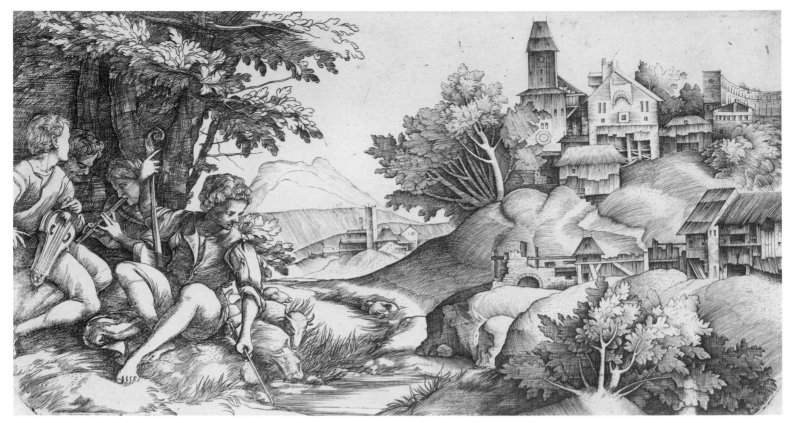

Figure 22 **Giulio and Domenico Campagnola**, *Shepherds in a Landscape*, c. 1517–18, engraving, 5⁵⁄₁₆ x 10⅛ in. (135:257 mm), P.10,878

years, through the firm of Messrs. Vickery, Atkins & Torrey, sold to Mr. Ladd the greater part, and by far the most important portion of, his collection. I have, therefore, not only a personal knowledge of it, but a keen personal interest in its welfare, and its being made a source of inspiration to the public."[11] He even went so far as to meet John Van Derlip, president of the Minneapolis Society of Fine Arts, in New York to discuss the acquisition. Later Carrington wrote to Breck, "Unless I am much mistaken you are on the road to have a really significant Department of Prints."[12]

Carrington arranged to visit Minneapolis to assist in examining the prints. After viewing the entire collection, he and Breck issued a joint statement for the Minneapolis Society of Fine Arts trustees: "The Collection is exceptionally important as illustrating the history and principles of engraving as exemplified by the work of the leading engravers and etchers from Dürer and Rembrandt until our own day, being especially strong in the works of nineteenth-century masters. It should be of permanent and increasing value and interest, not only to the print-student, but to the larger public."[13] By now there was no doubt that this was an extraordinary opportunity for the young museum, yet the purchase price of $230,000 was a stumbling block. When it was clear that this sum would cripple the Institute's acquisition budget for years to come, Jones privately offered $225,000 for the collection and then gave it anonymously

to the museum. With this generous gesture he helped Minneapolis establish one of the first public print departments in the entire nation (and the first west of the Mississippi), predating even those of the Art Institute of Chicago and the Metropolitan Museum of Art in New York.

The Ladd Collection Arrives in Minneapolis

The gift of the Ladd collection created quite a stir when it was announced at the annual meeting of the Minneapolis Society of Fine Arts on October 11, 1916. Breck reported, "The gift, for its magnitude and importance, will ever be notable in the annals of American museums."[14] Newspaper articles noted that the acquisition had single-handedly raised the Institute's stature to a level closer to that of older, more established museums. Now, when compared with the Museum of Fine Arts, Boston, the Institute was stronger in the area of nineteenth-century prints. Howard Mansfield, a trustee of the Metropolitan Museum of Art and a well-known collector of works by Whistler, proclaimed that the Whistler etchings alone would bring renown to the collection.[15] In fact, a special exhibition of etchings by Whistler, Rembrandt, and Meryon heralded the Ladd collection's relocation to Minneapolis.

This inaugural exhibition was organized by the new acting curator of prints and drawings, Marie C. Lehr, a twenty-year

veteran of the Boston print department. To ensure that the collection was properly displayed, catalogued, and presented to the public, Carrington had sent Lehr, one of his own staff, to Minneapolis. In giving up one of his best employees, he remarked, "I have thought the matter over carefully and I feel that if I am really to serve you, I should not stop for considerations of personal convenience."[16] Lehr came to the Institute on a trial basis for one year but stayed for more than twenty-five. Prints and Drawings was the first separate curatorial department at the Institute, and Lehr was the museum's only curator, besides the director, for her entire tenure. She was instrumental in educating the Minneapolis public about the history of printmaking and became an important sounding board for collectors such as Jones as they built their collections.

In her first article for the *Bulletin*, Lehr wrote that, while the value of the collection was estimated at more than $225,000, "this sum does not begin to represent the real value of the collection and its intrinsic worth to the community.

Figure 23 **Albrecht Dürer**, *The Prodigal Son*, 1496, engraving, 9 11/16 x 7 7/16 in. (246:189 mm), Bequest of Herschel V. Jones, P.68.142

It is not a question of money alone. A collection of the quality and scope of what is now owned by the Minneapolis Society of Fine Arts cannot be collected in a day or a year or at random, but requires deliberate and trained selection. Many of the prints cannot be bought now at any price."[17] Visitors were encouraged to come to the Print Study Room to examine works and to use the reference library. Lehr explained, "Through the generosity and above all, the vision of the anonymous donor, the opportunity is open to everyone of becoming acquainted with a field of art that otherwise would be restricted to the special student, collector and connoisseur."[18] With his gift of prints and the establishment of a study room staffed with an experienced curator, Jones set an important precedent for future benefactors to the museum.

Dearly Departed: Jones Sells Some Prints

Before he donated the Ladd collection to the Institute, Jones extracted 263 prints for reasons that remain unclear to us today. All but 7 were sold at auction by the American Art Association in New York in January 1917.[19] As for deciding which prints to cull, Jones may have consulted Carrington or Breck. Despite Jones's attraction to old master prints, several were in the sale, including nine engravings and one woodcut by Albrecht Dürer and eleven etchings by Rembrandt. Surprisingly, these were not the works that brought the highest prices. Dürer's *Prodigal Son* brought $270, but six other prints sold for as little as $20 each.[20] The eleven Rembrandt etchings fetched even lower amounts on average, ranging from $150 to only $10.[21] Although one or two of these prints had condition problems, most were from distinguished collections and had excellent provenances. In the case of the Dürer *Prodigal Son*, Jones replaced it with a better impression (fig. 23), but in most cases he probably intended to use the proceeds to secure rare additional prints.

Ever conscious of his new collection's stature, Jones augmented the old master area with many exceptional examples, but he seems to have been inclined to reduce permanently the modern prints, which from today's vantage point accounts for some of the most painful losses. For example, the Ladd collection contained two suites of Whistler's *French Set*; Jones sold the better set from the first printing of 1858, while retaining a set that was missing the title page. In all, Jones sold twenty-one Whistler etchings, including many superb impressions printed by the artist

Figure 24 **Unknown German artist**, *The Man of Sorrows*, c. 1480–90, hand-colored woodcut, 3 ¼ x 2 ⁷⁄₁₆ in. (83:62 mm), P.10,584

Minneapolis Journal. At the time it was a four-page evening newspaper with a circulation of about 10,000. He quickly showed his entrepreneurial flare by establishing a popular market page, an astute addition to the paper considering Minneapolis's crucial role in the grain trade. The move brought increased circulation to the *Journal* and distinction to the young Jones.

His interest in the grain market went beyond mere reporting. Jones asked to be sent out to appraise the grain well before harvest time to observe growth and forecast the probable yield. The effort required close observation and extensive travel, but it resulted in accurate grain reports at a time when government reports were far from reliable. Jones cemented his reputation as a crop forecaster in 1900, when he decided to go back into the fields midseason to reassess his earlier prediction. His final analysis was much more accurate than the one the government provided, and he had a loyal following from then on. Despite his forecasting talent, however, his true ambition was to own the *Journal.* He got his opportunity in 1908, when he purchased the paper for $1.2 million. His belief that "credit, based on character and integrity," was more important than available cash was put to the test: his personal fortune amounted to only $25,000, and he borrowed the remaining capital.[25]

himself.[22] The Whistlers brought some of the highest prices of the auction, with *Chancellerie Loches*, an etching done on the artist's honeymoon in the Loire Valley in 1888, fetching $1,650. For the most part, Jones sold modern prints from artists already well represented in the collection, selling sixteen Hadens, twelve D. Y. Camerons, and six Félix Buhots. Regrettably, he did sell a lone early trial proof by Mary Cassatt, which left only ten works by this important artist in the collection.

Prints of a Man:
Herschel V. Jones as Collector

Herschel V. Jones had two great ambitions in life: to be the proprietor of a great newspaper and to own an important library.[23] At age ten he published his own newspaper, making six to eight copies in pencil and delivering the issues to his friends. At age fifteen he was setting type and writing articles at the village weekly, and three years later he was editor, publisher, and owner of the paper. Not content with his rapid success, Jones then decided to try his luck beyond the Catskills. At age twenty-two he traveled to various midwestern cities to survey the newspaper opportunities. After visiting Chicago, Kansas City, Omaha, St. Louis, Bismarck, St. Paul, and Minneapolis, he decided that the latter held the most promise for his future.[24] Arriving in his new hometown in 1885, he began work as one of three reporters at the

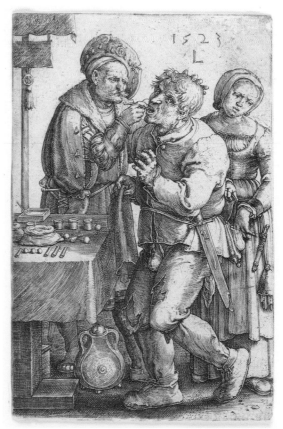

Figure 25 **Lucas van Leyden**, *The Dentist*, 1523, engraving, 4 ⁹⁄₁₆ x 2 ¹³⁄₁₆ in. (116:75 mm), P.10,633

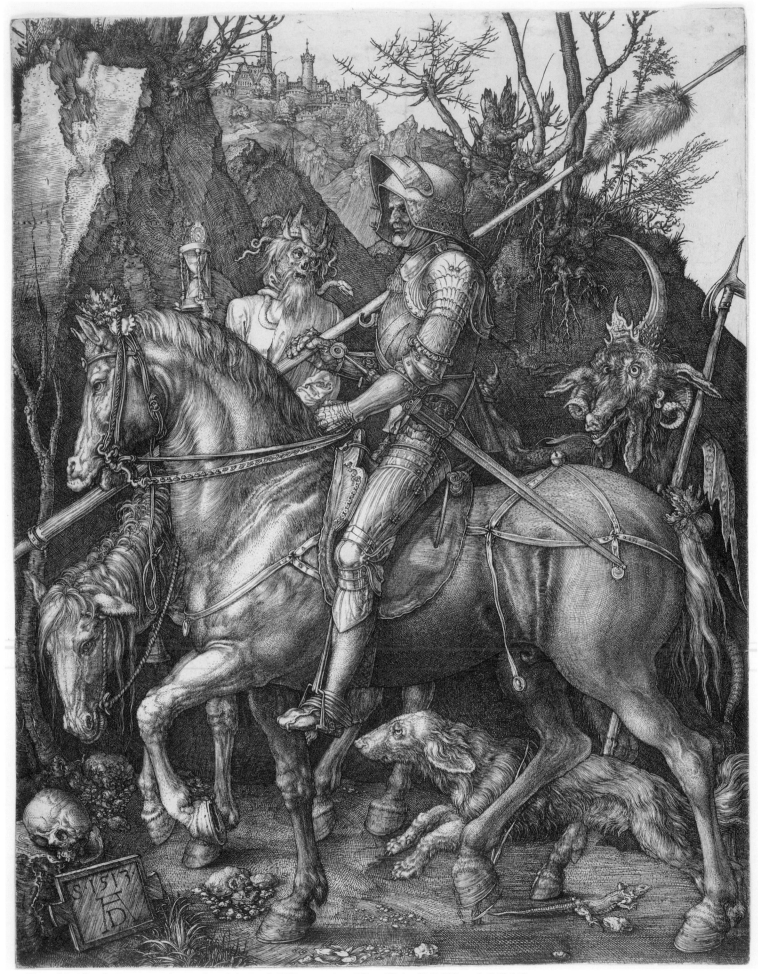

Figure 26 **Albrecht Dürer**, *Knight, Death, and the Devil*, 1513, engraving, 9 11/16 x 7 7/16 in. (246:189 mm), P. 68.149

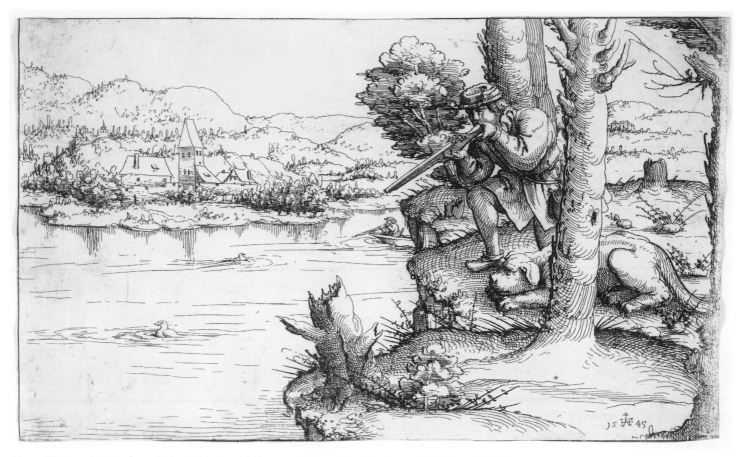

Figure 27 **Augustin Hirschvogel**, *Duck Shooting with Firearms*, 1545, etching, 6½ x 11 in. (165:279 mm), P.68.174

Now Jones set about pursuing his other lifelong goal: building a great personal library. He bought his first work, Alfred Lord Tennyson's *Poems*, as a young boy and from there amassed several distinct libraries over his lifetime. As his interests changed, he was able to sell each individual library at a considerable profit, revealing his skill as an intelligent and savvy collector. He frequently concentrated on fields where there was no general interest, which enabled him to accumulate important works before prices became prohibitive. His earliest collection focused on first editions of modern American authors. He sold this at auction in 1906 along with a group of English and French literary works; a selection of illustrated books by George Cruikshank, William Hogarth, and others; works related to Napoleon; and an extensive collection of English tracts and pamphlets of the seventeenth century.[26]

Jones next turned to early printed books, or incunabula, and sixteenth- and seventeenth-century works. This collection of more than 1,700 items was sold in a historic auction on three separate days in late 1916 and early 1917. It included illuminated books of hours, original manuscripts by William Butler Yeats and Mark Twain, the Bridgewater copy of John Milton's *Cosmos*, and twenty-three rare editions by William Shakespeare. The sale established new auction records, bringing in nearly $400,000, with the highest-ever average price of $226.11 per lot.[27] Considering that the latter figure was nearly the typical price of a Model T Ford at the time, these were indeed impressive amounts. The first of these three sales happened just a month after Jones purchased the Ladd collection, and much of the proceeds may have gone toward buying the prints. The *Journal* was also doing quite well, and advertising sales were bringing in healthy profits.[28]

In 1923 Jones parted with his collection of Elizabethan literature. In a letter to the auction house dated October 22, 1922, he stated that he collected the volumes to give him comfort in his time of bereavement over the loss of an earlier library. But instead of finding comfort, "I find myself miserable in being compelled to face the impossibility of collecting another English library," he wrote. "I shall be happier with none than with the few. Therefore, I am sending them to you for disposal."[29] His last great book collection focused on Americana. In less than six years the perceptive collector had gathered together 1,700 volumes covering American history from Columbus to the exploration of the Klondike gold fields. This grouping cemented Jones's reputation as one of the most astute book collectors of the time. Among his last projects was to oversee a deluxe two-volume description

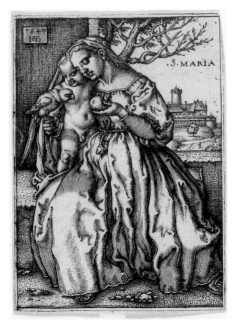

Figure 28 **Sebald Beham**, *Virgin and Child with a Parrot*, 1549, engraving, 3¼ x 2¼ in. (83:57 mm), gift of Miss Tessie Jones, P.13,782

of 300 of the more valuable books in this collection. *Adventures in Americana* was published at his expense the week before his death in 1928.[30] In addition to his separate libraries, Jones created a "reading library" of general literature that ultimately numbered 3,000 volumes and remained with his family after his death.

It was natural that Jones, who was drawn to printed material in both his profession and his avocation, would be interested in engravings, etchings, lithographs, and woodcuts. Before he stepped forward to purchase the Ladd collection, however, he had bought only a few prints. He acquired his first engraving during a visit to New York with his eldest daughter, Tessie Wilcox Jones (1886–1967), in October 1915. From the beginning he bought only the very best; this initial work was an excellent impression of Sebald Beham's *Virgin and Child with a Parrot* (fig. 28). His earliest acquisitions were old master prints from the fifteenth and sixteenth centuries, an area that would remain his prime interest until his death. As Breck wrote to Sachs at Harvard about Jones in November 1915, "One of our Trustees is showing an interest in prints and has just acquired three superb examples, including a remarkably fine example of Dürer's *St. Jerome in His Study*" (cat. no. 30).[31] It would be a few years before Jones approached print collecting with the same drive and intensity that he had shown with his rare books, but once he did, he revealed his characteristic insight and daring. He had definite ideas about the strengths and weaknesses of the Ladd collection, and when he gave it to the Institute, his one caveat was that he did not want his name attached to the gift until after he had "secured a number of rare additional prints to fill in the gaps, making it a collection that represents with remarkable completeness the entire history of the graphic arts."[32]

Although remembered primarily for his acquisitions of old master works, Jones did exhibit some early interest in works from the nineteenth and early twentieth centuries. Among the many gifts donated after his initial 1916 gift, was a group of nearly 100 wood engravings and woodcuts by Auguste-Louis Lepère (fig. 36), one of his favorite artists.

In 1920, however, he chose to sell nearly 300 of his own nineteenth-century prints at auction in New York, including works by Whistler, Zorn, Eugène Delacroix, and Honoré Daumier.[33] His decision to sell these prints rather than give them to the Institute may have reflected his belief that the Ladd collection, already strong in the modern masters, had enough nineteenth-century examples.

A Passion for Old Masters

Jones's shift from modern prints to works from the fifteenth and sixteenth centuries may have been encouraged by his old acquaintance FitzRoy Carrington. In 1921 the curator left Boston to become the old-master print specialist at M. Knoedler & Co. gallery in New York City. Carrington's knowledge of this era was legendary, and he would have been an excellent ally. Five years earlier, in his appraisal of the Ladd collection, Carrington had recommended that the Institute start acquiring fifteenth- and sixteenth-century works immediately.[34] At Knoedler he would have had access to choice works that the Institute was lacking, and he must have directed Jones to these prints. Jones purchased the

Figure 29 **Heinrich Aldegrever**, *Rhea Sylvia (Romulus and Remus)*, c. 1530, engraving, 5¹³⁄₁₆ x 3⅞ in. (148:98 mm), P.10,997

Figure 30 **Marcantonio Raimondi,** *Two Cupids Leading Children in a Dance,* c. 1517–20, engraving, 3¹⁵⁄₁₆ x 6¼ in. (100:159 mm), P.10,937

majority of his collection from Knoedler, acquiring, among other things, a group of Jacopo de' Barbari engravings (fig. 21), thirty intaglio and relief prints by Lucas van Leyden (fig. 25), and an equally large number of works by Martin Schongauer and Augustin Hirschvogel (fig. 27). When he sought additional Rembrandt prints, Jones spread out his purchases over several galleries, buying impressions from Keppel Gallery in New York, the Bresler Gallery in Milwaukee, and the Rosenbach Galleries in Philadelphia. He purchased his first prints from the Keppel Gallery in 1915 and subsequently worked with the gallery to secure prints by Dürer, Hans Baldung Grien, and Israhel van Meckenem. The resourceful Jones also purchased nineteenth- and early twentieth-century prints by Lepère, Millet, Meryon, and James McBey from Kennedy & Company and Arthur H. Hahlo & Company galleries in New York, as well as from Albert Roullier's gallery in Chicago.

No matter where he did business, Jones always purchased the best impression and the highest-quality print available. He had learned through his book collecting that this was an excellent guiding principle. As

Figure 31 **Albrecht Altdorfer,** *Allegorical Figure,* c. 1515–18, engraving, 3¹³⁄₁₆ x 1⅞ in. (97:48 mm), P.10,862

for the Italian Renaissance, he sought out rare and important prints by such luminaries as Giovanni Antonio da Brescia, Andrea Mantegna, Antonio Pollaiuolo, and Marcantonio Raimondi (fig. 30). He rounded out the northern collection with beautiful impressions by Heinrich Aldegrever (fig. 29), Albrecht Altdorfer (fig. 31), Hans Burgkmair, Hans Holbein, and Lucas Cranach the Elder. Importantly, his personal collection contained the only known impressions in the United States of Benedetto Montagna's engraving *The Holy Family with the Infant Saint John in a Landscape* (fig. 32) and Master •I•I•CA's *Saint Lucy* (cat. no. 13).

Probably because of his earlier attraction to incunabula and books of hours, Jones ventured into the specialized area of early hand-colored woodcuts and metalcuts. These early prints are among the rarest and most esoteric in the collection and are virtually unobtainable today. He accumulated a small but choice group of these precious works from the Knoedler gallery in 1925 because he was knowledgeable enough to act at a rare time when some were available. This area was completely lacking in the Ladd collection, and nearly

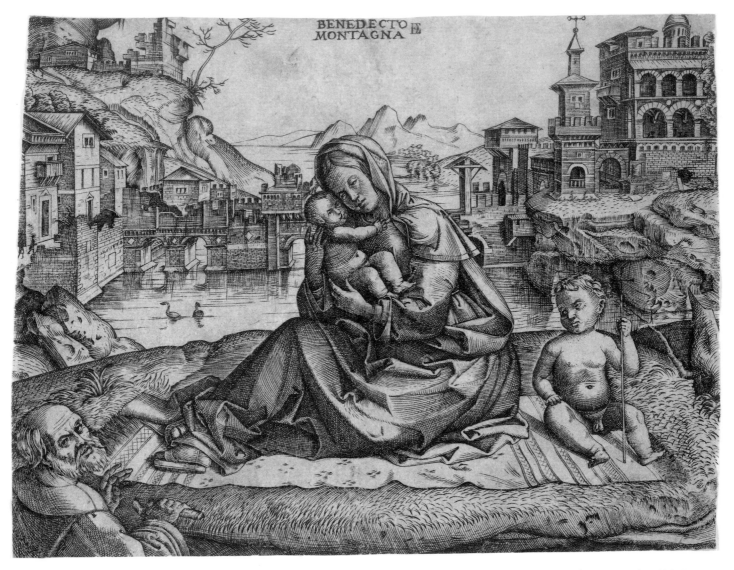

Figure 32 **Benedetto Montagna**, *The Holy Family with the Infant Saint John in a Landscape*, c. 1506–12, engraving, 5½ x 7¼ in. (140:184 mm), P. 68.240

twenty extraordinary examples of these, including *Christ on the Cross with Angels, Sun, and Moon* (fig. 19), and *The Man of Sorrows* (fig. 24), came to the Institute through Jones's great vision.

Jones was extremely devoted to his print collection in the mid-1920s. He had sold his Elizabethan book collection in 1923 and, although still actively seeking out Americana, was eager to perfect his print holdings. In 1925 and 1926 he made six separate gifts of nearly 400 prints to the Institute—often soon after they had come into his possession. It was at this time that he gave a complete set of the first edition of Dürer's *Life of the Virgin* and forty important prints by Lucas van Leyden, including *Emperor Maximilian I* (fig. 35), the first print made on copper and the first ever to combine engraving and etching on the same plate.

As an experienced collector, Jones was attuned to quality whether the medium was books, prints, or paintings. While a trustee and member of the Institute's long-range develop-

ment committee, he advocated quality over quantity. Instead of spending precious accession funds on minor works, he lobbied for the Institute to conserve its money until great masterpieces were available. Jones firmly believed that works of the highest distinction would endure, and his own painting collection contained many impressive works. After his death, the Institute received Lucas Cranach the Elder's *Madonna and Child with Grapes* and the enviable Canaletto *Grand Canal from Palazzo Flangini to Palazzo Bembo*. Jones also helped bring to Minneapolis what is arguably the museum's greatest oil painting, Rembrandt's *Lucretia* (fig. 33). This masterpiece became part of the permanent collection in 1934 when Jones's widow sold this incredible painting to the Institute.[36]

Figure 33 **Rembrandt van Rijn,** *Lucretia,* 1666, oil on canvas, 43⅜ x 36¹⁵⁄₁₆ in. (1102:923 mm), The William Hood Dunwoody Fund, 34.19

The Legacy of Herschel V. Jones

Jones fell ill in 1926 and spent the last eighteen months of his life in and out of the Mayo Clinic in Rochester, Minnesota. When one of the *Journal* employees wished him a speedy recovery, Jones replied, "It's pretty hard to die just when you have got things coming your way."[35] Jones's sons Carl, Jefferson, and Moses were working at the paper, and in

1926 he turned the management of the *Journal* over to his eldest son, Carl.[37] During this trying time Jones continued to collect; in fact, he purchased Rembrandt's *Lucretia* only a year before he succumbed to heart disease on May 24, 1928, at age sixty-seven.

It was only when his death was imminent that Jones allowed the Institute to reveal his generosity as the donor of the Ladd collection and eight additional gifts of prints. The

Figure 34 **Parmigianino**, *Saints Peter and John Healing the Sick at the Gates of the Temple*, c. 1530, etching and woodcut printed in two tones of ochre ink, 11 x 15⅝ in. (279:397 mm), gift of funds from Janet and Winton Jones in memory of Thirza Jones Cleveland, P.99.15.3

most important of these later gifts came in 1926 with the arrival of 239 old master works. In 1928 the entire Jones gift was valued at between $600,000 and $700,000 and included the work of 583 artists.[38] To celebrate the announcement, a large exhibition of about 200 prints, many of them never seen by museum visitors, was put on display in the print galleries.[39] The trustees drafted a resolution acknowledging Jones's role as a benefactor of the Minneapolis Society of Fine Arts and characterized the gift as being "as wise and enduring as it is splendid and noble."[40]

In his will, Jones left the remainder of his print collection to his widow, Lydia Wilcox Jones (1861–1942), and his unmarried daughter, Tessie, to enjoy during their lifetimes. Thereafter it was to come to the Institute.[41] Lydia sold the *Journal* in 1939 and moved with Tessie to a modern Italian villa on the Hudson River in upstate New York. Herschel's prints and paintings filled the new home, and after her mother's death in 1942, Tessie continued to enjoy her father's treasures. After Tessie died in November 1967, the rest of the Jones Collection—255 prints and thirteen paintings—came to the Institute. All told, Herschel V. Jones's gifts, which included paintings, the Ladd collection, and the nearly 700 prints from his own collection, was and still is the largest gift of artwork ever donated to The Minneapolis Institute of Arts.

Yet Jones's legacy is not measured by artwork alone. His family's ongoing stewardship of and devotion to the Department of Prints and Drawings has provided for numerous acquisitions and impressive growth. After curator

Lehr's retirement in 1942, the print curator position remained vacant until Herschel's son Carl Waring Jones (1887–1957) brought in Harold Joachim in 1956. Although Joachim remained just two years before leaving to head the print department at the Art Institute of Chicago, he did much to revive community interest in the graphic arts and acquired several masterpieces, including possibly the finest impression of Dürer's *Adam and Eve* in the country. Carl also funded an educational program dedicated to prints at the Institute.[42] On the department's fiftieth anniversary, in 1966, Carl's children—Winton Jones (1924–2003), Waring Jones (b. 1927), and Thirza Jones Cleveland (1929–1997)—contributed to the renovation of the print gallery and study room named in honor of their grandfather. Winton inherited his grandfather's passion, and many key works entered the collection through his generosity, including a rare etching and woodcut by Parmigianino (fig. 34). After Winton's death, in 2003, his family designated a gallery in his name and endowed a fund so that the Institute could continue to add old master prints to the collection.

The foundation that Herschel V. Jones laid with such foresight and generosity in 1916 has today grown into a department of remarkable depth, containing some of the world's finest and rarest prints. Every year the Institute organizes nearly a dozen separate gallery exhibitions drawn entirely from its prints and drawings holdings, fulfilling Jones's wish for museum visitors to make the "fullest use" of the collection he loved so well.

Figure 35 **Lucas van Leyden**, *Emperor Maximilian I*, 1520, engraving and etching, 10¼ x 7⅝ in. (260:194 mm), P.10,913

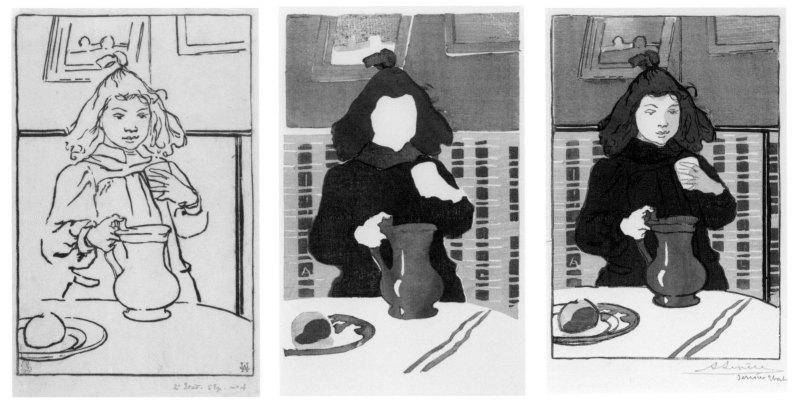

Figure 36 **Auguste-Louis Lepère**, *Young Girl with a Pitcher*, 1890, color woodcut, 7⅜₆ x 4¹³⁄₁₆ in. (186:122 mm), accompanied by progressive proofs (left and center), P.10,518, P.10,521, P.10,522

Notes

1. Jeffrey A. Hess, *Their Splendid Legacy: The First One Hundred Years of The Minneapolis Society of Fine Arts* (Minneapolis: Minneapolis Society of Fine Arts, 1985), 34. Hess's book is one of the best sources of information on the early years of the Institute.

2. *Minneapolis Journal*, January 8, 1915.

3. Joseph Breck, "XIX Century Etchings," *Bulletin of the Minneapolis Institute of Arts* 4 (November 1915): 114.

4. Frederic Torrey to Joseph Breck, January 3, 1916, box 6, Minneapolis Institute of Arts Print Department Archives.

5. "Catalogue of the Ladd Collection," 2 vols., typewritten manuscript, Department of Prints and Drawings, Minneapolis Institute of Arts.

6. "FitzRoy Carrington," *Bulletin of the Museum of Fine Arts, Boston*, 53 (February 1955): 18.

7. FitzRoy Carrington to Joseph Breck, January 12, 1916, box 6, Minneapolis Institute of Arts Print Department Archives.

8. Carrington discussed his desire to create more public print departments in a letter to Joseph Breck (January 14, 1916, box 6, Minneapolis Institute of Arts Print Department Archives).

9. The following articles all appeared in *Print Collector's Quarterly*: Frank Weitenkampf, "The Print-Collection of the New York Public Library," 1, no. 4 (1911): 457–63; Francis Bullard, "The Print Department of the Museum of Fine Arts, Boston," 2, no. 2 (1912): 183–206; Willis O. Chapin, "The Print-Collection of the Albright Art Gallery, Buffalo," 2, no. 1 (1912): 50–55; John Cotton Dana, "Print-Collections in Small Libraries," 3, no. 1 (1913): 60–69; Arthur Jeffrey Parsons, "The Division of Prints of the Library of Congress," 3, no. 3 (1913): 310–35; William M. Ivins Jr., "The Print Department of the Metropolitan Museum of Art," 7, no. 1 (1917): 103–4; Marie C. Lehr, "The Print Department of the Minneapolis Institute of Arts," 7, no. 3 (1917): 288–97.

10. FitzRoy Carrington to Joseph Breck, January 15, 1916, box 6, Minneapolis Institute of Arts Print Department Archives.

11. Ibid.

12. FitzRoy Carrington to Joseph Breck, March 1, 1916, box 6, Minneapolis Institute of Arts Print Department Archives.

13. FitzRoy Carrington and Joseph Breck to the trustees of the Minneapolis Society of Fine Arts, March 21, 1916, box 6, Minneapolis Institute of Arts Print Department Archives.

14. "Anonymous Donor Gives Art Society Famous Collection," *Minneapolis Journal*, October 12, 1916.

15. "$225,000 Gift Puts Minneapolis Ahead of Older Art Museums," *Minneapolis Journal*, October 15, 1916.

16. FitzRoy Carrington to Joseph Breck, February 21, 1916, box 6, Minneapolis Institute of Arts Print Department Archives.

17. Marie C. Lehr, "The Print Collection," *Bulletin of the Minneapolis Institute of Arts* 5 (November 1916): 62.

18. Ibid.

19. *Illustrated Catalogue of Engravings, Etchings, and Mezzotints from Collections of Note, Including Those of H. V. Jones, Esq., of Minneapolis, Minn., Mrs. Margaret F. Everit, of Newark, N.J., and the Late Mrs. William H. Reid, of New Canaan, Conn.*, sale cat. (New York: American Art Association, 1917).

20. The other Dürer prints sold include *The Virgin with Short Hair, Virgin Nursing the Child, The Holy Family and the Dragonfly, Saint Jerome in Penitence, The Little Fortune, The Flight into Egypt, The Little Horse,* and *Albert of Brandenburg* (ibid., nos. 192, 194, 195, 197, 199, 203, 205, 208, 209).

21. The other Rembrandts sold include *Rembrandt and Saskia, Abraham Caressing Isaac, The Vision of Ezekiel, Joseph Relating His Dream, Lion Hunt, Two Peasants Traveling, Old Man with a Short Beard, Resting*

against a Bank, View of Amsterdam (copy of the original etching, probably by J. Bretherton), *Jan Cornelis Sylvius, Bust of an Old Man with Flowing Beard and White Sleeve,* and *Man in a Broad-Brimmed Hat and Ruff* (ibid., nos. 365–73, 375, 376).

22. For the twenty-one Whistler prints sold by Jones, see ibid., nos. 416–28, 439, 453, 454, 458–60, 462, 464.

23. Edward C. Gale, "Herschel V. Jones," *Minnesota History* 10 (March 1929): 28.

24. John Koblas, *H. V. Jones: A Newspaperman's Imprint on Minneapolis History* (St. Cloud, Minn.: North Star Press of St. Cloud, 2003), 22.

25. Dumas Malone, ed., "Jones, Herschel Vespasian," *Dictionary of American Biography,* vol. 5 (New York: Charles Scribners Sons, 1960), 174.

26. *Selections from the Library of Mr. H. V. Jones of Minneapolis, Minn., to Be Sold Thursday and Friday, April 5 & 6, 1906,* sale cat. (New York: Merwin-Clayton Sales Co., 1906).

27. *Rare Books from the Library of H. V. Jones of Minneapolis, Minn. (A–H), to Be Sold November 20, 1916,* sale cat. (New York: Anderson Galleries, 1916); *Rare Books from the Library of H. V. Jones of Minneapolis, Minn. (H–P), to Be Sold January 29 & 30, 1917,* sale cat. (New York: Anderson Galleries, 1917); *Rare Books from the Library of H. V. Jones of Minneapolis, Minn. (P–Z with Addenda), to Be Sold March 4 & 5, 1917,* sale cat. (New York: Anderson Galleries, 1917).

28. Koblas, *H. V. Jones,* 259.

29. *The Later Library of H. V. Jones* (New York: Anderson Galleries, 1923).

30. Herschel V. Jones, *Adventures in Americana, 1492–1897: The Romance of Voyage and Discovery from Spain to the Indies, the Spanish Main, and North America; inland to the Ohio Country; on toward the Mississippi; through to California; over Chilkoot Pass to the Gold Fields of Alaska,* 2 vols. (New York: William Edwin Rudge, 1928). It is believed that after Jones's death his son Carl sold the entire Americana collection to the book dealer A.S.W. Rosenbach for $225,000.

31. Joseph Breck to Paul Sachs, November 1915, box 6, Minneapolis Institute of Arts Print Department Archives. Jones purchased the Dürer from the Keppel Gallery in New York, and it was probably through this transaction that he first heard about the imminent sale of the Ladd collection.

32. "The Herschel V. Jones Gift of Prints," *Bulletin of the Minneapolis Institute of Arts* 17 (May 1928): cover.

33. *Modern Etchings: The Collection of Herschel V. Jones,* sale cat. (New York: Anderson Galleries, March 28, 29, 1921).

34. In his appraisal of the Ladd collection, Carrington wrote, "As for the valuation of the collection—in guessing 'moderns,' be conservative,—in prints—the old masters, when good, we should get as soon as we can—they are growing rare (as you know better than I do!)—and will cost more each year—but some men (shall I say Bone, Cameron et al) may 'come down' in 50 or 100 years—or less!" (Carrington to Breck, January 12, 1916).

35. Koblas, *H. V. Jones,* 305.

36. Minutes of the Executive Committee of the Minneapolis Society of Fine Arts, June 18, 1934. The other painting sold by Lydia Jones was El Greco's *Portrait of a Nobleman.* This work was deaccessioned in 1958.

37. Herschel and Lydia Jones had seven children: Tessie Wilcox Jones (1886–1967), Carl Waring Jones (1887–1957), Florence Jones Ronald (Mrs. George W. Ronald) (1889–unknown), Paul Merchant Jones (1890–1974), Jefferson Jones (1891–1965), Moses Chase Jones (1894–1979), and Frances Jones Leslie (Mrs. Arnette W. Leslie) (1895–1983).

38. The quantities and some facts were misreported in "H.V. Jones Gives Noted Collection to Institute," *Minneapolis Journal,* May 17, 1928; for corrected copy, see typewritten manuscript in box 6, Minneapolis Institute of Arts Print Department Archives.

39. "The Jones Gift of Prints," *Bulletin of the Minneapolis Institute of Arts* 17 (June 1928): 106–8.

40. "Jones Gives Noted Collection."

41. See documents regarding the last wills and testaments of Herschel V. Jones and Tessie W. Jones, box 6, Minneapolis Institute of Arts Print Department Archives.

42. Carl Jones gave $25,000 on November 25, 1953, for the first education program of the Print Department of the Institute. His intentions are laid out in a letter of November 25, 1953, to Putnam Dana McMillan, president of the Minneapolis Society of Fine Arts, Box 6, Minneapolis Institute of Arts Print Department Archives.

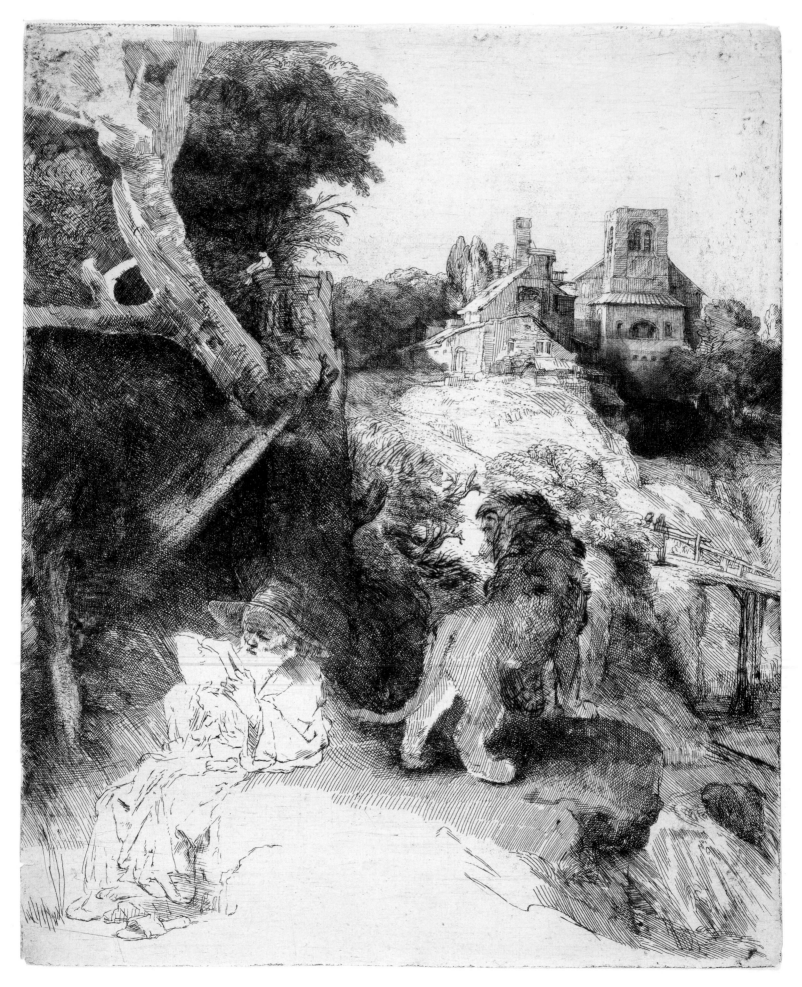

Rembrandt van Rijn, *Saint Jerome Reading in an Italian Landscape*, 1651–52, etching and drypoint, 10¼ x 8¼ in. (260:210 mm), P. 68.406

Notes to the Reader

This catalogue contains a select sampling of works chosen to reflect the range and depth of the Herschel V. Jones Collection, housed in the Department of Prints and Drawings at The Minneapolis Institute of Arts. The first installment of the Herschel V. Jones Gift of Prints came to the Institute in 1916, when Jones purchased the William M. Ladd collection and gave more than 5,300 works anonymously to the Institute. Eight additional gifts came between 1916 and 1928. On Jones's death in 1928, the collection passed to his wife, Lydia Wilcox Jones, and then to his daughter Tessie Wilcox Jones. The balance of the Jones print collection came to the museum in 1968, after Tessie's death, as part of the Bequest of Herschel V. Jones.

The catalogue entries are arranged according to both the geographical location and the time period in which the prints were executed. Each print has been catalogued according to the following guidelines.

Title and Date

The currently accepted title typically is given in English. Each undated print has been assigned an approximate date.

Measurements

Measurements are given in inches and millimeters, with height preceding width. If a borderline or plate mark exists, it, rather than the sheet, has been measured. If the impression has been trimmed, its condition has been noted when possible.

References

Whenever possible, one or more of the standard catalogues of the artist's work has been cited. The states listed are those assigned by the author. Full references for all catalogues cited are given in the bibliography. When appropriate, sources that contain more general discussions of the artists and their works are cited in the footnotes to each entry.

Watermarks

When found, watermarks are described, and when possible, a reference to the watermark, such as a Briquet number, is given.

Provenance

The sequence of the provenance is from the earliest to the last recorded owner. The presence of collector's marks is noted, and Lugt numbers are given whenever possible.

Credit Lines and Accession Numbers

For each work, a credit line is given, including the date when it entered the collection of The Minneapolis Institute of Arts, followed by the accession number.

Early Woodcuts and Metalcuts

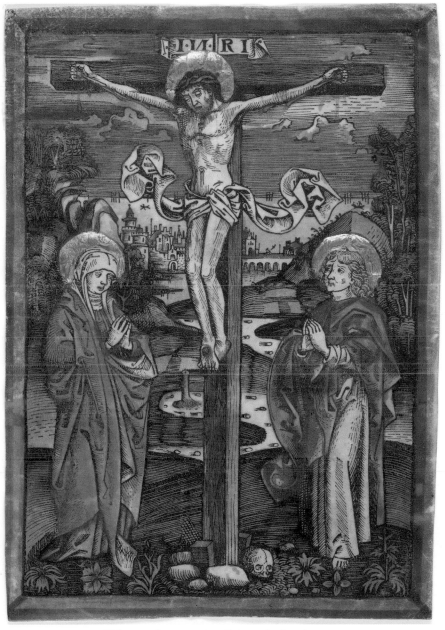

Unknown German artist, *Christ on the Cross between Mary and Saint John,* 1499, hand-colored woodcut, 7⅞ x 5⁷⁄₁₆ in. (200:138 mm), P.68.83

1

Firabet of Rapperswil

Swiss, active c. 1465–80

Crucifix with Three Angels and the Symbols of the Evangelists, c. 1465

Hand-colored woodcut with red, green, yellow,
light brown, and dark brown
15½ x 9¹¹⁄₁₆ in. (393:248 mm)
Watermark: Small bull's head with double-lined staff
and trefoil (not in Briquet)
References: Schreiber I & VIII.940m
Provenance: Angiolini, Milan; Gilhofer & Rauschburg;
Knoedler & Co., 1925
Bequest of Herschel V. Jones, 1968 (P.68.164)

This print is undoubtedly the earliest in the Herschel V. Jones Collection. Not only have the colors survived with remarkable freshness, but it is also probably the first known print to contain both the name of the artisan—presumably the woodblock cutter—and his address, which is the town of Rapperswil, on the Lake of Zurich, in Switzerland.[1] He proudly proclaimed his handiwork with a beautifully carved signature; the handwritten one next to it may have been added later.

Devotional woodcuts are exceedingly rare today because, ironically, they were such a common part of fifteenth-century life. Available by the thousands from peddlers or monastics and at shrines and fairs, these mostly unsigned images were carried around, tacked up for use as home altars, sewn into clothing, and prayed to constantly in the belief that they had special intercessionary power. Because they were used in everyday devotions and not collected or preserved as fine art, relatively few have come down to us; only two impressions of *Crucifix with Three Angels and the Symbols of the Evangelists* are known to exist.

The Crucifixion was a popular theme evoking Christ's suffering and the promise of salvation. This particular depiction is unusual for including the names and symbols of the four Evangelists: John's eagle, Matthew's angel, Luke's ox, and Mark's lion. Praying to this image, then, would remind the faithful of Christ's connection to the Gospels and the symbolism of the Mass.[2] As an example of a devotional woodcut, *Crucifix* is quite refined, in part for its use of short, even hatch marks to create a sense of volume. The ornate cross indicates that the image may have been based on a work originally made of gold or silver.[3] Like other devotional woodcuts, this would have been an inexpensive version of a fine work for the less-privileged citizenry to venerate.
M.J.K.

Notes
1. Harold Joachim, *Prints, 1400–1800: A Loan Exhibition from Museums and Private Collections* ([Minneapolis]: Minneapolis Institute of Arts, 1956), 1.
2. Richard S. Field, *Fifteenth-Century Woodcuts and Metalcuts* (Washington, D.C.: Publications Department, National Gallery of Art, 1965), unpaginated.
3. Joachim, *Prints*, 1.

Master of Jesus in Bethany

Netherlandish, active c. 1465–84

Christ and the Woman of Samaria, c. 1470

Hand-colored metalcut with green, claret red, and yellow
9³⁄₁₆ x 6¹³⁄₁₆ in. (233:173 mm)
References: Schreiber V & VIII.2214x
Provenance: Otto Hiersemann, Leipzig; Colnaghi;
 Knoedler & Co., 1928
Bequest of Herschel V. Jones, 1968 (P.68.90)

The gloriously patterned prints known as metalcuts flowered in the Rhine region in the last half of the fifteenth century, virtually disappearing after 1500.[1] Thought to be the work of metalsmiths and armorers rather than woodcutters, metalcuts are printed in relief, just as woodblocks are. The design is articulated on the surface of the plate using punches, stamps, and a knife; because so many metalcuts have small, round punch marks, they are also referred to as dotted prints.

Christ and the Woman of Samaria takes up a biblical theme that may have resulted from a demand in the late fifteenth century for new religious subjects. In the story (John 4.4 42), Jesus' disciples go to town to buy meat while he sits, exhausted, at a well. When a humble Samaritan woman arrives to draw water, she is surprised when Jesus asks for a drink because Jews and Samaritans did not intermingle. Jesus then reveals his omniscience by naming details of her wanton past. Back in Samaria, she relates this marvel to the townspeople, who in turn come to hear the Messiah speak.

Because they were made for a very short time, metalcuts, especially examples in such superb condition, are extremely scarce. This densely worked print sparkles with an exquisite range of knife marks, dots, and dies—including star, crescent, and flower shapes. The lettering above the well, which translates as "Give me a drink," would have been particularly difficult to hollow out on the metal plate. The narrative detail, such as the expressive way Jesus lifts his hand to emphasize his teachings to the Samaritan woman, is a Netherlandish trademark, as is the subdued palette employed in this print.[2]

M.J.K.

Notes
1. Richard S. Field, *Fifteenth-Century Woodcuts and Metalcuts* (Washington, D.C.: Publications Department, National Gallery of Art, 1965), unpaginated.
2. Ibid.

Anonymous

German, 15th century

Saint Veronica with the Sudarium, c. 1475

Hand-colored woodcut with blue, green, yellow, red, and
 gray, with orange border
7 ⁷⁄₁₀ x 5 in. (186:127 mm)
Watermark: Scales in circle (close to Briquet 2451),
 Riemburg, 1475
References: Schreiber III.1721
Provenance: F. Angiolini, Milan; Knoedler & Co., 1926
Bequest of Herschel V. Jones, 1968 (P. 68.80)

In common legend, Veronica took pity on Jesus while he
carried his cross to Calvary and offered him a cloth, or
sudarium, to wipe his face. Miraculously the impression of
the Holy Face remained on the cloth. Today the relic of
Saint Veronica (the name Veronica comes from *vera icon*, or
true image) is preserved at Saint Peter's in Rome, but by the
fifteenth century the image had already taken on signifi-
cant power. In the thirteenth century Pope Innocent III
announced that praying to the relic, or even a replica of it,
would relieve people of punishment for their sins.[1] Hence
images like this hand-colored woodcut flourished.

The Sudarium had special significance for printmakers
because the act of imprinting Christ's face epitomizes, in a
kind of sacred precedent, their own art. To help along a pil-
grim's spiritual reflections, a *Briefmaler*, or colorist, would
hand-apply the red drops of blood seen here and in Firabet
of Rapperswil's woodcut (cat. no. 1) to emphasize Christ's

suffering. The pigment is no doubt red lead, which often
turned gray-brown over time, and the distinctive orange
border, characteristic of Augsburg woodcuts, was produced
by mixing red lead with buckthorn berries.[2] Along with the
dripping blood, the crown of thorns was added to Sudarium
images in the 1400s, again to heighten the audience's empathy
and emotional involvement with the print.[3]

M.J.K.

Notes
1. Charles W. Talbot, ed., *Dürer in America: His Graphic Work* (Washington,
 D.C.: National Gallery of Art, 1971), 143.
2. Susan Dackerman, *Painted Prints: The Revelation of Color in Northern
 Renaissance and Baroque Engravings, Etchings, and Woodcuts* (Baltimore:
 Baltimore Museum of Art; University Park: Pennsylvania State University
 Press, 2002), 57, 136–38.
3. Talbot, *Dürer in America*, 143.

N.D.L.
CASA.F.

Printmaking in Southern Europe
Before 1600

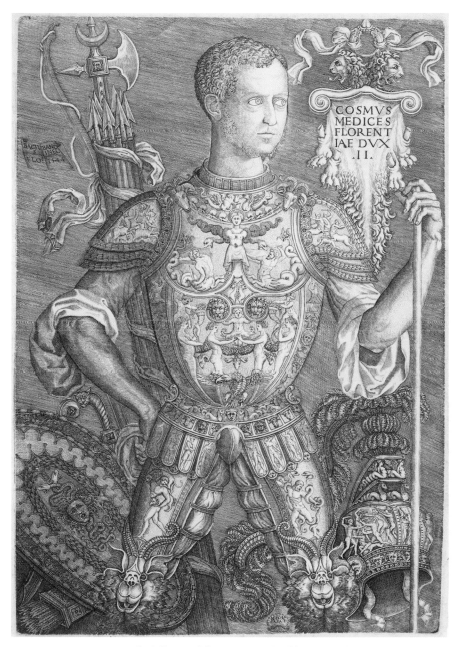

Niccolo della Casa (after Baccio Bandinelli), *Cosimo I de Medici*, 1544, engraving, 16¾ x 11¾ in. (426:299 mm), P.10,879

4 & 5

Master of the E-Series Tarocchi

Italian, 15th century

Justice, c. 1465

Engraving heightened with gold with traces of red
7 ⅟₁₆ x 3¹⁵⁄₁₆ in. (179:100 mm)
References: Hind E.I.37a
Provenance: Dr. W. A. Ackerman (L. 791); Colnaghi;
 Knoedler & Co., 1926
Bequest of Herschel V. Jones, 1968 (P. 68.100)

Euterpe, c. 1465

Engraving heightened with gold
7 ⅟₁₆ x 3¹⁵⁄₁₆ in. (179:100 mm)
References: Hind E.I.18a
Provenance: Albertina duplicate (no mark); Colnaghi;
 Knoedler & Co., 1926
Bequest of Herschel V. Jones, 1968 (P. 68.96)

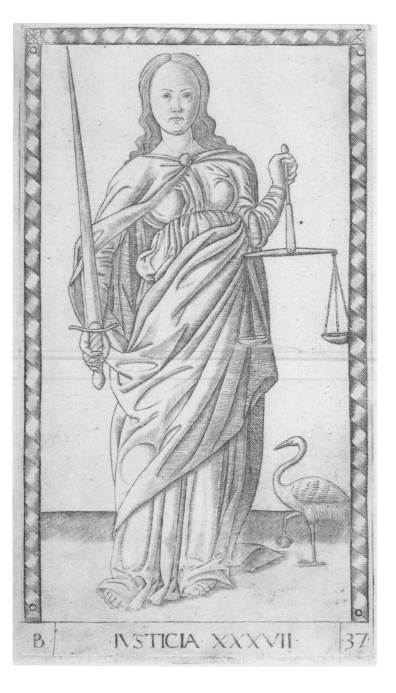

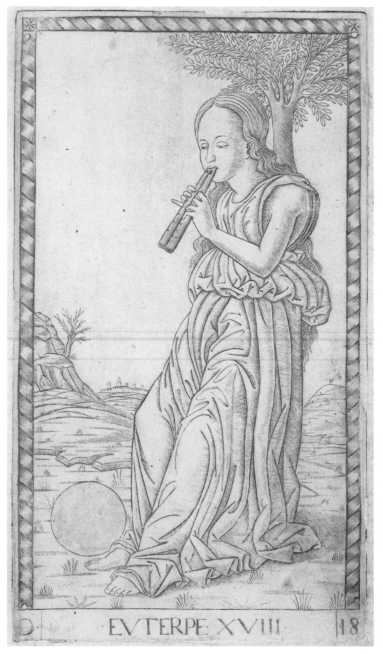

Very early Italian prints included playing cards as well as the Tarocchi, a set of instructive prints that may have served as tarot cards. Tarocchi were certainly invented before 1450 in northern Italy, where the game became a popular aristocratic diversion. The earliest documentary references to Tarocchi are found in 1442 in the account books of the Ferrarese court.[1] It is possible that they were meant to be used as didactic images or even bound to form a small instructive volume.[2] The occult use of tarot cards developed later, apparently in eighteenth-century France.[3]

The six Tarocchi in the Jones Collection all belong to the "E series" of the so-called Mantegna Tarocchi, which in fact have no discernible relationship to artist Andrea Mantegna and did not serve as a deck of tarot cards. An anonymous engraver produced the E series (as distinguished from the inferior S series) in Ferrara between 1460 and 1470, the decade when engraving began to flourish in that northeastern Italian city. Two sets of the E-series Tarocchi were created, each containing fifty separate images divided into suits or groups.

Unlike a true deck of tarot cards, the E-series Tarocchi cannot have functioned as playing cards because they are too large to be held comfortably and several surviving sets are actually bound together as books.[4] Whoever designed the series relied on a hand-painted tarot deck for a specific prototype. Technically the E series is distinguished by its great precision of outline and modeling, and is clearly the work of an experienced engraver.[5] The engravings form a carefully ordered and elaborate symbolic set of allegorical figures. Each image bears, in addition to its title, a number identifying its position in the series and a letter indicating the particular suit to which it belongs.

Justice is number thirty-seven of the suit composed of Genii and Virtues, indicated by the letter *B* in the lower left corner. Justice is one of the four Cardinal Virtues, along with Prudence, Fortitude, and Temperance. Renaissance humanists regarded her as the foremost of these Virtues. The sword is emblematic of her power, and the scales signify impartiality.[6] The crane holding a stone in one claw represents vigilance, because if it fell asleep, the stone would drop and immediately awaken it.[7]

Euterpe is number eighteen of the suit comprising the Muses and Apollo, indicated by the letter *D*. Euterpe was one of the Muses, the nine daughters of Zeus and the Titaness Mnemosyne. They were associated with the god Apollo, and by Roman times each Muse was considered to be the patroness of a specific art. Euterpe, the patroness of flute music, is shown playing the double flute. In this series the Muses are accompanied by blank disks, which are meant to represent the celestial spheres of the Ptolemaic universe.[8]
J. I. S.

Notes
1. Ronald Decker, Thierry Depaulis, and Michael Dummett, *A Wicked Pack of Cards* (London: Gerald Duckworth and Co., 1996), 27; the authors cite Firmicus Maternus, *Ancient Astrology: Theory and Practice*, trans. Jean Rhys Bram (Park Ridge, N.J.: Noyes Press, 1975), as their source.
2. Jay A. Levenson, Konrad Oberhuber, and Jacquelyn L. Sheehan, *Early Italian Engravings from the National Gallery of Art* (Washington, D.C.: National Gallery of Art, 1973), 82.
3. Decker et al., *Wicked Pack of Cards*, 35.
4. Mark J. Zucker, *Early Italian Masters*, vol. 24 (commentary), pt. 3, of *The Illustrated Bartsch* (New York: Abaris Books, 2000), 1.
5. Ibid., xviii. The delicate cross-hatching is reminiscent of early niello prints by Maso Finiguerra and of other Florentine prints.
6. James Hall, *Dictionary of Subjects and Symbols in Art* (New York: Icon Editions, 1979), 183.
7. Ibid., 322.
8. Jean Seznec, *The Survival of the Pagan Gods*, trans. Barbara F. Sessions (New York: Pantheon, 1953), 141.

Francesco Rosselli

Italian, 1445–before 1513

The Samian Sibyl: Broad Manner, 1485–1500

Engraving
6 ¹⁵⁄₁₆ x 4 ⅛ in. (177:105 mm)
References: Hind C.II.6B i/iii
Watermark: Unidentified flower
Provenance: Ambroise Firmin-Didot (L. 119);
 Louis Gallichon (L. 1060); Colnaghi; Knoedler & Co., 1926
Bequest of Herschel V. Jones, 1968 (P.68.94)

According to the first-century B.C. Roman scholar Varro, the ancient world had ten sibyls, a word that comes from the ancient Greek word *sibylla*, meaning "prophetess."[1] The Samian Sibyl was a priestess who presided over the Apollonian oracle at Samos, a Greek colony off the west coast of Asia Minor. In Christian literature and art the sibyls achieved the status of the Old Testament prophets and were assigned the role of prophesying the coming of Christ as a way to reconcile classical pagan figures with Christianity.

Francesco Rosselli's engraved series is closely based on the twenty-four prophets and twelve sibyls engraved by Baccio Baldini (1436–c. 1487) in the 1470s. While Baldini's series was engraved in the "fine manner," Rosselli utilized the "broad manner," characterized by modeling lines that are generally shorter, more deeply cut (thus thicker), and more widely spaced than those employed in the fine manner. It is believed that he used a type of burin popular with northern European engravers, which had a lozenge-shaped section. He probably brought this tool to Florence in 1482 from Hungary, where he had spent a few years.[2]

Although the majority of Baldini's engravings are derived from Florentine models, *The Samian Sibyl* is based on an as-yet-unidentified northern model, possibly French or Burgundian.[3] The sibyl's costume is closely related to contemporary secular decoration, particularly to the paintings on *cassone* (marriage chests), which usually bore scenes from ancient history. Below the sibyl are eight verses that art historian Emile Mâle recognized as corresponding to verses spoken by the prophets and sibyls in fifteenth-century *sacre rappresentazioni*, or mystery plays, which were performed by religious confraternities in church squares during festivals.[4]
J. I. S.

Notes

1. Michael Avi Yonah and Israel Shatzman, *Illustrated Encyclopedia of the Classical World* (New York: Harper & Row, 1975), 421.
2. David Landau, "Printmaking in the Age of Lorenzo," in *Florentine Drawing at the Time of Lorenzo the Magnificent*, ed. Elizabeth Cropper (Bologna: Nuova Alfa Editorial, 1992), 179.
3. Avi Yonah and Shatzman, *Illustrated Encyclopedia*, 161.
4. Jay A. Levenson, Konrad Oberhuber, and Jacquelyn L. Sheehan, *Early Italian Engravings from the National Gallery of Art* (Washington, D.C.: National Gallery of Art, 1973), 22–25.

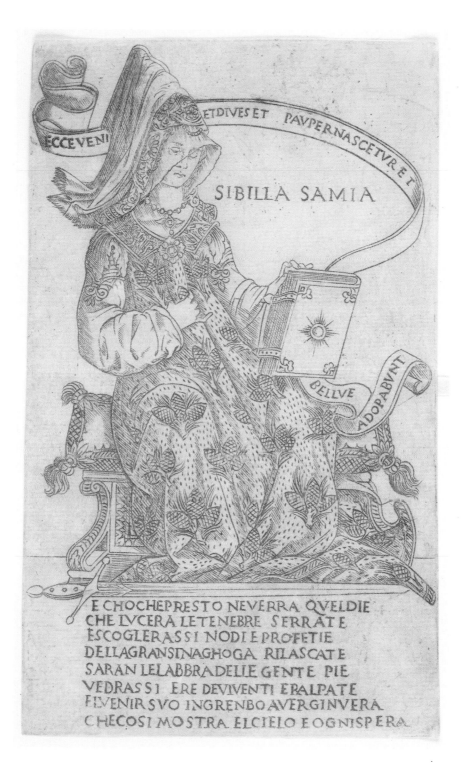

ECCE VENI ET DIVES ET PAVPER NASCETVR E I

SIBILLA SAMIA

BELLVE ADORABVNT

E CHO CHE PRESTO NE VERRA QVEL DIE
CHE LVCERA LE TENEBRE SERRATE
ESCOGLERAS SI NODI E PROFETIE
DELLA GRAN SINAGHOGA RILASCATE
SARAN LE LABBRA DELLE GENTE PIE
VEDRAS SI ERE DE VIVENTI E PALPATE
FI VENIR SVO IN GRENBO A VERGIN VERA
CHE COSI MOSTRA EL CIELO E OGNI SPERA

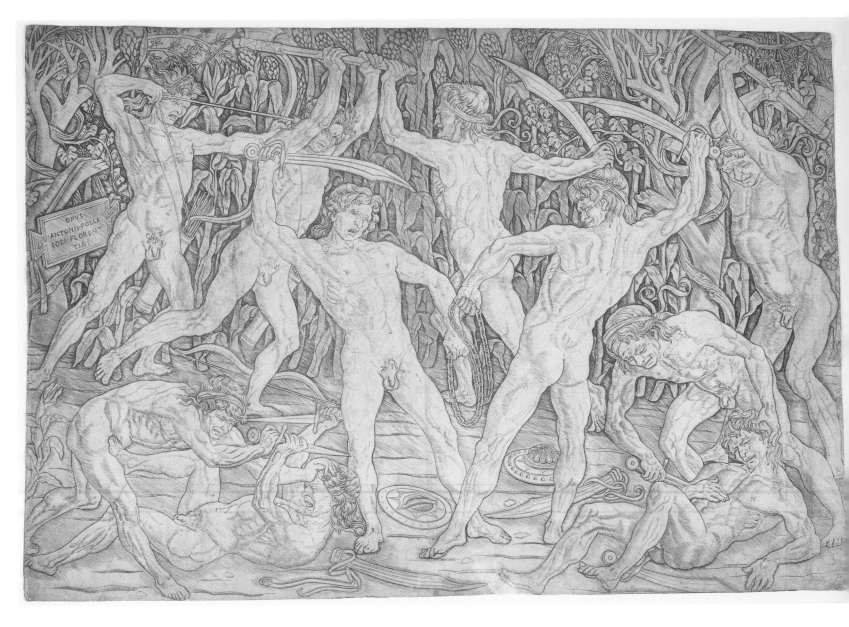

7

Antonio Pollaiuolo

Italian, c. 1432–1498

Battle of the Nudes, c. 1470

Engraving
15⅜ x 22⅛ in. (390:562 mm), trimmed
References: Bartsch 2; Hind D.I.1
Provenance: Unidentified (L. 2880); Frederick Keppel
Bequest of Herschel V. Jones, 1968 (P. 68.246)

Battle of the Nudes is a landmark in the history of Renaissance art. It is unquestionably the single most important and influential Florentine engraving of the fifteenth century.[1] The print is exceptional for its theme, style, and imposing scale; most engravings of the period were executed on plates half this size.[2] It is also the only known print by Antonio Pollaiuolo and the earliest engraving in Italy to bear the artist's full signature, visible on a rectangular plaque hanging from a tree at left.[3]

Scholars have proposed numerous explanations for the subject, with its apparently senseless slaughter, but no one has offered a convincing literary source, instead requiring viewers to invent their own narrative. Similarly, no exact antique prototype has been found for either the composition or the individual figures, although the classicizing

qualities of both have always been recognized and were clearly intentional.[4] Perhaps the most plausible explanation is that it was a demonstration piece intended to disseminate Florentine artistic ideas and to showcase Pollaiuolo's ability to portray the male nude, front and back, in action. Despite the fact that Leonardo da Vinci ridiculed the figures as "sacks of nuts," Pollaiuolo changed art through his naturalistic study of muscle and bone.[5]

In this print, Pollaiuolo used a "zigzag" technique, which he apparently originated, to simulate the "return stroke" found in pen-and-ink drawings. To achieve this continuous back-and-forth line, the artist carefully cut two discrete rows of parallel lines—one at a slight angle to the other—and then seamlessly integrated the two, forming elongated Vs where they converge at either end. This innovation, used in modeling the muscular bodies, represented a considerable improvement over the straightforward parallel shading and cross-hatching found in earlier prints.[6]

J. I. S.

Notes
1. Mark J. Zucker, *Early Italian Masters,* vol. 25 (commentary) of *The Illustrated Bartsch* (New York: Abaris Books, 2000), 12.
2. Shelley R. Langdale, *Battle of the Nudes: Pollaiuolo's Renaissance Masterpiece* (Cleveland: Cleveland Museum of Art, 2002), 56.
3. Jay A. Levenson, Konrad Oberhuber, and Jacquelyn L. Sheehan, *Early Italian Engravings from the National Gallery of Art* (Washington, D.C.: National Gallery of Art, 1973), 66.
4. See Langdale, *Battle of the Nudes,* 57 n. 14, for an overview of the various interpretations of the subject matter of this print.
5. A. Hyatt Mayor, *Prints and People: A Social History of Printed Pictures* (New York: Metropolitan Museum of Art, 1971), unpaginated.
6. Langdale, *Battle of the Nudes,* 25.

Andrea Mantegna

Italian, c. 1431–1506

Battle of the Sea Gods, c. 1485–88

Engraving and drypoint
Left half: 13¼ x 17¾ in. (337:451 mm)
Right half: 13¼ x 17⅞ in. (337:454 mm)
References: Hind 5 (left half); Hind 6 ii/ii (right half)
Watermark: Scales(?) in circle (close to Briquet 2480)
Provenance: Albert Roullier, 1917
Bequest of Herschel V. Jones, 1968 (P. 68.210, P. 68.211)

Andrea Mantegna, while most famous as a painter and draftsman, was also an extremely influential graphic artist, one of the first in northern Italy to make prints from engraved copper plates. *Battle of the Sea Gods*—arranged in a shallow, friezelike setting—addresses the theme of envy, a subject close to Mantegna's heart: he was a contentious personality who had several well-publicized rivalries with fellow artists in his lifetime. In this composition, Tritons, Nereids, and hippocampi are spurred on by Envy, the hag at left holding a plaque reading INVID for *invidia*, or envy.[1] The combat takes on a burlesque tone when one realizes that the warriors are using fish, bones, and animal skulls as

their weapons. Despite biographer Giorgio Vasari's assertions that Mantegna learned engraving in Rome from 1488 to 1490, a study of his technique indicates that he began engraving much earlier, possibly in the 1460s, after he entered the service of the Gonzaga court in Mantua.[2] Like Antonio Pollaiuolo (cat. no. 7), Mantegna imitated the even shading of pen-and-ink drawings, tracing his burin in a single direction from left to right and from top to bottom. *Battle of the Sea Gods* represents Mantegna's late, more expressive style, in which the individual modeling line assumed greater strength, the lines were more deeply incised and more widely spaced, and the primary lines were supplemented by shorter, oblique lines between them.[3] Mantegna appears to have employed drypoint and a burin with a lozenge-shaped section.[4] He seems in fact to have used two burins, which made lines of different thicknesses.

Battle of the Sea Gods is divided into two sheets, probably due to the technical difficulties encountered in printing a single large plate.[5] Its large size indicates that it was intended to be displayed on a wall, as a painting would be. These two companion prints are among the seven engravings for which Mantegna is credited with both the design and the execution. Thanks to Herschel V. Jones, the Institute owns six of these engravings. J. I. S.

Notes

1. Michael A. Jacobsen, "The Meaning of Mantegna's Battle of Sea Monsters," *Art Bulletin* 64 (December 1982): 624.

2. Jay A. Levenson, Konrad Oberhuber, and Jacquelyn L. Sheehan, *Early Italian Engravings from the National Gallery of Art* (Washington, D.C.: National Gallery of Art, 1973), 168.

3. This change in technique, first observed in the *Bacchanals*, suggests the influence of Pollaiuolo's *Battle of the Nudes* (c. 1470; cat. no. 7). Contrary to accepted opinion, Mantegna's shading technique is not limited to parallel hatching with return strokes but occasionally includes zigzag lines and cross-hatching (ibid.).

4. David Landau and Peter Parshall, *The Renaissance Print, 1470–1550* (New Haven: Yale University Press, 1994), 71.

5. The clarity of the impression suggests that Mantegna had access to a roller press (ibid., 70–71).

Giovanni Antonio da Brescia

Italian, c. 1460–c. 1520

Holy Family with Saint Elizabeth and the Infant Saint John, c. 1495–1505

Engraving
11⅜ x 10⅛ in. (296:257 mm), trimmed
References: Hind 4 i/ii; Bartsch 5
Provenance: Albertina duplicate (L. 5g); Knoedler & Co., 1925
Bequest of Herschel V. Jones, 1968 (P. 68.129)

Saint Elizabeth does not always accompany her son, John the Baptist, in scenes of the Holy Family, but here she is indispensable to the compositional balance that Italians craved. Elizabeth and her husband, Zacharias, were quite elderly when the angel Gabriel appeared to say that Zacharias's prayers would be answered and the childless couple would bear a child named John (Luke 1.5–36). Giovanni Antonio da Brescia engraved this scene after a related subject painted by Andrea Mantegna (see cat. no. 8), who was both his teacher and his employer.[1] There is little documentation of Giovanni Antonio's life, but his longtime association with Mantegna is certain. Besides engraving for the great master, he seems to have spent much of his career copying other artists' prints or making engravings based on their sketches.[2]

The monumental *Holy Family with Saint Elizabeth and the Infant Saint John* shows Giovanni Antonio's reliance on distinct outlines and long, thin parallel lines, techniques that give his prints force yet also a grayish softness. Scholars have remarked about his harsh "metallic" surfaces and airless hatching style,[3] but these qualities also somehow seem suited to the intense, beautifully aged face of Saint Elizabeth and the wistful stoicism of the Virgin Mary. Another characteristic of his work is partially shaded backgrounds that simply trail off. This print is one of only eight impressions of the first state, before the background texture was changed to cross-hatching.

M. J. K.

Notes

1. David Landau and Peter Parshall, *The Renaissance Print, 1470–1550* (New Haven: Yale University Press, 1994), 112.
2. Jay A. Levenson, Konrad Oberhuber, and Jacquelyn L. Sheehan, *Early Italian Engravings from the National Gallery of Art* (Washington, D.C.: National Gallery of Art, 1973), 235–37.
3. Ibid., 240.

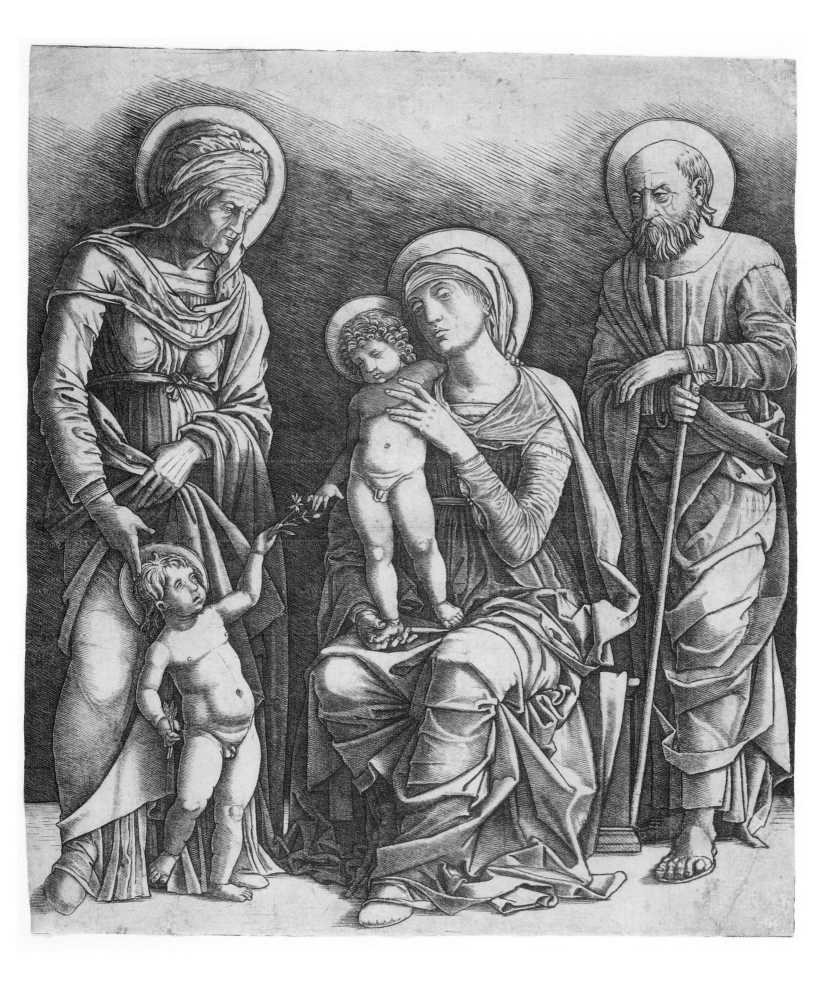

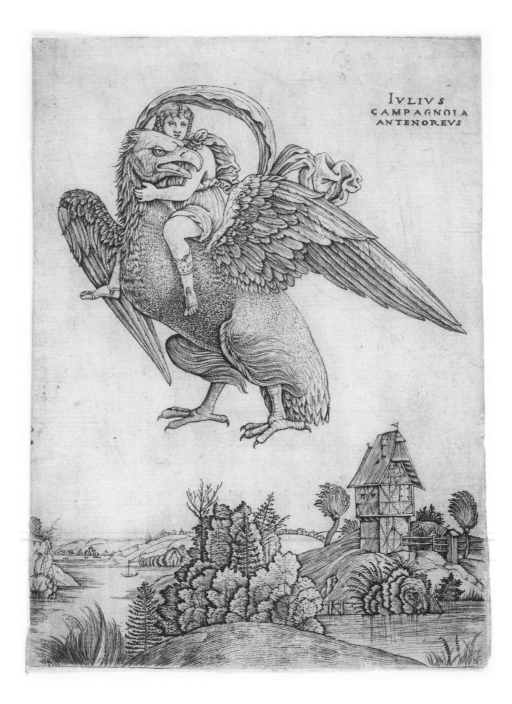

IVLIVS
CAMPAGNOLA
ANTENOREVS

10

Giulio Campagnola
Italian, c. 1482–after 1515

Ganymede, c. 1500–1505

Engraving
6%₁₆ x 4¹³⁄₁₆ (167:122 mm), trimmed
References: Hind 4 ii/ii; Bartsch 5
Provenance: Frederick Keppel, 1926
Bequest of Herschel V. Jones, 1968 (P.68.132)

In Homer's *Iliad*, Ganymede is the "loveliest born of the race of mortals."[1] Jupiter (or Zeus) fell in love with the beautiful Trojan boy and stole him away to live on Olympus, where he became wine pourer to the gods. After years of service, he was made immortal in the form of the constellation Aquarius, the water carrier. The myth has been an enduring subject for artists, from carvers of ancient sarcophagi to Michelangelo and later Rembrandt.[2] Interpretations range from chaste to carnal. Some saw Ganymede's abduction as a metaphor for homoerotic passion; others espoused the Neoplatonic view of the pure human soul rising toward divine love.[3] The latter seems to have been Giulio Campagnola's approach. One indication is the boy's very young age.[4] Giulio also shows the boy not in the throes of a terrified abduction, but in a complacent embrace with Jupiter's eagle. Ganymede's feet echo the eagle's talons, reinforcing their joint sense of purpose. Adding to the spiritual interpretation is the drapery that extends, halolike, over Ganymede's head. The erudite Giulio could well have known Platonic discussions of spiritual love; he was born a short while after the Italians had translated Plato's writings into Latin, and he knew Latin, Greek, and Hebrew.[5]

At around age fifteen Giulio is thought to have gone to the Gonzaga court in Mantua, at his father's urging, to be near the great Andrea Mantegna.[6] The influence of that period is evident in the face of Ganymede, whose broad, slightly stony features are undeniably Mantegnesque. Early on, Giulio was also in the habit of adapting landscapes from Albrecht Dürer.[7] The quaintly Teutonic scenery in *Ganymede* is faithfully copied from Dürer's *Virgin and Child with the Monkey* (fig. 10a). On the eagle's chest and back we can see the beginnings of Giulio's mature style, in which he famously created entire prints from varying intensities of dots. The word Antenoreus, beneath the artist's Latin signature emblazoned in the upper right corner of the print, refers to Giulio's home of Padua.[8]

M. J. K.

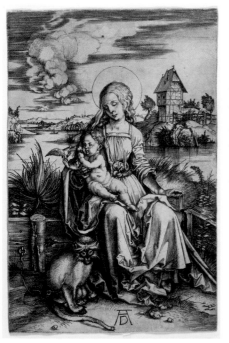

Figure 10a
Albrecht Dürer,
*Virgin and Child
with the Monkey,*
c. 1489, engraving,
7⁷⁄₁₆ x 4¾ in.
(189:121 mm),
P. 145

Notes
1. *The Iliad of Homer*, trans. Richard Lattimore (Chicago: University of Chicago Press, 1951), 410 (20.230–35).
2. James M. Saslow, *Ganymede in the Renaissance: Homosexuality in Art and Society* (New Haven: Yale University Press, 1986), 20, 101.
3. Ibid., 2–4.
4. Wendy Thompson, *Poets, Lovers, and Heroes in Italian Mythological Prints* (New York: Metropolitan Museum of Art, 2004), 38.
5. Jay A. Levenson, Konrad Oberhuber, and Jacquelyn L. Sheehan, *Early Italian Engravings from the National Gallery of Art* (Washington, D.C.: National Gallery of Art, 1973), 390.
6. Ibid.
7. Ibid., 393.
8. Mark J. Zucker, *Early Italian Masters*, vol. 25 (commentary) of *The Illustrated Bartsch* (New York: Abaris Books, 1984), 473.

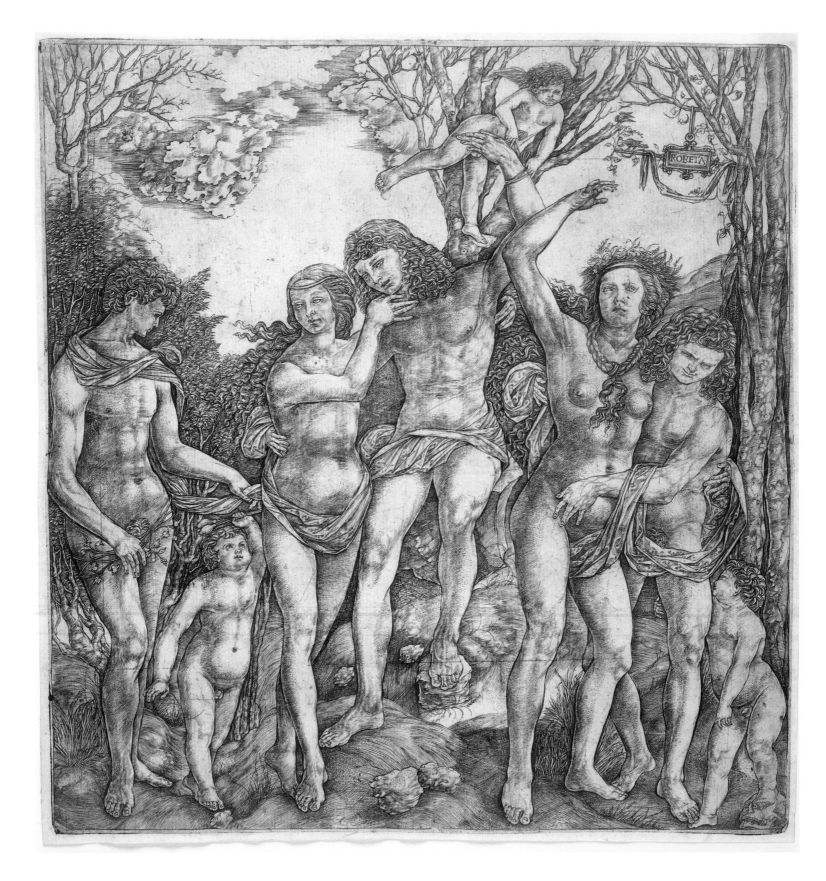

11

Christofano di Michele Martini, called il Robetta

Italian, 1462–after 1522

An Allegory of the Power of Love, c. 1500–1520

Engraving
11¹¹⁄₁₆ x 11 in. (298:283 mm)
References: Hind 29; Bartsch 25
Watermark: Six-pointed star and letter *M* in a shield
 (close to Briquet 8392)
Provenance: "Luca d'Glanda" (in ink, verso, not in Lugt);
 Knoedler & Co., 1925
Bequest of Herschel V. Jones, 1968 (P. 68.250)

The Florentine Christofano di Michele Martini, called il Robetta, created a group of engravings that reveal influences from both German and Italian artists. From Albrecht Dürer and the artists of the north, Robetta learned to model his figures with a combination of curving parallel lines and dotted flecks. From his compatriots in Italy he borrowed the distinctive facial features of his figures, which mirror those in Filippino Lippi's work.[1]

Robetta's choice of subject matter reflects an important trend in Italian printmaking at the turn of the sixteenth century. While nearly 90 percent of paintings were devoted to religious themes, the figure for prints was only 65 percent.[2] Possibly because prints were less time-consuming and costly to produce than oils and could be undertaken outside the watchful eye of patrons, printmakers had more freedom to explore historical, mythological, and allegorical topics. For his venture into secular printmaking, Robetta chose a complex allegory on the subject of carnal love. Scholars today still struggle to unravel the meaning behind *An Allegory of the Power of Love*, but it is believed that the artist based most of his interpretation of spiritual and physical love on classical sources.[3]

Robetta's figures are divided into two distinct groups. The couple on the right includes a female representation of Voluptas, the Greek god of pleasure, embraced by a man distracted by a putto pointing to a skull. This memento mori, or reminder of the inevitability of death, is surely

there to warn the man of the vanity of physical pleasure. Robetta may have taken the theme of young lovers encountering death from the northern tradition, since it was popular with artists of this region. The couple on the left is more difficult to decipher, but it appears that the man whose arm is being bound to a tree by Cupid must be a "captive of love."[4] The two lovers are tied to the somewhat androgynous figure at the extreme left and seem to be ensnared by his power. The putto who stands between the couple and the mysterious figure holds a pair of poppy blossoms and may represent Hypnos, or Sleep, the child of Night, who gave mortals dreams of foolishness or inspiration. The other putto would then be his twin brother, Thanatos, or Death. This scene, which at first glance resembles a light-hearted romp in the woods, may in fact have a more ominous meaning.[5]

L.D.M.

Notes
1. Arthur M. Hind, *Early Italian Engravings*, vol. 1 (London: Bernard Quaritch, 1939), 197.
2. David Landau and Peter Parshall, *The Renaissance Print, 1470–1550* (New Haven: Yale University Press, 1994), 89.
3. Ibid., 89–90.
4. Jay A. Levenson, Konrad Oberhuber, and Jacquelyn L. Sheehan, *Early Italian Engravings from the National Gallery of Art* (Washington, D.C.: National Gallery of Art, 1973), 290.
5. Ibid.

Master I.B. with the Bird (Giovanni Battista Palumba?)

Italian, active 1500–1525

Saint Jerome and the Lion, c. 1509

Woodcut
11⅜ x 8⅝ in. (296:220 mm)
References: Bartsch 1
Provenance: Rudolf Ritter von Gutmann (L. 2770);
 Knoedler & Co., 1925
Bequest of Herschel V. Jones, 1968 (P.68.219)

Apart from chiaroscuro woodcuts, Italians never embraced woodcut as wholeheartedly as did the Germans. Master I.B. with the Bird showed a true commitment to the medium, however, producing a significant body of single-leaf woodcuts along with engravings. Like many other artists, he looked to Albrecht Dürer for inspiration, especially in his landscapes. But Master I.B. with the Bird made his own mark too, with uncommonly large woodcuts and recurring stylistic peculiarities, such as slender hands, and bodies posed with the weight on one leg.[1] Of his eleven woodcuts, *Saint Jerome and the Lion* is one of the finest and most intricate.

Saint Jerome, christened Eusebius Hieronymus Sophronius, was born about A.D. 325 into a life of leisure and literature. While studying in Rome, where he learned Greek and Latin, he converted to Christianity and eventually became a hermit, the guise in which we see him here. Serene yet thin from years of denial, the saint wears the classical garb that Master I.B. with the Bird so favored in his prints. Nearby are Jerome's attributes: a skull, symbolizing life's transience; a book, signifying his scholarly pursuits; and, on the tree at right, his cardinal's hat and a crucifix, denoting his devotion. In one episode of the saint's legend, he pulled a thorn from the paw of a lion, which gained him a devoted companion for life. By Dürer's day this theme of compassion subduing bestial power was viewed as outdated, and in his famous engraving dated 1514 (cat. no. 30), Dürer featured Saint Jerome in his study.[2]

Today many scholars consider Master I.B. with the Bird to be the Lombard artist Giovanni (Ioannes in Latin) Battista Palumba. This is based in part on the fact that the Italian word for pigeon is *palombo*, and this monogrammist routinely signed his plates with initials and a small bird, seen in the insignia at lower right.[3] The additional *M* monogram could belong to the craftsman who cut the design in the block.

M.J.K.

Notes
1. James Byam Shaw, "The Master I.B. with the Bird," pt. 2, *Print Collector's Quarterly* 20 (January 1933): 13.
2. Charles W. Talbot, ed., *Dürer in America: His Graphic Work* (Washington, D.C.: National Gallery of Art, 1971), 348.
3. Jay A. Levenson, Konrad Oberhuber, and Jacquelyn L. Sheehan, *Early Italian Engravings from the National Gallery of Art* (Washington, D.C.: National Gallery of Art, 1973), 440.

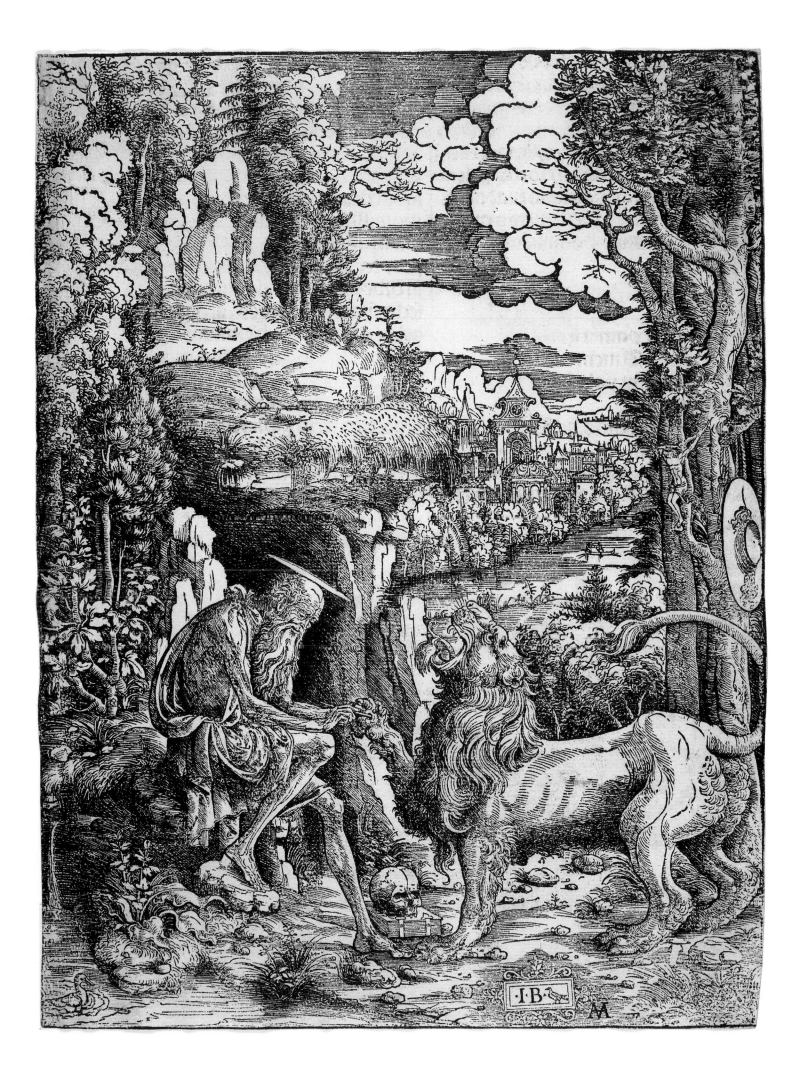

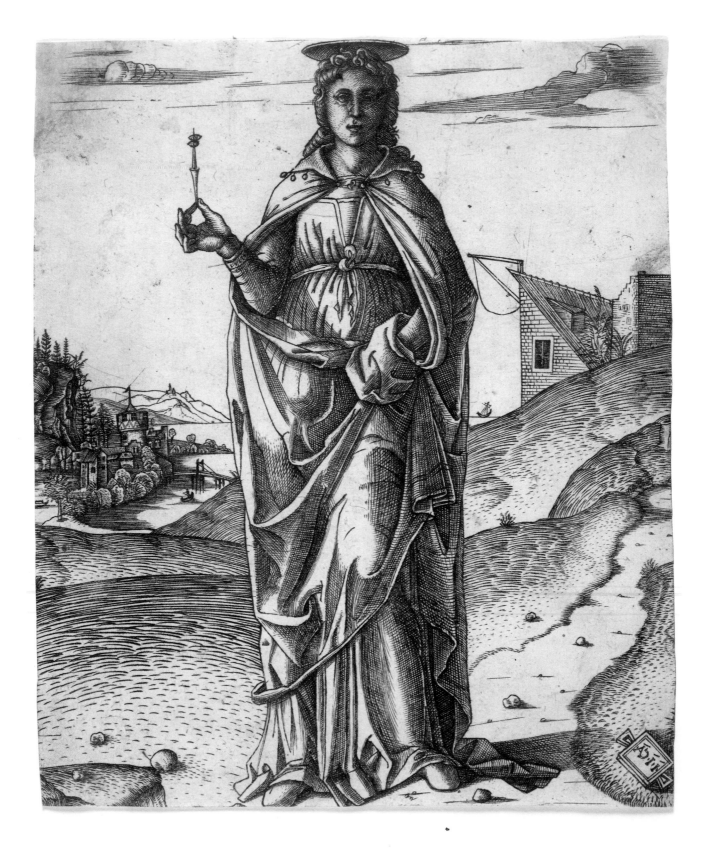

13

Master •I•I•CA

Italian, active c. 1500–1510

Saint Lucy, c. 1510

Engraving
7¾ x 6⅜ in. (196:164 mm), trimmed
References: Bartsch 1; Hind 2
Provenance: Frederick Keppel, 1925
Gift of Miss Tessie Jones in memory of her parents,
 Mr. and Mrs. Herschel V. Jones, 1966 (P.13,762)

This print is one of just two or three confirmed engravings by the anonymous Master •I•I•CA.[1] Of the six impressions of *Saint Lucy* known to exist, the Jones sheet is the only one in the United States. The martyr stands matter-of-factly with her two eyeballs skewered on a stick, possibly the tool she plucked them out with. Lucy had the misfortune of living in Syracuse around A.D. 300, when Emperor Diocletian was persecuting Christians. Upon hearing that her ailing mother had been cured at Saint Agatha's shrine, Lucy gave all her riches to the poor. This so angered her betrothed that he turned her in to the authorities as a Christian. For remaining steadfast, Lucy was tied to four straining oxen, burned, subjected to molten lead in her ears, and more. She finally succumbed to a dagger in the throat. The indignity to her eyes was a later addition to her legend: a persistent admirer was so enamored of her beautiful eyes that she removed them and sent them to him on a dish. She later miraculously regained her sight. Visual artists of course would have been attracted to themes of sight and seeing. Master •I•I•CA acknowledges our presence by returning our gaze not with one pair of eyes, but with two.

Master •I•I•CA's affinity for the style of northern Italian printmakers, notably the parallel hatching and cross-hatching and the sculptural approach to drapery, has led art historians to associate him with the school of Andrea Mantegna.[2] Even so, *Saint Lucy* is another example of how Albrecht Dürer's extraordinary achievements modulated the character of Italian prints. In the hillocks and in the saint's right shoulder and thigh, we can see how Master •I•I•CA adopted Dürer's way of curving the lines to conform to an object's shape. As Giulio Campagnola did in *Ganymede* (cat. no. 10), the artist also borrowed practically every detail of his background from Dürer.

In 1966 Herschel V. Jones's daughter Tessie selected a small group of her father's prints still in her possession to give to the museum, including this scarce sheet.
M.J.K.

Notes
1. Mark J. Zucker, *Early Italian Masters,* vol. 25 (commentary) of *The Illustrated Bartsch* (New York: Abaris Books, 1984), 491, and Jay A. Levenson, Konrad Oberhuber, and Jacquelyn L. Sheehan, *Early Italian Engravings from the National Gallery of Art* (Washington, D.C.: National Gallery of Art, 1973), 335. The only other engraving he signed is *The Nativity,* although Levenson et al. believe that he is also responsible for *Justice.*
2. Levenson et al., *Early Italian Engravings,* 335.

Jacopo de' Barbari

Italian, c. 1460–before 1516

Mars and Venus, c. 1510–12

Engraving with additions in graphite, ink, and wash
11⅞₆ x 6¹⁵⁄₁₆ in. (294:176 mm)
Watermark: Gothic *P* with flower (Briquet 8658)
References: Hind 13; Bartsch 20
Provenance: Ambroise Firmin-Didot (L. 119);
 A. Freiherr von Lanna (L. 2773); Paul Davidsohn (L. 654);
 Frederick Keppel, 1920
Bequest of Herschel V. Jones, 1968 (P. 68.117)

Jacopo de' Barbari, an Italian most likely born in Venice, came by his unusual moniker from the years he spent working in royal courts north of the Alps, among the "barbarians." His sojourn began in Nuremberg in the employ of Emperor Maximilian I in 1500, a time when retaining an Italian artist was a mark of refinement. Art historians speculate that 1500 was also around the time Jacopo met Albrecht Dürer and that Dürer took inspiration from the idealized figure types in Jacopo's prints.[1] The Italian in turn borrowed ideas and techniques from northern printmakers. Rather than continue Andrea Mantegna's tradition of shading with straight parallel hatch marks (see cat. no. 8), Jacopo began curving his lines so as to follow the rounded contours of an image, a northern trademark.

This print shows the god of war subdued by his love for Venus, who holds their tiny offspring, Cupid. Mars's armor points to the dual nature of Jacopo's career. It is borrowed from Roman antiquity, an Italian obsession at the time, yet has the detailing characteristic of German and Netherlandish printmakers. The print is marked by delicate modeling on the gracefully demure figures, which could be attributed to Jacopo's familiarity with yet another famous northern engraver, Lucas van Leyden (cat. nos. 28, 29).[2]

Although Jacopo did not date his prints, Jay A. Levenson places *Mars and Venus* at about 1510–12.[3] There are a couple of possible explanations for the ink and brush additions on the left side of this rich impression. One theory is that the printing was uneven in the area of the shield, sword, and hand and that these were completed by hand. Another theory is that this was a working proof and that the additions reveal Jacopo's creative process. In any case, the print's distinguished provenance would help to ensure that it was not doctored at a later date. The impression is faintly signed with Jacopo's hallmark caduceus, a wand with two entwined snakes that is also the symbol of the messenger god Mercury.

M.J.K.

Notes
1. Jay A. Levenson, "Jacopo de' Barbari and Northern Art of the Early Sixteenth Century" (Ph.D. diss., New York University, 1978), 81–84.
2. Jay A. Levenson, Konrad Oberhuber, and Jacquelyn L. Sheehan, *Early Italian Engravings from the National Gallery of Art* (Washington, D.C.: National Gallery of Art, 1973), 353.
3. Levenson, "Jacopo de' Barbari," 253.

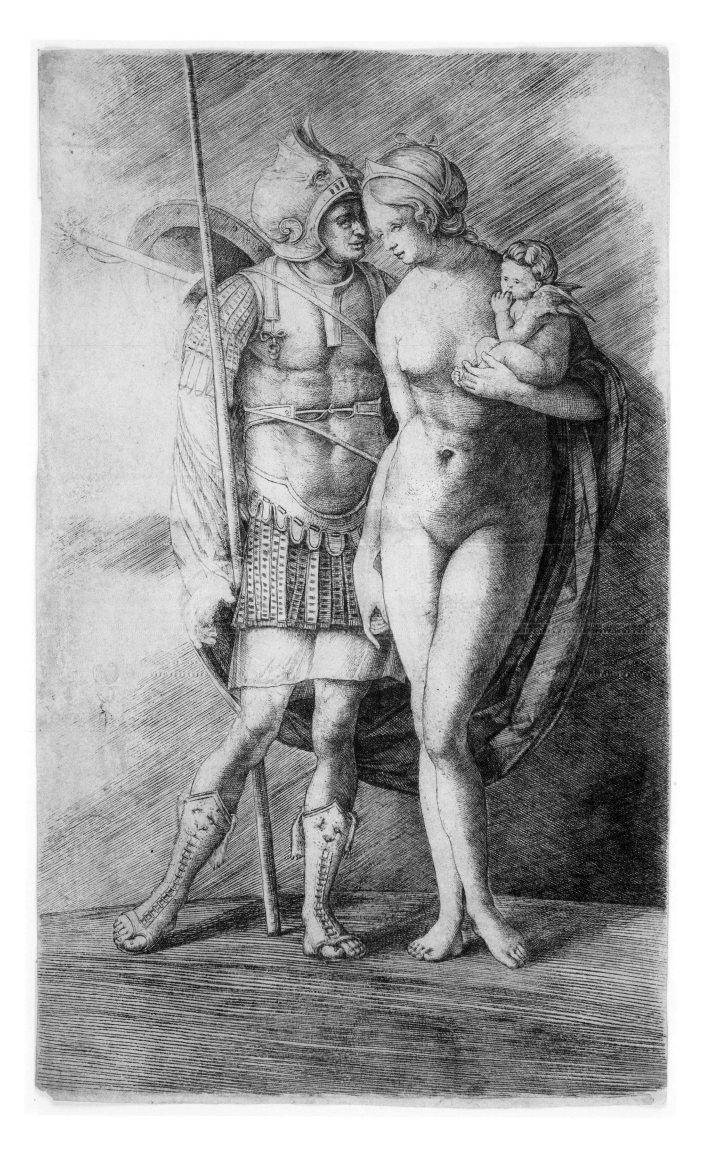

Master NA•DAT with the Mousetrap

Italian, active 1500–1520

The Virgin and Child Enthroned with Saint Anne, c. 1512–13

Engraving
5⅝ x 8⅜ in. (144:213 mm)
Watermark: Six-pointed star above circle
References: Hind 1 i/ii; Bartsch 1
Provenance: British Museum duplicate (L. 300, 305);
 Knoedler & Co., 1917
Bequest of Herschel V. Jones, 1968 (P. 68.241)

Very little is known about the artist of this distinctive engraving. His unusual signature of NA•DAT with a drawing of a mousetrap—seen in the lower right corner of the boldly patterned floor—appears on only three prints. The central image of *The Virgin and Child Enthroned with Saint Anne* is based on a sculpture by Andrea Sansovino installed against a pillar in the church of Santo Agostino in Rome. Although the master fashioned his own pillars, the statue's setting may have prompted the unusual architectural arrangement of NA•DAT's engraving.[1]

The large central inscription reads, "Grace to her from whom this immaculate ground was taken, from whom the truth has grown." The Immaculate Conception, or the belief that the Virgin Mary was free from original sin, is the theme of this engraving. The idea of the Immaculate Conception was popularized in Jacobus de Voragine's *Golden Legend* of about 1260; by the early sixteenth century, however, the doctrine was in dispute.[2] NA•DAT's engraving encourages the viewer to have faith in this then-controversial belief by including two supporting scenes on either side of the central image. On the left, an angel reveals the birth of the Virgin to Joachim, Anne's husband and Mary's father. On the right, we see Joseph, Mary's husband, also receiving news from an angel. He was upset to learn that Mary was pregnant since they had never consummated their marriage, and he was planning to divorce her. The angel appears with the proclamation: "Son of David, do not fear to accept Mary as your wife, for what is conceived in her is of the Holy Spirit." After this vision, Joseph returned home to his wife and proceeded to raise Jesus as his own son.

L. D. M.

Notes
1. Jay A. Levenson, Konrad Oberhuber, and Jacquelyn L. Sheehan, *Early Italian Engravings from the National Gallery of Art* (Washington, D.C.: National Gallery of Art, 1973), 504.
2. Jacobus de Voragine, *The Golden Legend: Readings on the Saints*, trans. William Granger Ryan, vol. 1 (Princeton: Princeton University Press, 1993), 148–49, and ibid.

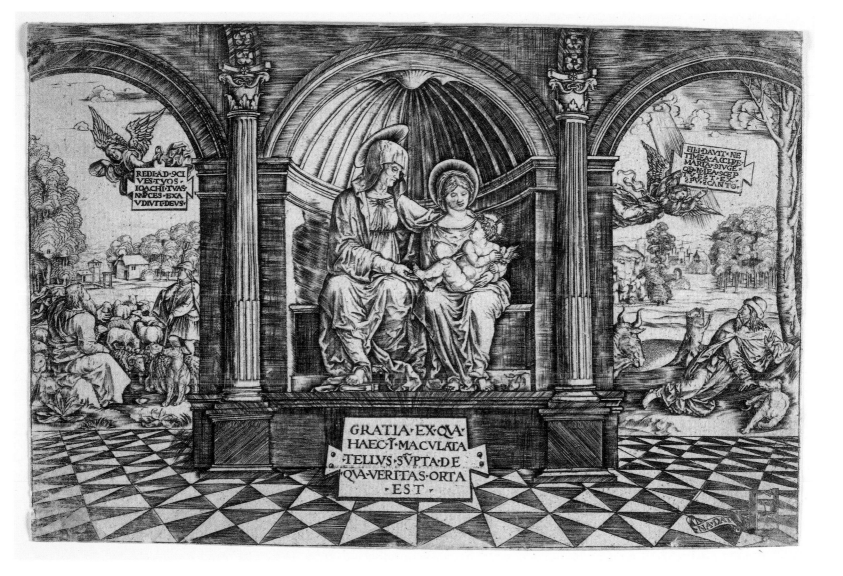

REDI·AD·SCI
VES·TVOS·
IOACHI·TVAS
N·PCES·EXA
VDIVIT·DEVS·

FILI·DAVIT·NE
TIMEA·ACIPE
MARIA·IVGE
QD·N·EA·XEP
TV·EST·EX·
2·PV·SANTO·

GRATIA·EX·QA·
HAEC·I·MACVLATA
TELLVS·SVPTA·DE
QA·VERITAS·ORTA
·EST·

Master of the Year 1515

Active in Italy, c. 1515–20

Mars Bound by Cupid, c. 1515–20

Drypoint
6⅞ x 5³⁄₁₆ in. (175:132 mm)
Watermark: Bear (Briquet 12268)
References: Hind 3; Bartsch 6
Provenance: James Reiss (L. 1522); J. P. Heseltine (L. 1508);
 Frederick Keppel; Knoedler & Co., 1926
Bequest of Herschel V. Jones, 1968 (P.68.217)

The Master of the Year 1515 gets his name from the one dated engraving in his oeuvre. It is an idiosyncratic name for a most idiosyncratic printmaker. At a time when most sixteenth-century artists were pursuing classical and sacred subjects or were consumed by issues of design or didacticism, this artist focused on wit and whimsy. Indeed, the very fact that he did not sign his prints may have given him the freedom to indulge his eccentricity.[1] Among his most mischievous works is *Mars Bound by Cupid*, in which Cupid purposefully blindfolds his captive. The theme of love conquering the mighty god of war was not unknown at the time, but the Master of the Year 1515 played up the indignity by sitting Mars on a heap of his own armor. The artist isolated his figures against a spare background, the better to focus attention on the lovely play of diagonals that glide through the composition.

Experts have criticized the Master of the Year 1515 for his poorly drawn nude figures, but he more than compensated for that with his singular use of drypoint, which he employed more than any other sixteenth-century artist.[2]

Although it is not clear what kind of tools the artist used, drypoint typically involves retaining the burr, or the small curls of metal that are displaced when a line is incised into a metal plate. The burr traps ink and prints a rich, velvety impression. The intensity of the effect here indicates that this sheet was one of the earliest printed; very few drypoints of this quality can be pulled from a plate before the burr wears away under the pressure of the press.

There are forty-one known prints by this artist, yet his influence was limited because the drypoint technique produces so few successful examples. At one time he was thought to be the sculptor Agostino Busti, called il Bambaia, but this theory has been rejected.[3]

M. J. K.

Notes
1. Patricia Emison, "Prolegomenon to the Study of Italian Renaissance Prints," *Word and Image* 2 (January–March 1995): 7.
2. David Landau and Peter Parshall, *The Renaissance Print, 1470–1550* (New Haven: Yale University Press, 1994), 271–72.
3. Ibid., 271.

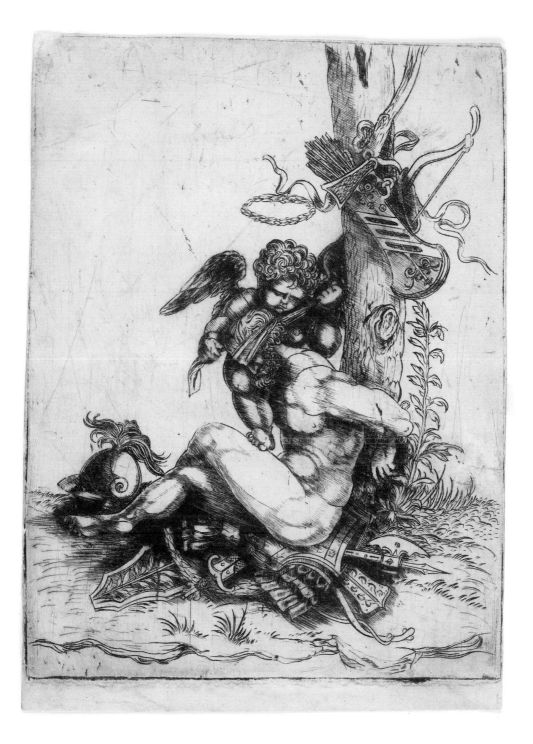

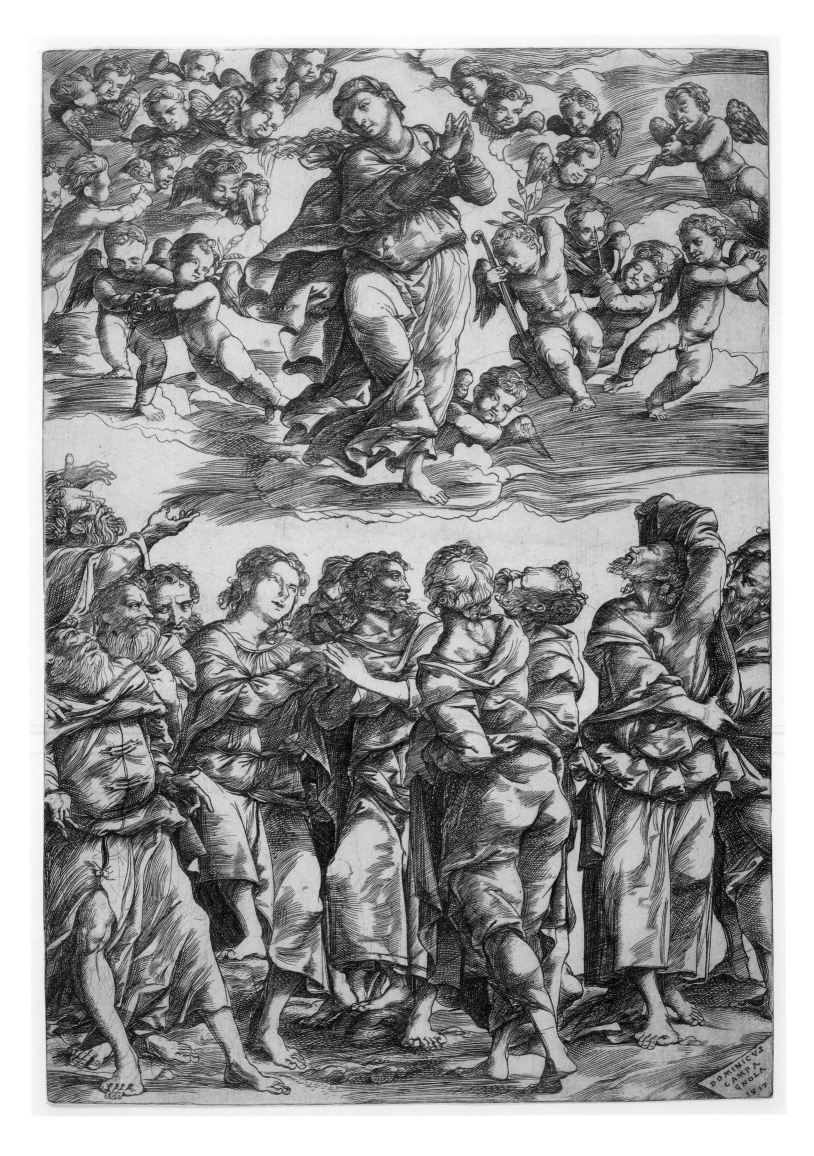

Domenico Campagnola

Italian, 1500–1564

The Assumption of the Virgin, 1517

Engraving
11¼ x 7¾ in. (286:198 mm)
Watermark: Forge and hammer (similar to Briquet 5964)
References: Hind 3 i/ii; Bartsch 4
Provenance: Albertina duplicate (L. 5g);
 Kennedy Galleries, 1926
Bequest of Herschel V. Jones, 1968 (P.68.131)

Mary's assumption into heaven was a popular theme during the Renaissance, even though the Roman Catholic Church did not officially accept the event as dogma until 1950. According to the *Golden Legend*, the apostles miraculously reconvened at the Virgin's deathbed and again three days later at her tomb when she rose up to be reunited with her soul and ascend into heaven.[1] Here, as with other engravings, Domenico took his inspiration from Titian, specifically Titian's drawing for an altarpiece in Santa Maria Gloriosa dei Frari in Venice, completed a year after Domenico's print.[2] In another component of the story, Mary tosses her sash to Thomas as proof of her miraculous assumption; the figure with the cloth-wrapped arm at the right, exchanging looks with an angel, may be this apostle.

The adopted son of Giulio Campagnola (cat. no. 10), the Venetian-born Domenico was a painter and woodcut artist who concentrated on engraving in the span of just two very productive years, 1517 and 1518. Despite a predilection for sharp noses and overcrowding his compositions with figures, Domenico had a great talent for creating

movement in his plates. In addition to emphatic gestures—and for him this included animated feet as well as arms—he sent his burin hatching in all directions so that the shaded areas also bristle with energy. The marvelously swirling drapery, limbs, heads, and putti contribute to the print's visionary aura.[3]

Domenico created just over a dozen prints during his brief foray into engraving, and the Herschel V. Jones Collection is privileged to have excellent impressions of six, including an unusual landscape (fig. 22) whose right side is by Giulio and whose left side was completed by Domenico. M.J.K.

Notes
1. H. Diane Russell with Bernadine Barnes, *Eva/Ave: Woman in Renaissance and Baroque Prints* (Washington, D.C.: National Gallery of Art; New York: Feminist Press at the City University of New York, 1990), 90–92.
2. Jay A. Levenson, Konrad Oberhuber, and Jacquelyn L. Sheehan, *Early Italian Engravings from the National Gallery of Art* (Washington, D.C.: National Gallery of Art, 1973), 420.
3. Russell, *Eva/Ave*, 92.

Ugo da Carpi

Italian, c. 1479–1532

David Slaying Goliath, c. 1518

After Raphael Sanzio

Chiaroscuro woodcut printed from three blocks in tan,
 light brown, and black
10 7/16 x 15 7/16 in. (264:392 mm)
References: Bartsch 8 i/iii
Provenance: K. E. Hasse (L. 860); Frederick Keppel;
 Kennedy Galleries, 1924
Gift of Herschel V. Jones, 1926 (P. 10,881)

The chiaroscuro woodcut was an innovation of the early 1500s that capitalized on the growing taste among collectors for drawings. Printed from multiple blocks, each creating a distinct tone, this specialized kind of woodcut was intended to imitate the freshness and energy of pen-and-wash preparatory drawings on colored paper. These prints were valued not only for their technical virtuosity but also for their powerful distillation of a composition's *disegno*.

Ugo da Carpi pioneered the chiaroscuro woodcut in Italy, probably influenced by earlier experiments in Germany by Hans Burgkmair and Lucas Cranach (cat. no. 27), which had made their way to Venice.[1] The son of Count Astolfo de Panico, Ugo learned the art of block cutting in Venice while working for the prestigious book publisher Bernardino Benalio.[2] By 1518 he was in Rome, where his complicated technique gained popularity in Italian workshops. Indeed, he set a trend that captivated European connoisseurs for centuries.

As he did for several of his chiaroscuro woodcuts, Ugo relied on a composition by Raphael for *David Slaying Goliath*. The scene is based on Raphael's fresco design for the eleventh vault of the Vatican loggias, but Ugo's rendering treats the Philistines and Israelites in the background differently, indicating that the woodcut may have been modeled after a lost drawing made in Raphael's workshop. This impression shows unusually even inking, a high degree of registration, and remarkably distinct edges in the tan, light brown, and black blocks.

M. J. K.

Notes
1. Barbara Bays et al., *Beyond Black and White: Chiaroscuro Prints from Indiana Collections* (Bloomington: Indiana University Art Museum, 1989), 21, 23.
2. Luigi Servolini, "Ugo da Carpi," *Print Collector's Quarterly* 26 (February 1939): 33, 37.

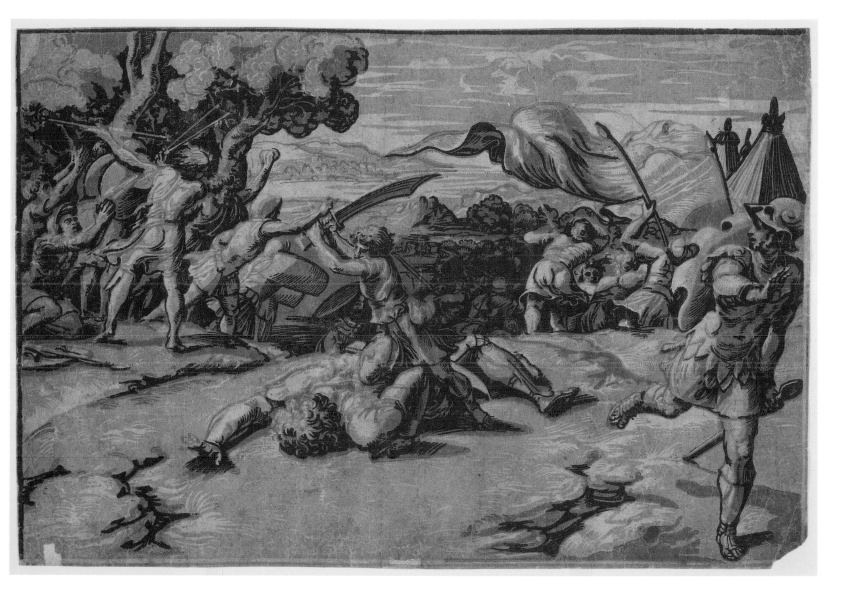

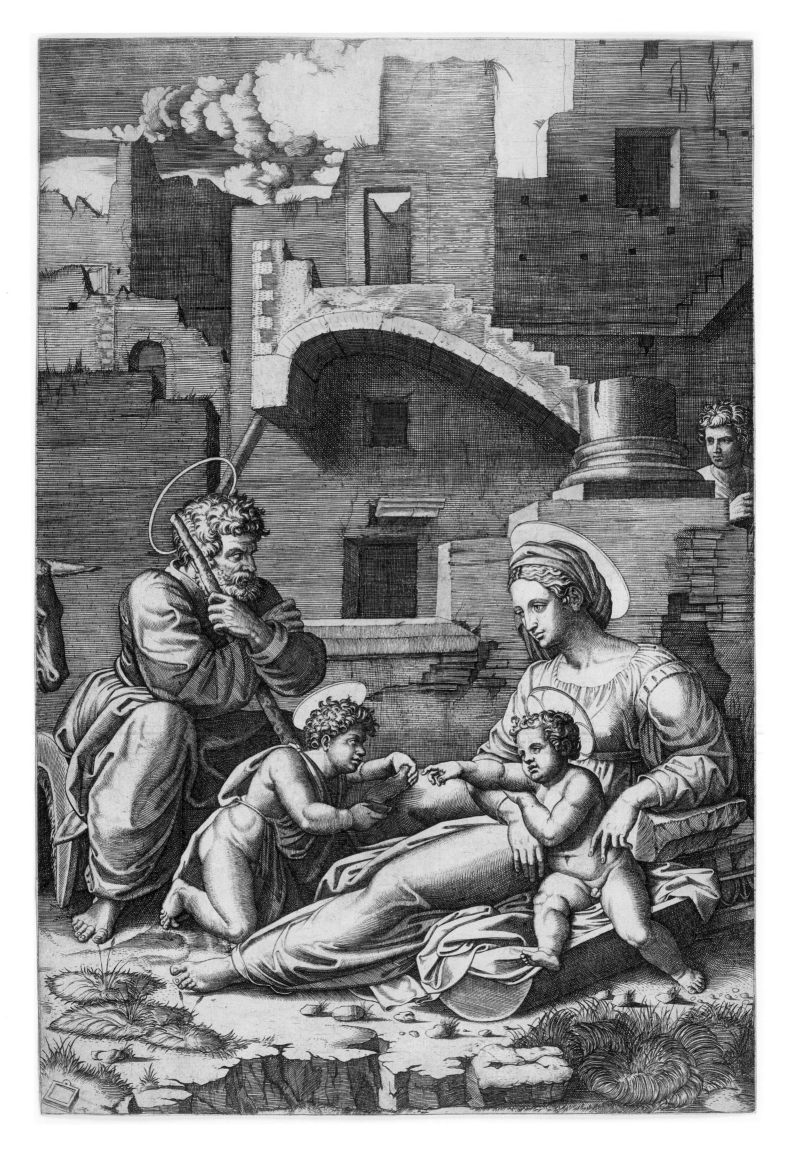

Marcantonio Raimondi

Italian, c. 1475/80–c. 1534

Virgin with the Long Thigh, c. 1520–25

After Raphael Sanzio

Engraving touched with ink wash
15¾ x 10⁹⁄₁₆ in. (400:268 mm)
Watermark: Greek cross (close to Briquet 5392)
References: Bartsch 57; Shoemaker 59
Provenance: Knoedler & Co., 1926
Bequest of Herschel V. Jones, 1968 (P.68.247)

Marcantonio Raimondi is a historic figure not because of his brilliant drafting skills but because he invented a technique that influenced printmaking forever. By studying Albrecht Dürer's exquisite textures, he devised a simplified, rational system of engraving that could, in A. Hyatt Mayor's words, "surround a shape without calling attention to itself."[1] With his new system of regularized hatching, cross-hatching, flicks, and dots, Marcantonio could translate another artist's composition into a print while retaining its essential *disegno*, or the visual strength of the design. When Raphael wanted to broadcast his genius to a wider European audience, Marcantonio was the agent he chose.

Today we can connect some fifty of Marcantonio's prints to Raphael's drawings.[2] *Virgin with the Long Thigh* was engraved around the time of Raphael's premature death in 1520. It shows Marcantonio's ability to achieve the rich tonality of a painting and the sculptural quality so vital to the Italian High Renaissance, but it also exemplifies the cool artificiality that could result from his networks of lines. The figures look hardened, lacking the tenderness or warmth typical of Holy Family pictures. And despite her lovely rounded volumes, the Virgin seems frozen, focused on some faraway place beyond the edges of the print. At some point in its history the engraving was touched extensively with pale gray wash, particularly noticeable in the arched fragment of the ruins.

Marcantonio also engraved designs by Raphael's workshop, and although some experts argue that this image originated with his pupil Giulio Romano, others believe that it is probably based on a Raphael *modello*.[3] The empty tablet in the lower left corner, characteristic of Marcantonio's later prints, may be a tribute to the absent Raphael, whose classical inventions so transformed Italian art. Printmakers who succeeded Marcantonio began adopting his graphic system to reproduce paintings, frescoes, and statues. Few printmakers enjoyed the kind of close collaboration that developed between Marcantonio and Raphael, however, with Marcantonio adding his own interpretation to the compositions, as is perhaps the case with the ruins elaborated here.[4] Other artists were content to make exact copies after someone else's finished works, giving rise to the phenomenon of reproductive printmaking.

M.J.K.

Notes

1. A. Hyatt Mayor, *Prints and People: A Social History of Printed Pictures* (New York: Metropolitan Museum of Art, 1971).
2. David Landau and Peter Parshall, *The Renaissance Print, 1470–1550* (New Haven: Yale University Press, 1994), 122.
3. Innis H. Shoemaker and Elizabeth Broun, *The Engravings of Marcantonio Raimondi* (Lawrence: Spencer Museum of Art, University of Kansas; Chapel Hill: Ackland Art Museum, University of North Carolina, 1981), 178, and Landau and Parshall, *Renaissance Print*, 137.
4. Shoemaker, *Engravings*, 178.

Master M
(School of Agostino de' Musi, called Veneziano)
Italian, c. 1490–c. 1540

Death Surprising a Woman, 16th century

Engraving
14 1/8 x 9 15/16 in. (359:252 mm)
Watermark: Three-pronged anchor in circle (not in Briquet)
References: Bartsch 1; Nagler IV 1439
Provenance: Paul Davidsohn (L. 654); Arthur H. Hahlo, 1926
Bequest of Herschel V. Jones, 1968 (P. 68.220)

Antique thinking, particularly Plato's, held great sway in Renaissance Italy. In some interpretations, Neoplatonism was expressed as a longing for a perfect, divine realm beyond the earthly one, where one transcends the mundane to be unified with the One, or true being. Anne B. Freedberg, in her explanation of *Death Surprising a Woman*, found a compelling source in Plato's *Phaedrus*, which describes the nature of the soul.[1] When it is immortal, the soul takes flight toward heaven, but in its mortal state it rests on earth and is embodied in human form. Freedberg proposes that in Master M's engraving the soul has taken the form of an earthbound woman who sadly looks at her shoulder in the mirror, perhaps at the spot where the fallen wing used to be. As the woman mourns her loss of immortality, a gleeful cadaver rushes in behind a wheel—probably the Wheel of Fortune—gripping an hourglass, all symbols of the mortal condition that now binds her.[2] The interpretation is supported by the Latin inscription, *Mortalia facta peribunt* (Made mortal, she must die). In addition, Freedberg has noted that the nude figure resembles Michelangelo's sculpture *Dying Slave* (1513), which was intended for the tomb of Pope Julius II, a fact that may account for the *M* monogram.

Agostino Veneziano de' Musi was an important artist in the circle of Marcantonio Raimondi (cat. no. 19). The soft modeling on the woman and the starkly lit figure of Death emerging from the background, not to mention the uniform hatching and cross-hatching on the cadaver, perhaps inspired by Marcantonio, have suggested to scholars that this print was engraved by an anonymous master in Agostino's school.[3] Agostino himself typically signed his prints with *AV* or a full signature, not an *M*, as seen here.
M.J.K.

Notes
1. Anne B. Freedberg, "Some Recent Accessions: 'Made Mortal They Must Die,'" *Bulletin, Museum of Fine Arts, Boston* 58 (1960): 106–7.
2. Clifton C. Olds, Ralph G. Williams, and William R. Levin, *Images of Love and Death in Late Medieval and Renaissance Art* (Ann Arbor: University of Michigan Museum of Art, [1976]), 88.
3. Ibid.

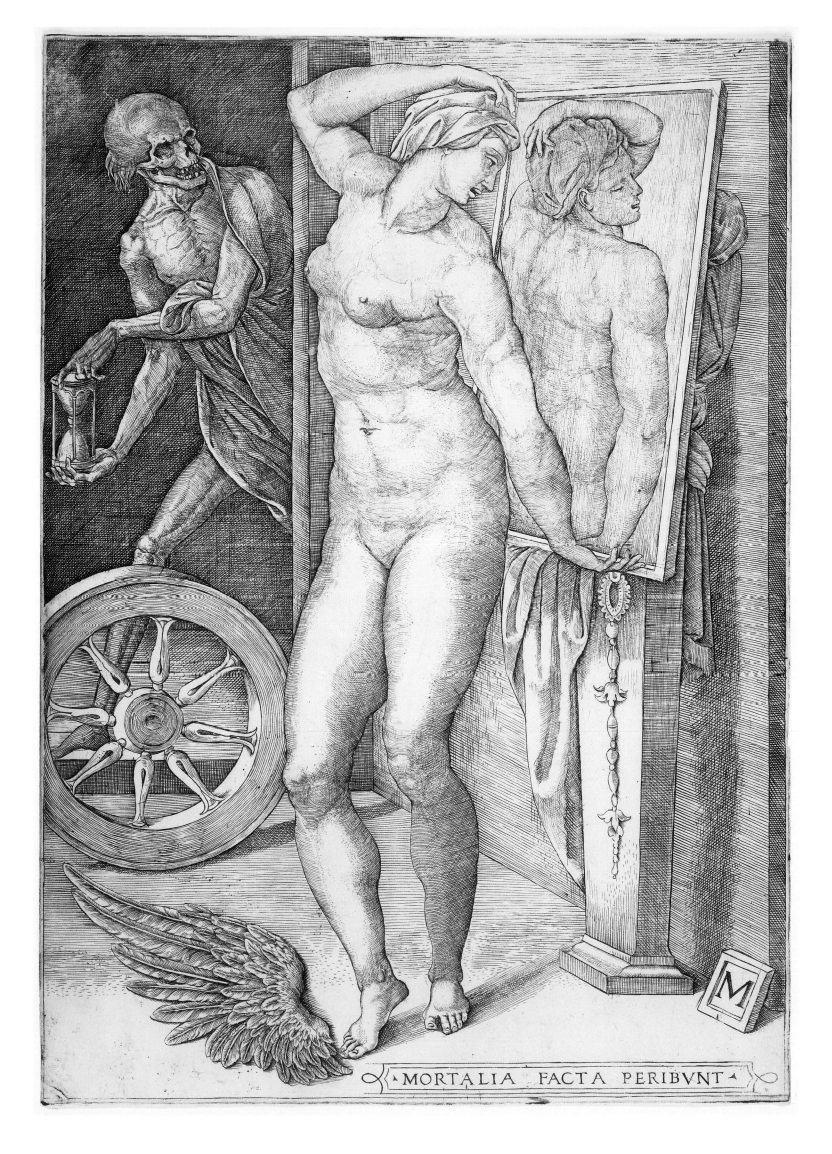

MORTALIA FACTA PERIBVNT

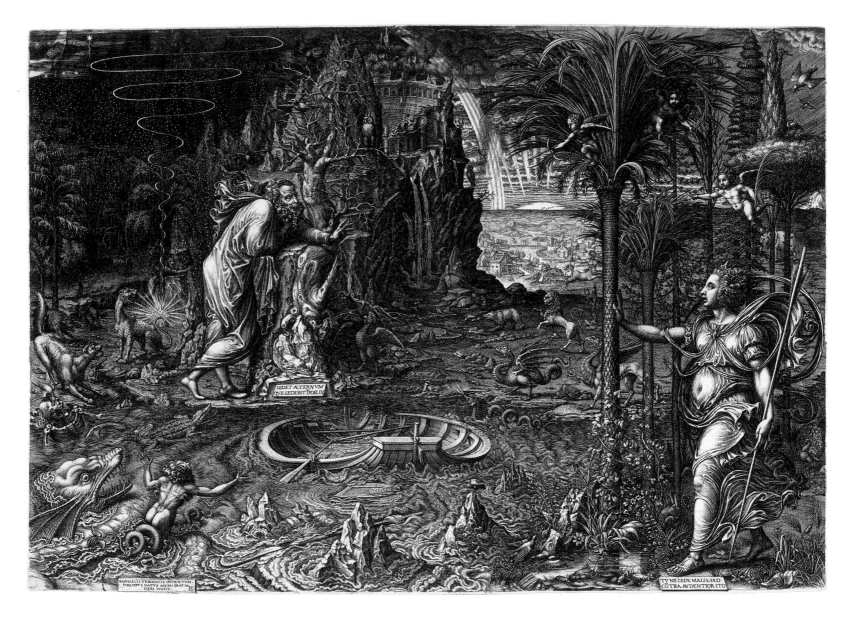

SEDET AETERNVM
QVE SEDEBIT INFOELIX

RAPHAELIS VRBINATIS INVENTVM.
PHILIPPVS DATVS ANIMI GRATIA
FIERI IVSSIT.

TV NE CEDE MALIS, SED
CÕTRA AVDENTIOR ITO

Giorgio Ghisi

Italian, 1520–1582

Allegory of Life (The Dream of Raphael), 1561

Engraving
14 15⁄16 x 21¼ in. (379:538 mm)
References: Lewis and Lewis 28 iia/vi; Bartsch 67
Provenance: Unidentified T; Edme Durand (L. 741);
 François Debois (L. 985); Ambroise Firmin-Didot (L. 119);
 J.H.P. (L. 1474a); Juan Jorge Peoli (L. 2020);
 Albert Roullier, 1917
Bequest of Herschel V. Jones, 1968 (P.68.167)

Giorgio Ghisi's masterpiece, the most famous print of his career, is still a puzzle after several centuries. The key to understanding it seems to lie in the figure of the man who leans against a tree and is surrounded by a sea monster, mermaid, skeleton, bat, scorpion, and various menacing beasts. In one interpretation, the foundering boat represents his misdirected life, and the female figure, possibly Reason, is poised to give him hope. Her environs are more benign, consisting of a rabbit, snail, peacock, frogs, and other creatures on a fertile shore. Other commentators believe that the man is an alchemist experiencing visions of melancholy.[1] Meaning also may be found in the inscriptions next to the two figures, which come from a section on hell in Virgil's *Aeneid*.[2]

The plaque on the bottom left may be the most confounding part of all. It reads: "Raphael of Urbino invented it. Philippus Datus had it made for the pleasure of his soul." No such patron has ever been found, and the only image identified with Raphael is the man, who resembles a figure in Raphael's fresco *The School of Athens* (1509–11). In attaching the great painter's name to his print, Ghisi may have been trying to widen its marketability.[3] Nearly all of his engravings were based on compositions by other artists—notably Giulio Romano, Michelangelo, Raphael, Primaticcio, Luca Penni, and Bronzino. *Allegory of Life* is unusual because it appears that Ghisi devised it himself with relatively little borrowing from any one artist.[4] Still, he may have wanted the cachet of Raphael's name on the plaque, which is why the print is also known as *The Dream of Raphael*. Because the male figure looks like Michelangelo, it is sometimes called *The Melancholy of Michelangelo* as well.

Despite a career translating images by various artists, Ghisi developed an unmistakable style, likely learned in Mantua from Giovanni Battista Mantovano, called Scultori, the father of Diana Mantovana (cat. no. 22). Ghisi's work is marked by strong darks, acutely defined lighting, and particularly in this engraving, a glistening ornamental quality.
M.J.K.

Notes
1. Suzanne Boorsch, Michal Lewis, and R. E. Lewis, *The Engravings of Giorgio Ghisi* (New York: Metropolitan Museum of Art, 1985), 117.
2. Ibid., 116.
3. Michael Bury, "On Some Engravings by Giorgio Ghisi Commonly Called 'Reproductive,'" *Print Quarterly* 10 (March 1993): 17.
4. Boorsch et al., *Engravings*, 23, 25.

Diana Mantovana

Italian, c. 1547/48–1612

Latona Giving Birth to Apollo and Diana, after 1575

After Giulio Romano

Engraving
10¼ x 15⅛ in. (262.385 mm)
References: Bellini 9 ii/vi; Bartsch 39-I i/ii; Massari 9 i/v
Provenance: Robert Dumesnil (L. 2200); Frederick Keppel;
 William M. Ladd
Gift of Herschel V. Jones, 1916 (P. 450)

W omen engravers such as Diana Mantovana were rarities in the late Renaissance. It was even rarer for a woman to be mentioned by biographer Giorgio Vasari in the 1568 edition of his *Lives of the Most Eminent Painters, Sculptors, and Architects*, a major work of art history. Mantovana, also known as Diana Scultori (and sometimes as Diana Ghisi due to confusion in Vasari's account), was schooled in engraving techniques by her father, the printmaker and sculptor Giovanni Battista Mantovano, whom we have come to know by the name Scultori.[1] Vasari's brief remarks about the young Diana—"when I saw her, a very well-bred and charming young lady, and her works, which are most beautiful, I was stunned"—paved the way for the enterprising artist to construct a printmaking career for herself in both her birthplace of Mantua and the heady environs of sixteenth-century Rome. Mantovana is further distinguished as the first woman to sign her prints with her own name, as seen in the lower left corner of this work.[2]

For *Latona Giving Birth to Apollo and Diana*, Mantovana relied on a design by painter Giulio Romano (1499–1546), as she did for other prints. In her day, it was common for printmakers to base their works on the inventions of other artists. Giulio was not only renowned as Raphael's best pupil, but he also had overseen the artistic activities of the Mantuan court, where Mantovana's father worked. This print portrays the birth of the twins Apollo and Diana on the island of Delos. According to myth, when Zeus found that his paramour Latona, or Leto, was pregnant, he forsook her because he feared the wrath of his wife, Hera. Forced to travel the world looking for a place to bear her children, Latona finally settled on the little island of Delos, adrift in the sea. The print reflects the Mantuan preference for strong contrasts, typified by the work of Giorgio Ghisi (cat. no. 21). The challenge of being a woman artist undertaking such a subject—especially for someone living in Rome during the Counter-Reformation, which condemned nudity—may account for the many gestures of modesty in this scene.
M.J.K.

Notes
1. Valeria Pagani, "Adamo Scultori and Diana Mantovana," *Print Quarterly* 9 (March 1992): 74.
2. Evelyn Lincoln, "Making a Good Impression: Diana Mantuana's Printmaking Career," *Renaissance Quarterly* 50 (Winter 1997): 1101–47.

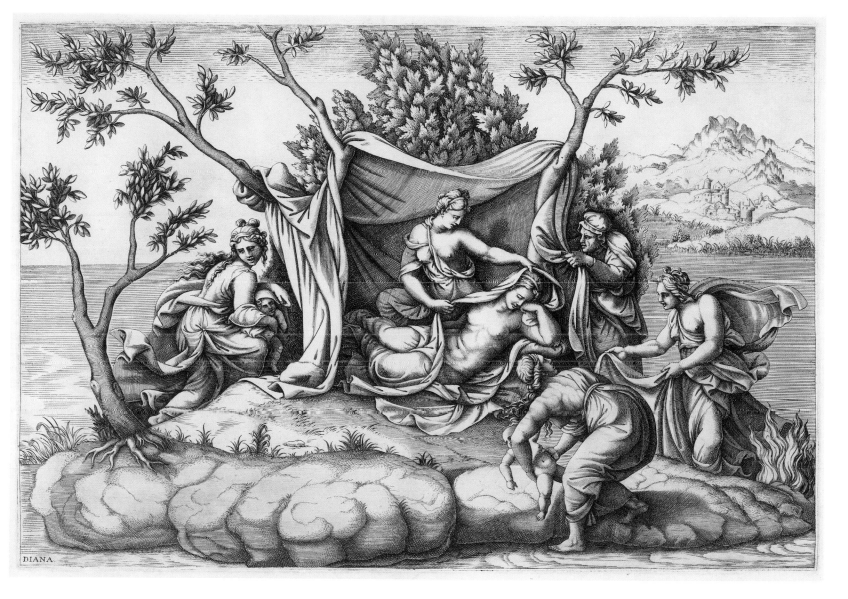

DIANA.

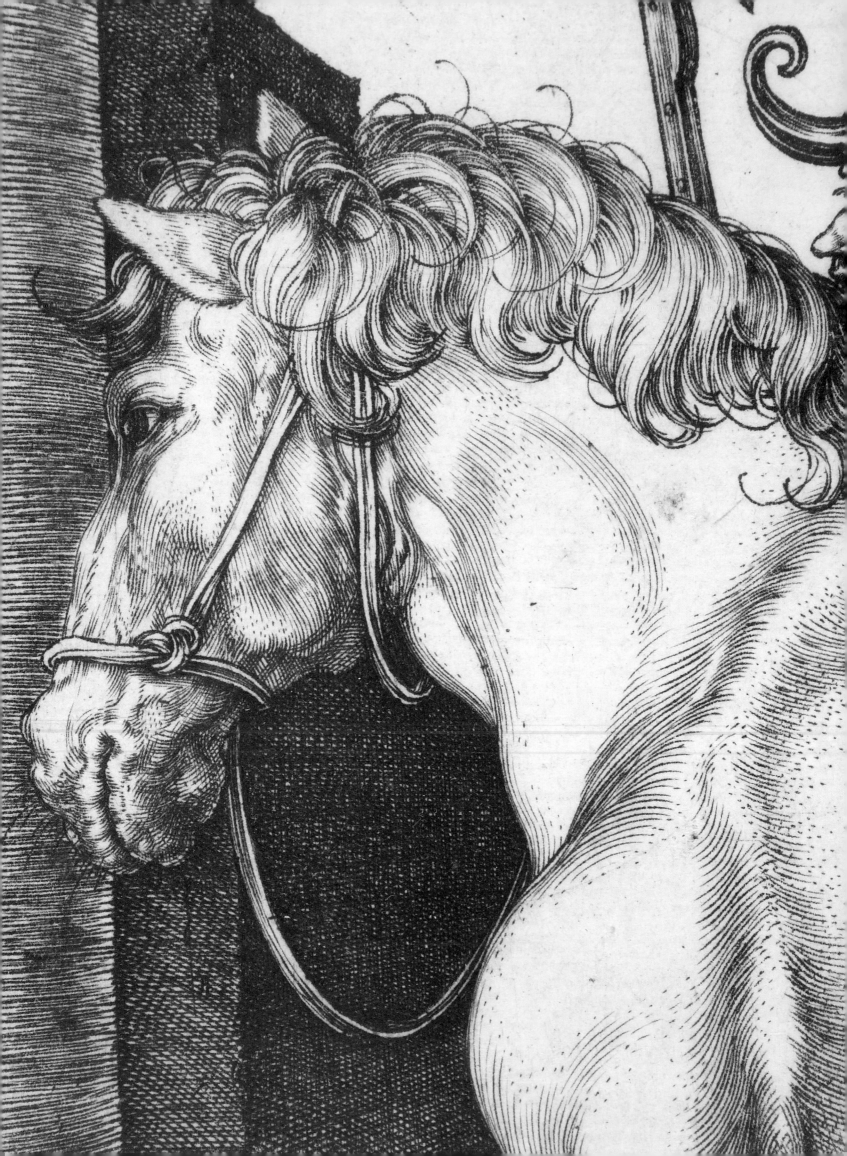

Renaissance Printmaking
in the North

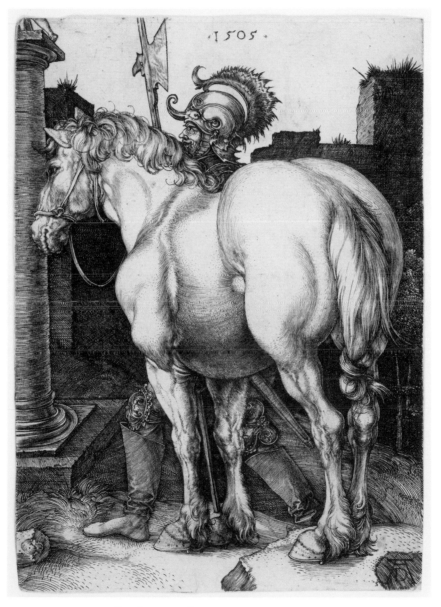

Albrecht Dürer, *The Great Horse*, 1505, engraving,
6½ x 4⅝ in. (165:117 mm), P.68.153

Martin Schongauer

German, c. 1450–1491

A Bishop's Crozier, c. 1475–80

Engraving
10 ¹¹/₁₆ x 4 ⅜ in. (272:111 mm), trimmed
Watermark: Small bull's head with star (Lehrs 48)
References: Lehrs 105; Bartsch 106
Provenance: Friedrich August II (L. 971); Colnaghi;
 Knoedler & Co., 1928
Bequest of Herschel V. Jones, 1968 (P.68.259)

So esteemed was Martin Schongauer in Germany that Albrecht Dürer headed to Colmar in 1492 to study with him, only to find that he had died the previous year. As an early *peintre-graveur*, Schongauer was among the first to apply pictorial sensibilities to printmaking. But because most of his paintings are lost, history knows him best as an engraver.

Schongauer knew his way around metalworking tools because his father was a goldsmith, a lineage evident in the ornate *Bishop's Crozier*. The print relates both to the Gothic tradition and to the Flemish panel paintings Schongauer undoubtedly saw on his travels to Burgundy and the Netherlands. Standing in the narrow Gothic archways are a king, Saint Margaret with her dragon, and Saint Barbara with her chalice. Arrayed in the crook are the Madonna and Child, whose facial types and quiet grace show the influence of Flemish artist Rogier van der Weyden, an important resource for Schongauer.[1] In a virtuosic flourish, Schongauer sprinkled four microscopic figures along the top of Mary's throne. As with fifteenth-century altarpieces, the Gothic architecture ties together each of the figural realms.

A Bishop's Crozier embodies the northern love of "small-scale, lovingly observed, finely crafted detail."[2] The tiny tableau is characteristic of the late medieval tradition of painting miniature scenes for illuminated manuscripts, but it also reflects an innovative approach to the new medium of engraving. Schongauer was one of the first printmakers to understand the importance of carving his lines deeply to produce numerous impressions and among the first to have his prints seriously collected and preserved, one reason the Herschel V. Jones Collection can claim twenty-seven prints in such fine condition. Schongauer was also the first artist to routinely sign his prints, as can be seen here in the tiny initials on the handle.[3] Thus he is revered not only for his technical precision and tonal intricacies but also for helping establish the artistic authority of prints in the north in the early decades of their existence.

M.J.K.

Notes
1. Alan Shestack, *The Complete Engravings of Martin Schongauer* (New York: Dover, 1969), xi–xii.
2. Craig Harbison, *The Mirror of the Artist: Northern Renaissance Art in Its Historical Context* (New York: Harry N. Abrams, 1995), 39, 41.
3. Giulia Bartrum, *German Renaissance Prints, 1490–1550* (London: British Museum Press, 1995), 20.

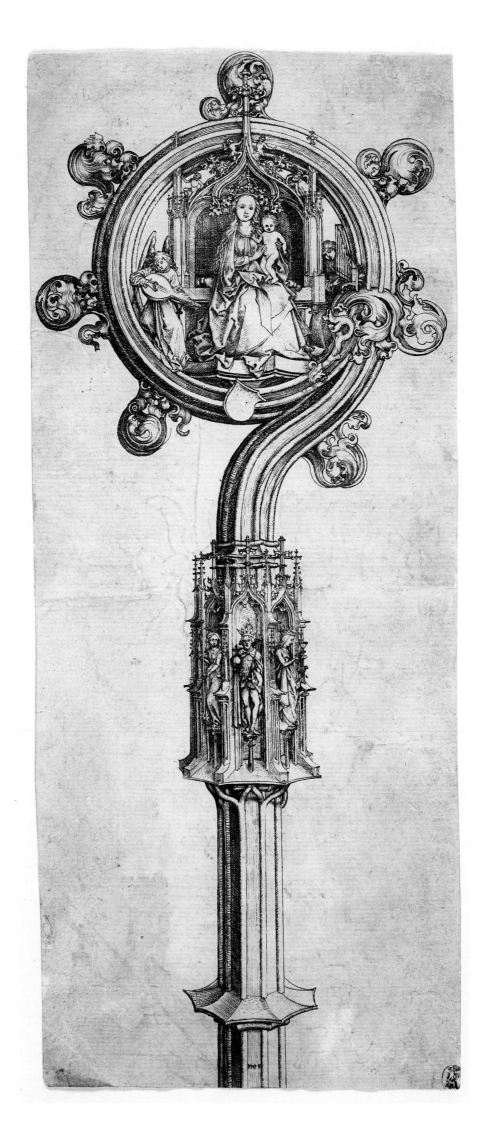

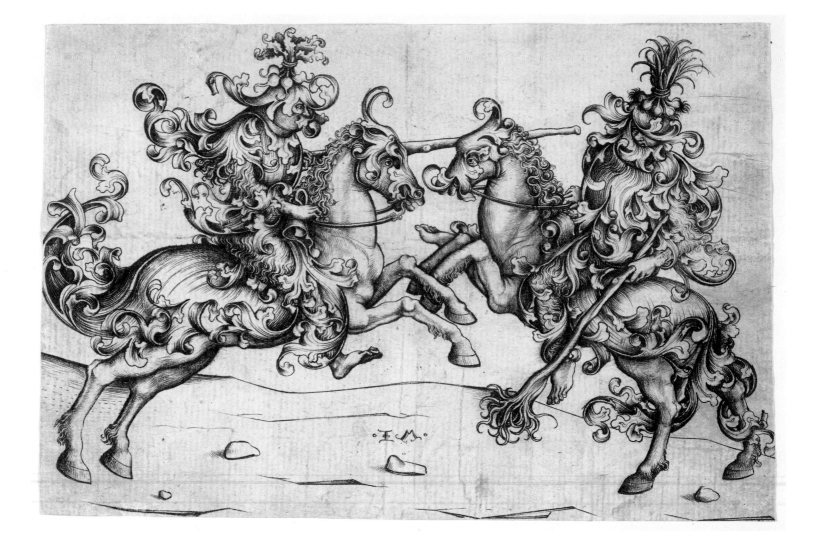

Israhel van Meckenem
German, c. 1445–1503

Joust of Two Wild Men, c. 1480

Engraving
5 1/16 x 7 1/2 in. (129:191 mm), trimmed
References: Hollstein 491 iii/iv/; Bartsch 200
Provenance: Colnaghi; Knoedler & Co., 1926
Gift of Herschel V. Jones, 1926 (P.10,920)

This engaging engraving is the type of ornamental pattern prized by fifteenth-century metalsmiths and passed around workshops for artisans to copy. Wild men had long been a part of medieval lore, but now instead of base mischief-makers inhabiting the margins of illuminated manuscripts, they had made the jump to popular culture as objects of affection and symbols of simpler times. These foliated riders wear helmets sprouting garlic and radishes and charge at each other with uprooted saplings. The scene, which appeared just as the ideals of chivalry were fading, is clearly a parody of jousting contests.[1]

Israhel van Meckenem loved fanciful subjects like this. He was the rascal of Renaissance printmaking, a flagrant copyist who freely appropriated designs that would sell. This delightful print, for example, is copied from *Combat of Two Wild Men on Horseback* (c. 1475–80) by the Housebook Master. Van Meckenem had an uncanny ability to gauge popular tastes. He bought and reworked plates by other artists (especially Master E.S.), copied engravings (including Albrecht Dürer's and Martin Schongauer's), and incised

his own plates deeply so that he could pull as many impressions as possible. Only about 10 percent of the prints he produced were based on his own designs.[2] Along with his entrepreneurial gift, van Meckenem was historically important for his innovations. He made the first printed self-portrait, he documented contemporary dress and customs, and he widened the niche for profane subjects. In so doing, he helped create a market for prints.

The son of a goldsmith-engraver called the Master of the Berlin Passion, van Meckenem lived mostly in the town of Bocholt, near the Rhine in Germany. As a practicing goldsmith himself, he had an affinity for ornamental prints such as *Joust of Two Wild Men*.

M.J.K.

Notes
1. Christa Grössinger, *Humour and Folly in Secular and Profane Prints of Northern Europe, 1430–1540* (London: Harvey Miller, 2002), 133.
2. David Landau and Peter Parshall, *The Renaissance Print, 1470–1550* (New Haven: Yale University Press, 1994), 57.

Albrecht Dürer

German, 1471–1528

The Four Horsemen, 1496–98
From the *Apocalypse*, 1511 edition

Woodcut
15⁹⁄₁₆ x 11¹⁄₁₆ in. (395:281 mm)
Watermark: Tower with crown and flower (Meder 259)
References: Bartsch 64; Meder 167; Hollstein 167
Provenance: Kupferstichkabinett, Staatliche Museen, Berlin
 (L. 1606) duplicate (L. 2398); William M. Ladd
Gift of Herschel V. Jones, 1916 (P. 206)

Any doubts about the status of woodcuts as fine art were dispelled by the appearance of Albrecht Dürer's *Apocalypse*. Published amid the millennial fears pervasive in northern Europe in the 1490s, the book consists of fifteen woodcuts inspired by Saint John's Book of Revelation. Here Dürer treats woodcut like engraving, producing lines so refined that it is supposed that he cut the blocks himself.[1] The *Apocalypse* marks the first time in publishing history that a bound volume was conceived by a single artist,[2] the first time an artist was his own publisher,[3] and the first time images had primacy over text. In fact, Dürer was so intent on his woodcuts standing on their own that the accompanying text, which runs on the verso of each leaf, is meant to be read independently of the images.

In this scene from Revelation (6.1–8), the four riders have been summoned by the opening of four seals. Each rider in his turn is commanded, "Come!" and Dürer filled the sheet with their dire, surging movement. The king with his bow symbolizes war; the sword-wielding slaughterer symbolizes discord; the well-fed man with the scales symbolizes famine; and the withered figure with the pitchfork— the only one touching the earth—is Death.[4] Behind Death, the figure of Hades swallows up a bishop while the horses trample all manner of humanity. In Dürer's conception, the stacked riders form diagonals at top and bottom, coming to a point as they approach the edge of the print to enhance the image of unstoppable fury.

Dürer published German and Latin versions of his ambitious book in 1498, followed by a Latin edition in 1511 with a new title page. The latter set is the one in the Jones Collection. As was standard in Dürer's time, the text was taken from the Vulgate, Saint Jerome's translation of the Bible into Latin, the common language of the Roman Catholic Church.

M. J. K.

Notes
1. Charles W. Talbot, ed., *Dürer in America: His Graphic Work* (Washington, D.C.: National Gallery of Art, 1971), 165.
2. Ibid., 164.
3. Clifton C. Olds, Ralph G. Williams, and William R. Levin, *Images of Love and Death in Late Medieval and Renaissance Art* (Ann Arbor: University of Michigan Museum of Art, [1976]), 75.
4. Ibid., 76.

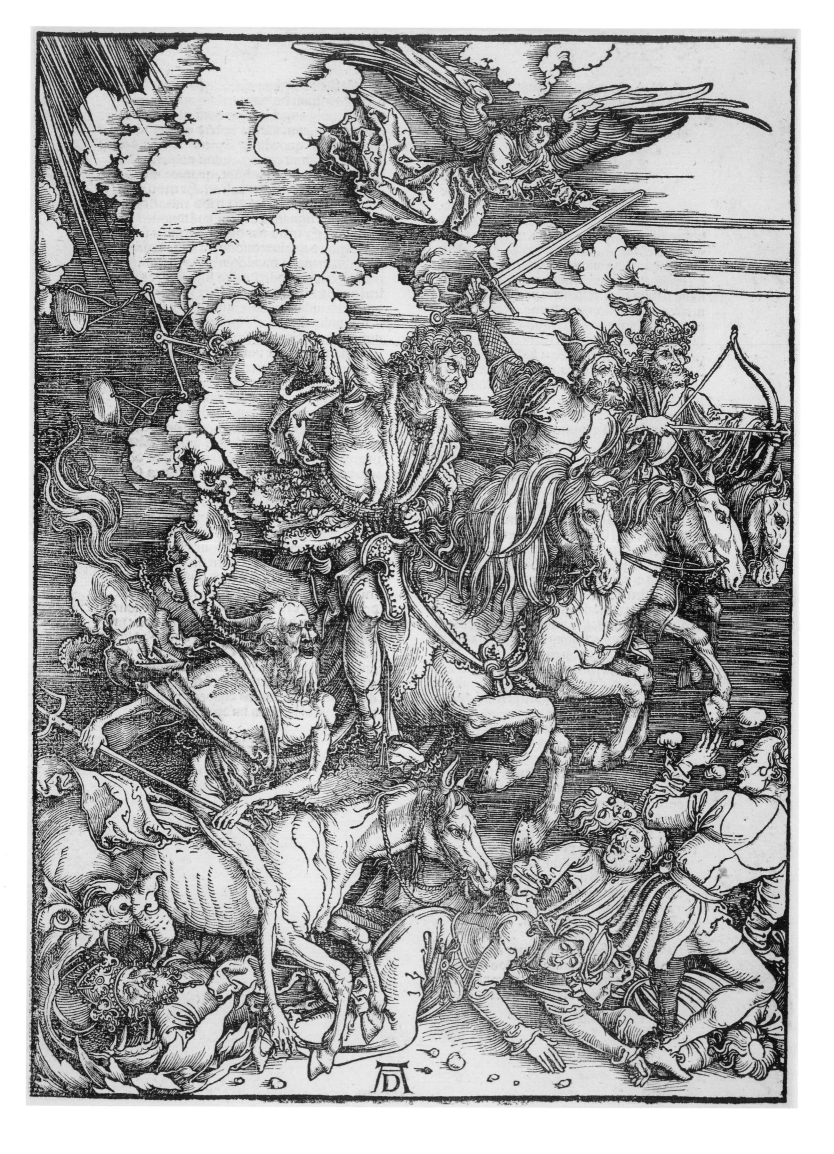

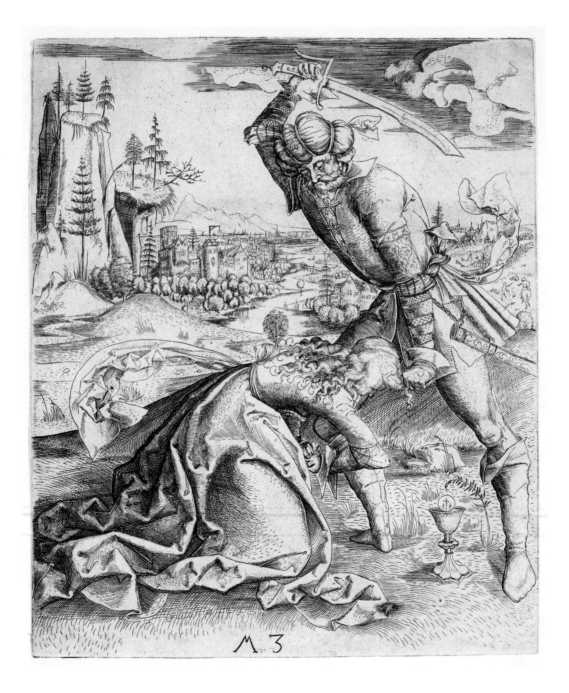

Master MZ

German, active c. 1500

Beheading of Saint Barbara, c. 1501

Engraving
6 x 4⅞ in. (152:124 mm)
References: Bartsch 9
Provenance: Albertina duplicate (L. 5g); Knoedler & Co., 1926
Gift of Herschel V. Jones, 1926 (P. 10,962)

Known for dainty lines and uncomfortable poses, the prints of Master MZ have a quiet charm. The artist's identity remains a mystery, although experts have suggested that he may be tied to the Munich goldsmith Matthäus Zaisinger. The master's atmospheric backgrounds and loose handling, however, indicate that he may have been a painter instead.[1] We know that he worked in Munich and made liberal use of compositions and motifs from the Nuremberg school, especially Albrecht Dürer's prints of the 1490s.[2]

According to legend, Saint Barbara was the beloved daughter of a heathen nobleman named Dioscurus. He was so afraid that a suitor would capture her affections that he shut her away in a tower. She managed to write to a great Christian teacher in Alexandria, who secretly sent a priest to instruct and baptize her. Later, when workmen were about, Barbara persuaded them to add another window to her room so that there would be three. When her father questioned her, Barbara said that the three windows represented the Holy Trinity. Furious that she had converted to Christianity, her father, here represented as a Turk, cut off her head. The engraving illustrates several attributes associated with the virgin martyr, including a host and chalice and her tower.

The only dates inscribed on Master MZ's twenty-two extant engravings are 1500, 1501, or 1503.[3] As one might expect given such a concentrated period of activity, the artist had his shortcomings. Often he failed to work out the logic of his compositions before picking up the burin. Many of his prints contain awkward perspective, oddities of scale, and as is evident in Dioscurus's stance, stiff, untenable poses.[4] These peculiarities are nevertheless secondary to the master's eye for anecdotal detail, such as the earnest clutch of Barbara's hands or the tender way her curls hang from her father's grasp. While his hair is bound tightly, hers falls freely, a symbol of the freedom of her soul.

M.J.K.

Notes

1. Alan Shestack, *Fifteenth-Century Engravings of Northern Europe* (Washington, D.C.: National Gallery of Art, 1967), unpaginated.
2. Ibid.
3. Ibid.
4. Erika S. Grünewald, "Works by Master MZ in the Oberlin Collection," *Bulletin—Allen Memorial Art Museum, Oberlin College* 31, no. 2 (1973–74): 70.

Lucas Cranach the Elder

German, 1472–1553

Saint Christopher, c. 1509

Chiaroscuro woodcut printed in reddish brown
11 x 7 ½ in. (281:191 mm)
References: Hollstein 79 1a/11e; Bartsch 58
Provenance: Unidentified P (L. 2065); Ambroise
 Firmin-Didot (L. 119); Henry S. Theobald (L. 1375);
 Frederick Keppel, 1916
Bequest of Herschel V. Jones, 1968 (P. 68.137)

One of the first chiaroscuro woodcuts ever made, *Saint Christopher* is typical of the northern approach to these novel prints. Instead of forming the composition from several tone blocks, as Italian artists often did (see cat. no. 18), Lucas Cranach and his German contemporaries relied on a dark line block to carry the main outline of the design. The color block was then carved in such a way that the white paper showed through as highlights. Cranach's print depicts the moment after the giant Saint Christopher, whose name means "Christ bearer," has carried his small charge across the river. The child had grown almost unbearably heavy and the waters dangerously fierce during the trip, and the saint strains awkwardly to climb onshore. The well-placed highlights on his large hands emphasize his struggle, while the deep reddish brown of the tone block creates an aura of nocturnal drama. His features take on a gentle grace with the revelation that he is carrying the Christ child.

Another sort of drama has swirled around *Saint Christopher*, making it the subject of a minor art historical mystery. The print is dated 1506 in the block, yet Friedrich the Wise of Saxony, for whom Cranach was court painter, did not grant the artist the right to use the winged serpent coat of arms until 1508.[1] Historians now believe that Cranach may have backdated his print so he could claim that he invented the chiaroscuro woodcut. As it is, he was among the very first to use the technique during its brief German heyday.

Cranach spent most of his career in the employ of the Saxon princes, whose crossed-sword crest often appears in his prints. His father was the painter Hans Maler, but Lucas took his name from his hometown of Kronach. Cranach ran a prosperous workshop in Wittenberg and was one of its most prominent citizens, even serving several terms as mayor.[2]
M.J.K.

Notes
1. David Landau and Peter Parshall, *The Renaissance Print, 1470–1550* (New Haven: Yale University Press, 1994), 191–92.
2. Giulia Bartrum, *German Renaissance Prints, 1490–1550* (London: British Museum Press, 1995), 166.

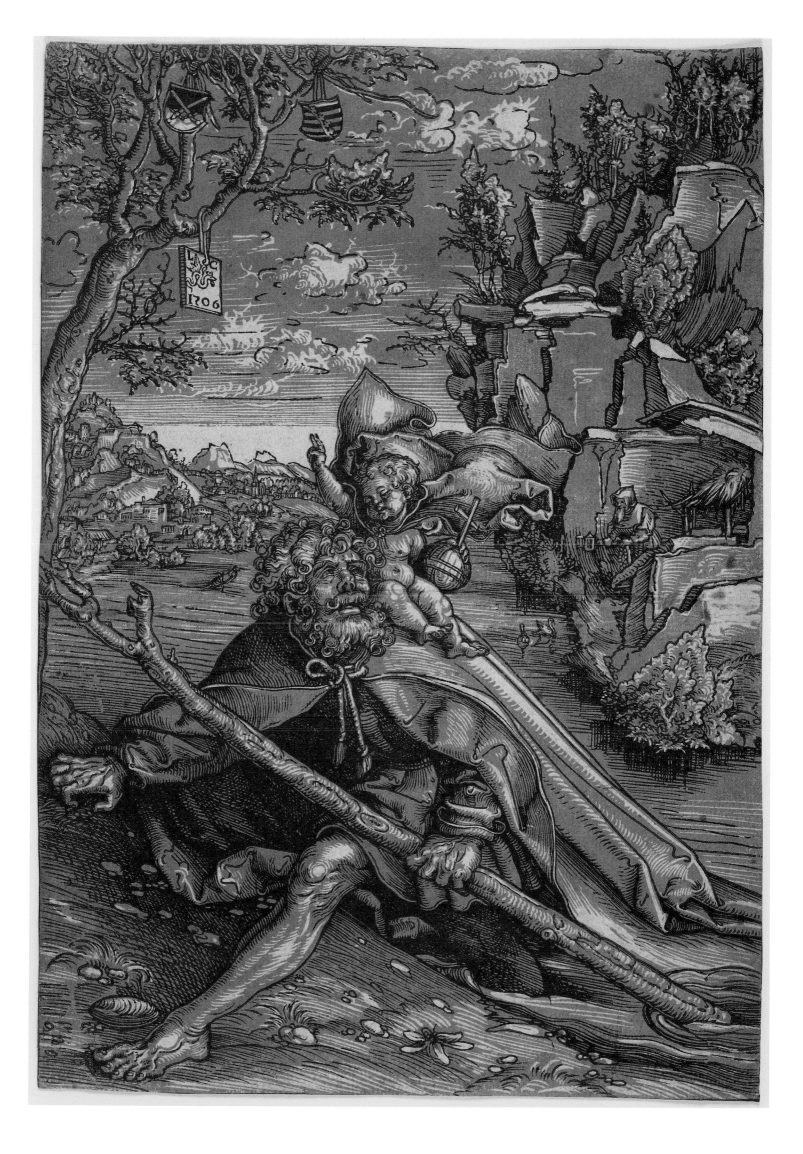

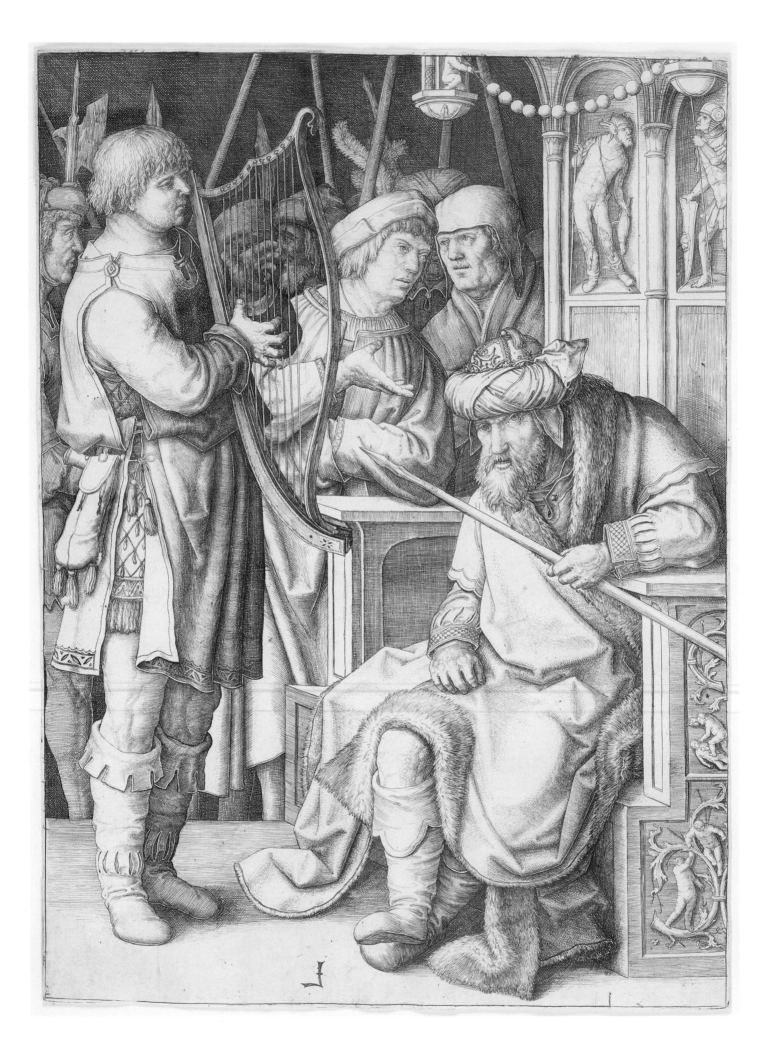

Lucas van Leyden

Dutch, c. 1489/94–1533

David Playing the Harp before Saul, c. 1508

Engraving
9 15/16 x 7 1/8 in. (253:182 mm)
Watermark: Gothic *P* with flower (Hollstein 27)
References: Hollstein 27 i/iii; Bartsch 27
Provenance: Pierre Mariette, 1693 and 1698 (see L. 1787);
 Albertina duplicate (L. 5g); Colnaghi;
 Knoedler & Co., 1925
Bequest of Herschel V. Jones, 1968 (P.68.198)

This print demonstrates why Lucas van Leyden was considered a prodigy. He began exploring engraving around 1505 and made *David Playing the Harp before Saul* just three years later, while still in his teens. It is one of his most acclaimed works, not least for its psychological depth. As was typical, he chose a seldom-seen Old Testament story and a highly dramatic moment in the narrative. The subject is Saul's troubled relationship with David, the shepherd who killed Goliath with a mere stone and sling. Saul became so jealous of the brave youth that he "eyed David from that day and forward" (1 Samuel 18.9). Lucas shows David trying to calm the king with his harp as Saul visibly sinks more deeply into madness. Hunched over by his "emotional depravity," Saul clutches his spear, which is pointed at David's chest.[1] As David looks at Saul, Saul looks at us, immediately involving us in the drama of whether he will in fact use his weapon. The dark, murky background, punctured with staffs and swords, provides a mirror of Saul's tormented mind, as does the violence of the ornamental figures that decorate his throne. His melancholy is further indicated by the middle figure, whose hand is placed inside his coat. The gesture can signify sloth, such as the inactivity produced by melancholy.[2]

Lucas was an exemplar of Netherlandish art and his country's answer to the brilliance of Albrecht Dürer. In true Dutch tradition, he excelled at detail. The fur of Saul's robe and the folds of his turban, the hem of David's tunic and the tassels on his pouch—all display the subtle burin work that brought Lucas international fame. Strong blacks are characteristic of his early prints, and an impression this crisp—note the distinct mesh of lines in the background—is especially prized. Lucas's daughter once said that he burned imperfect sheets, which is one reason that there are fewer good surviving impressions of his engravings than, say, of Dürer's.[3] This makes the fifty-nine prints by Lucas assembled in the Jones Collection particularly important.
M.J.K.

Notes
1. Peter Parshall, "Lucas van Leyden's Narrative Style," in *Lucas van Leyden Studies* (Haarlem: Fibula-Van Dishoeck, 1979), 207.
2. Ellen S. Jacobowitz and Stephanie Loeb Stepanek, *The Prints of Lucas van Leyden and His Contemporaries* (Washington, D.C.: National Gallery of Art, 1983), 64.
3. Ibid., 20.

Lucas van Leyden

Dutch, c. 1489/94–1533

Adam and Eve after the Expulsion from Paradise, 1510

Engraving
6⅜ x 4¹¹⁄₁₆ in. (162:119 mm)
Watermark: Quartered coat of arms with fleur-de-lis
 surmounted by crown (Hollstein 3)
References: Hollstein 11; Bartsch 11
Provenance: Earl of Aylesford (L. 58); Kupferstichkabinett,
 Staatliche Museen, Berlin (L. 1609, L. 2482); Colnaghi;
 Knoedler & Co., 1925
Bequest of Herschel V. Jones, 1968 (P.68.195)

Before this print appeared, no artist had ever portrayed Adam and Eve holding their son Cain while leaving the Garden of Eden.[1] In *Adam and Eve after the Expulsion from Paradise*, Lucas van Leyden compressed several events from the Genesis narrative—the pair being expelled and the admonition from God that Adam till the earth and Eve endure the pain of childbirth (Genesis 3.16–24, 4.1). Cain appears as a graphic reminder of their sin and the sin of every descendant to follow.[2] While Eve retains her classical elegance, however, Adam looks as if he has leapt from one of Lucas's genre prints. Adam's ignoble appearance seems to relate to a theme popular in Lucas's day about the dangerous, seductive power of women and men's susceptibility to their wiles. The Fall appears to have instantly turned Adam into a guileless rustic, while Eve's beauty lives on, a continued threat to unsuspecting men.

Lucas had a special gift for choosing unexpected themes that would captivate collectors, provoke interpretation, and reward close looking. In the Netherlands of the sixteenth century, printmakers faced an open market in which works traveled far and wide; no longer did an artist always know his or her patron. What's more, connoisseurs now hankered for the unique and inventive. Lucas, who apparently trained under a painter in the town of Leiden, gave them novelty and individuality. To achieve his particular style, he engraved his plates with thin, shallow lines, and as a result his plates yielded relatively few well-defined impressions. His delicate lines are gloriously apparent in Adam's beard and ragged hem, Eve's hair, and the desiccated tree, which curves in counterpoint to Eve's graceful pose.

M.J.K.

Notes
1. Ellen S. Jacobowitz and Stephanie Loeb Stepanek, *The Prints of Lucas van Leyden and His Contemporaries* (Washington, D.C.: National Gallery of Art, 1983), 86.
2. Larry Silver and Susan Smith, "Carnal Knowledge: The Late Engravings of Lucas van Leyden," in *Lucas van Leyden Studies* (Haarlem: Fibula-Van Dishoeck, 1979), 257.

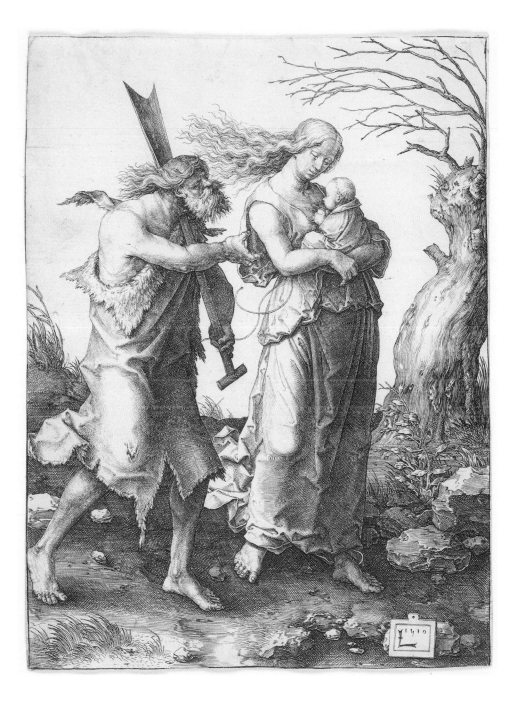

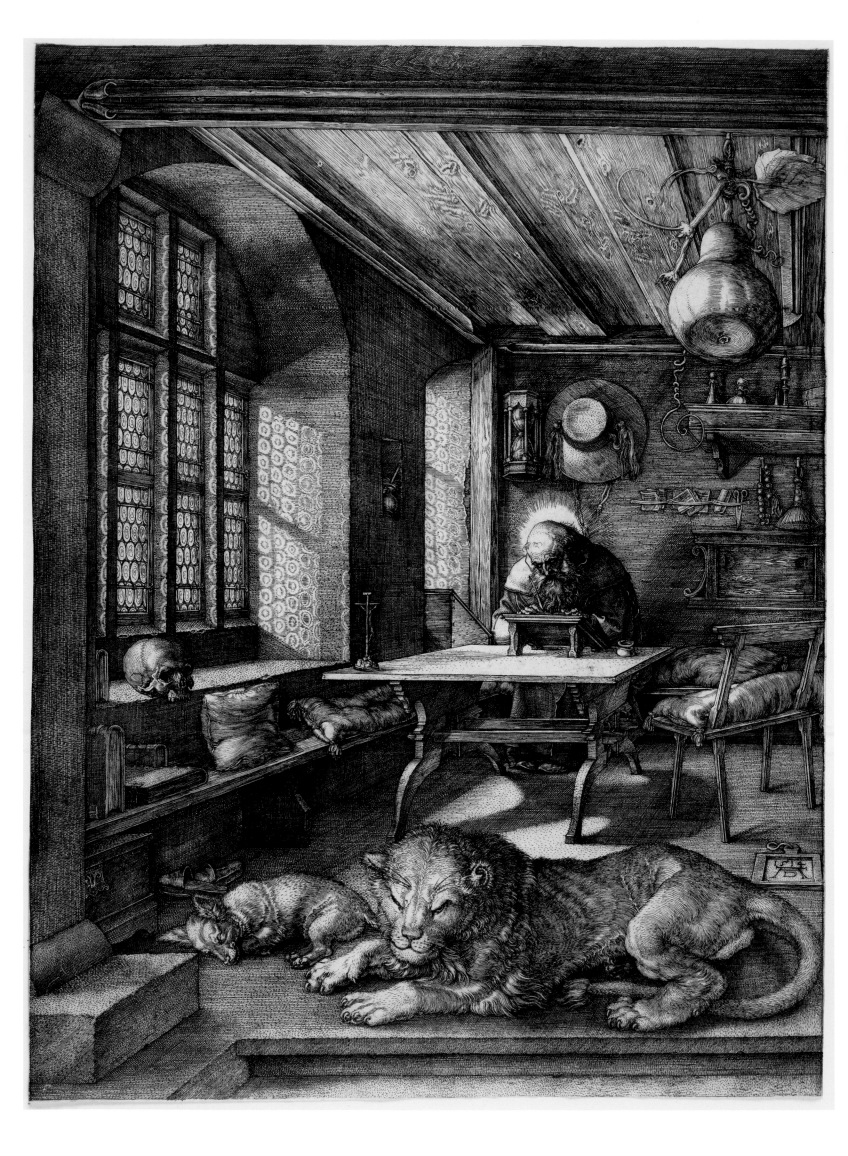

Albrecht Dürer

German, 1471–1528

Saint Jerome in His Study, 1514

Engraving
9 ⅝ x 7 ¼ in. (245:185 mm), trimmed
References: Meder 59 a/f; Hollstein 59; Strauss 77
Provenance: Duke of Buccleuch (L. 402);
 Frederick Keppel, 1915
Bequest of Herschel V. Jones, 1968 (P.68.145)

Albrecht Dürer's commanding *Meisterstiche*, or master engravings, constitute his personal reflections on the different roads to knowledge and virtue. The first, *Melencolia I* (fig. 42a), deals with the path of secular genius. The second, *Knight, Death, and the Devil* (fig. 26), presents the life of action in a practical, temptation-filled world. The last print, *Saint Jerome in His Study*, shows an ideal of spiritual, contemplative scholarship. Together these three prints represent the pinnacle of engraving, and thanks to Herschel V. Jones, all three are in the Institute's collection.

Saint Jerome, safeguarded as usual by his faithful lion, is famous for translating the Bible into Latin, a work called the Vulgate, which he undertook in a Bethlehem monastery around A.D. 390 after a period as a hermit (see cat. no. 12).

A formidable writer and linguist, he is shown working contentedly in his cozy cell. Among his typical attributes—skull, crucifix, lion, books, hourglass, and cardinal's hat—is a gourd suspended from the ceiling. With this detail Dürer seems to be alluding to a controversy over Jerome's interpretation of a plant name in the Book of Jonah; in a previous Latin translation, God sent a gourd to soothe Jonah, but Jerome interpreted the plant instead to be a kind of ivy.[1] The gourd's shape, also echoed in the skull and the hat on the wall, helps direct our eye toward the saint's head, poised as it is over sacred pursuits.

Such subtleties are what make *Saint Jerome in His Study* a landmark print. In keeping with the saint's "exacting intellectual and spiritual discipline," the print follows strict mathematical perspective.[2] Equally remarkable is the effect of sunlight filtering into the room, warmly illuminating the range of textures assembled in it.
M.J.K.

Notes
1. Peter W. Parshall, "Albrecht Dürer's *Saint Jerome in His Study*: A Philological Reference," *Art Bulletin* 53 (September 1971): 303.
2. Ibid.

Albrecht Dürer

German, 1471–1528

The Cannon, 1518

Etching on iron
8⁹⁄₁₆ x 12½ in. (218:324 mm)
References: Meder 96 ii/ii b; Hollstein 96 ii/ii; Strauss 86
Provenance: Peter Lely (L. 2092); William M. Ladd
Gift of Herschel V. Jones, 1916 (P.175)

When Albrecht Dürer made *The Cannon*, etching was in its infancy. The technique had migrated to the fine arts from the shops of armorers and gun makers, who used it to decorate weaponry. These designs were, like Dürer's print, etched on iron. Thus *The Cannon* presents a felicitous marriage of subject and technique.

Dürer's sometime patron Emperor Maximilian I loved artillery, even giving his cannons their own names, personalities, and ornament.[1] The toolbox on this cannon bears the arms of Nuremberg, Dürer's birthplace and home to several arms foundries.[2] Dürer biographer Erwin Panofsky notes that the Turk in the foreground is a self-portrait, while his costume is modeled after a painting by Gentile Bellini that Dürer had sketched on a trip to Venice.[3]

The magnificent panorama in the top half of *The Cannon* makes clear Dürer's profound influence on the Danube School (see cat. no. 40). In both watercolors and prints he worked out new graphic conventions for representing nature, inspiring future landscapists.[4] *The Cannon* was the last of just six etchings Dürer made between about 1514 and 1518; some believe that he abandoned the technique because he was disillusioned by the coarse lines that resulted from experimenting on iron.[5] The vitality of his draftsmanship is evident in the large tree and landscape, but the profusion of parallel lines in the near fields, roofs, and sky signal a persistent affection for the more controlled vocabulary of engraving.

The Institute has four of Dürer's six etchings, all part of the Jones gift. It is rare to find impressions of *The Cannon* completely free of rust spots, which are visible here in the path and pasture.

M.J.K.

Notes

1. Larry Silver, "Shining Armor: Emperor Maximilian, Chivalry, and War," in *Artful Armies, Beautiful Battles: Art and Warfare in Early Modern Europe*, ed. Pia Cuneo (Leiden: Brill, 2002), 77.

2. Alan Shestack and Charles Talbot, *Prints and Drawings of the Danube School* (New Haven: [Yale University Art Gallery, 1969]), 26.

3. Erwin Panofsky, *The Life and Art of Albrecht Dürer* (1955; Princeton: Princeton University Press, 1971), 197.

4. Shestack and Talbot, *Prints and Drawings*, 13, 17.

5. Arthur M. Hind, *A History of Engraving and Etching* (Boston: Houghton Mifflin, 1923), 106.

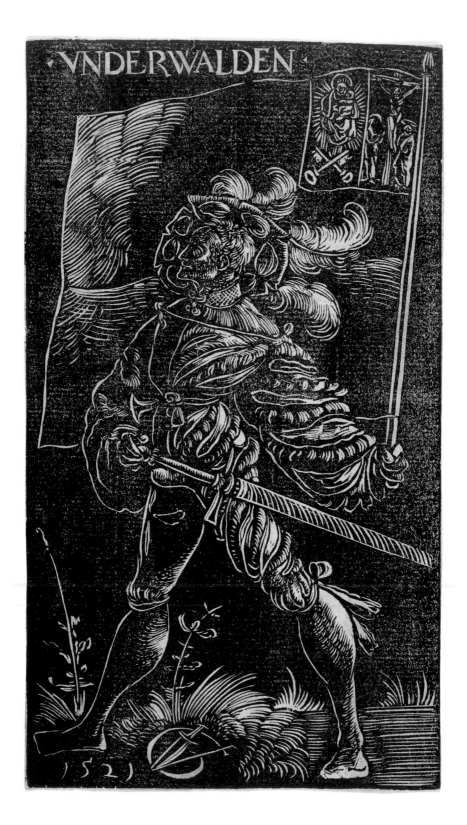

Urs Graf

Swiss, c. 1485–c. 1527/29

Standard Bearer of Unterwalden, 1521

White-line woodcut
7⁹⁄₁₆ x 4³⁄₁₆ in. (192:106 mm)
References: Hollstein 33
Provenance: Arthur H. Hahlo, 1926
Gift of Herschel V. Jones, 1926 (P.10,616)

The mercenary soldier strode into popular culture in the Middle Ages, when the nobility, no longer able to rely on the feudal system, hired paid recruits to go to war for them.[1] Swiss mercenaries, or Reisläufer, were highly sought after, fighting in the early sixteenth century for France or Italy, going wherever there was money to be made. A Swiss mercenary himself, Urs Graf glorified the profession in a series of woodcut standard bearers, each representing one of the sixteen cantons, or states, of the Swiss Confederation.[2] So heroic was this particular breed of foot soldier that he was paid five times the usual rate for his services.[3]

The subject of *Standard Bearer of Unterwalden* is a flamboyant spectacle in his fashionably slashed costume, ostrich plumes, and ribbons. His pronounced codpiece signals his virility. Graf's unusual white-line woodcut, in which the design is carved into the block rather than standing in relief, betrays his training as a goldsmith. The emphatic white lines heighten the figure's brio, while the pervasive darkness suggests danger and death. A curious feature is the biblical iconography in the corner of his standard, which could be the artist's way of addressing the uncertain religious atmosphere that his secular image faced during the Reformation.

Graf fit the image of a mercenary very well. When he was not off on one of his military campaigns—he went on at least five—he was earning a reputation as a scoundrel with a penchant for scandal. He was repeatedly jailed for transgressions in and around Basel: he beat his wife, maimed a stranger, played vicious pranks, and consorted with harlots.[4] He even included a dagger in his monogram, visible at lower left, to the right of the date. Although certain images of the Swiss Reisläufer and German Landsknecht served as propaganda for military expeditions, the wayward, itinerant nature of these soldiers was used eventually to reinforce the moral order of civic and family responsibility.[5] In time many would come to share humanist scholar Desiderius Erasmus's view of mercenaries as "absolutely the most abject and execrable type of human being."[6]

M.J.K.

Notes

1. Keith Moxey, *Peasants, Warriors, and Wives: Popular Imagery in the Reformation* (Chicago: University of Chicago Press, 1989), 71.
2. Christa Grössinger, *Humour and Folly in Secular and Profane Prints of Northern Europe, 1430–1540* (London: Harvey Miller, 2002), 160–61.
3. Ibid., 154.
4. Emil Major and Erwin Gradmann, *Urs Graf* (London: Home & Van Thal, 1947), 11–13.
5. Andrew Morrall, "Soldiers and Gypsies: Outsiders and Their Families in Early Sixteenth-Century German Art," in *Artful Armies, Beautiful Battles: Art and Warfare in Early Modern Europe*, ed. Pia Cuneo (Leiden: Brill, 2002), 170–73.
6. Moxey, *Peasants, Warriors, and Wives*, 95.

33

Daniel Hopfer

German, c. 1470–1536

The Festival, after 1520

Etching on iron, two sheets
9⅜ x 19⁷⁄₁₆ in. (245:488 mm) overall
References: Hollstein 83 i/iii; Bartsch 74
Provenance: Paul Davidsohn (L. 654); Bresler Gallery, 1925
Bequest of Herschel V. Jones, 1968 (P. 68.189, P. 68.190)

It is widely accepted that Daniel Hopfer made the first etching in the history of printmaking, a landmark that occurred perhaps as early as 1500.[1] He lived in Augsburg, where Emperor Maximilian I had an entire industry for making and decorating field armor. Although Hopfer's ornamental designs have been traced to at least one suit of armor, he also etched religious and secular prints on iron, including *The Festival*.[2] Both halves are signed with Hopfer's pinecone-like insignia, which, because his name translates to "hops keeper," may be a hops blossom.[3]

Peasants were the most popular genre subject well into the seventeenth century.[4] Often their habits were held up for satire or moralizing, but Hopfer's depiction is more ambiguous. Caught up in the holiday mood, his figures caper and carouse around a crowded inn. At the table one

112

man fondles another's companion, whose own demeanor is mocked by a prim and proper cat. To the table's right three women fend off a lecherous man. No fewer than five people are vomiting, three in the foreground. At the same time the festivities are quite orderly. The long table and bench are neatly aligned with the inn, the dancers stay confined within the fencing, and the violence and raucous movement of other peasant festival prints are absent. These peasants instead engage in gestures of restraint, exemplified by the figures in the clearing pulling two ruffians away from a potential brawl.

Hopfer's moralizing vision of containment may reflect the ideals of reformer Martin Luther, who was concerned that the peasant revolt of 1525 would endanger the social order.[5] Hopfer's treatment could also be read sympathetically as an expression of the belief that peasants embodied elements of the essential German nature—even its animal excesses.[6] Germans focused more intently on the virtues of their native culture when Maximilian died in 1519 and the Catholic outsider Charles V gained power.[7] The large etching, made up of two sheets, is cleverly divided down the middle by a tree. M.J.K.

Notes
1. David Landau and Peter Parshall, *The Renaissance Print, 1470–1550* (New Haven: Yale University Press, 1994), 323.
2. Ibid., 325.
3. Richard A. Vogler, in *The Hopfers of Augsburg: Sixteenth-Century Etchers* (Los Angeles: Grunwald Center for Graphic Arts, University of California, 1966), 8.
4. Eddy de Jongh and Ger Luijten, *Mirror of Everyday Life: Genre-prints in the Netherlands, 1550–1700* (Amsterdam: Rijks-museum; Ghent: Snoeck-Ducaju & Zoon, 1997), 48.
5. Keith Moxey, *Peasants, Warriors, and Wives: Popular Imagery in the Reformation* (Chicago: University of Chicago Press, 1989), 58.
6. Margaret D. Carroll, "Peasant Festivity and Political Identity in the Sixteenth Century," *Art History* 10 (September 1987): 290–91.
7. Ibid., 295.

34

Barthel Beham

German, 1502–1540

Mother and Child with Skull and Hourglass, c. 1528–30

Engraving
1 ¹¹⁄₁₆ x 2 ⁹⁄₁₆ in. (44:65 mm)
References: Hollstein 6
Provenance: Pierre Mariette, 1669 (L. 1789); A. E. Posonyi;
 A. Freiherr von Lanna (L. 2773); Paul J. Sachs (L. 2091);
 Knoedler & Co.
Bequest of Herschel V. Jones, 1968 (P.68.120)

An especially endearing trend of the German Renaissance was the fashion for tiny prints, a phenomenon inspired by the work of Albrecht Altdorfer (see fig. 31) and popularized by the *Kleinmeister*, or Little Masters, a group of artists much influenced by Albrecht Dürer. The brothers Sebald and Barthel Beham crafted some of the most exquisite prints of this period, contributing fresh new themes at a time when the Reformation made the old religious themes unpopular. The Little Masters, who also included Georg Pencz (cat. no. 38), correctly surmised that these small engravings—minutely detailed and with arresting subject matter—would find wide appeal among collectors.

35

Sebald Beham

German, 1500–1550

The Genius with the Alphabet, 1542

Engraving
1 ¹¹⁄₁₆ x 3 ¹⁄₁₆ in. (43:78 mm)
References: Hollstein 233 i/iii
Provenance: William M. Ladd
Gift of Herschel V. Jones, 1916 (P.109)

A number of these prints share Italian motifs and a regard for proper human form—a subject dear to Dürer's heart. In Sebald Beham's *Ornament with Two Genii Riding on Two Chimeras*, one of the many ornamental prints he made for artisans to copy, the artist employed a frieze format and young genii in the form of putti, both fixtures of Italian art.[1] Here and in his marvelous *Genius with the Alphabet*, Sebald alluded to the antique concept of Genius, a spirit who "is united with man from birth and who signals possible future dangers" through dreams or omens.[2] More intriguing still is Barthel's *Mother and Child with Skull and Hourglass*, with its Venetian costume and view of an Italianate building out the window.[3] As the hourglass and limp pose imply, the infant

Sebald Beham

German, 1500–1550

Ornament with Two Genii Riding on Two Chimeras, 1544

Engraving
1 ⅛ x 3 ¹⁵⁄₁₆ in. (34:100 mm)
References: Hollstein 241 iv/iv
Provenance: B. Keller (L. 384); Colnaghi; Albert Roullier
Gift of Herschel V. Jones, 1926 (P.10,592)

is probably dead; Barthel favored the theme of death and engraved several prints with skulls, a bone or two, and a dead child.[4]

Although the Beham brothers were born in Dürer's hometown of Nuremberg, there is no proof that either actually trained with him. Yet Dürer's style, engraving technique, and academic approach to proportion are everywhere evident in these tiny prints. Barthel, considered the more original and talented of the two, spent his final years in Italy, where he had been sent by his patron, Duke Wilhelm IV of Bavaria. Sebald briefly worked for Cardinal Albrecht of Brandenburg and later became a citizen of Frankfurt. He executed far more prints than his brother did, including many adapted from or copied after Barthel's designs but issued under his own name.[5]

M.J.K.

Notes
1. Jeffrey Chipps Smith, *Nuremberg: A Renaissance City, 1500–1618* (Austin: University of Texas Press, 1983), 195.
2. Stephen H. Goddard, ed., *The World in Miniature: Engravings by the German Little Masters, 1500–1550* (Lawrence: Spencer Museum of Art, University of Kansas, 1988), 67.
3. Giulia Bartrum, *German Renaissance Prints, 1490–1550* (London: British Museum Press, 1995), 127.
4. Goddard, *World in Miniature*, 157.
5. Bartrum, *German Renaissance Prints*, 100.

Master I.B.

German, active 1523–30

The Forge of the Heart, 1529

Engraving
5 13/16 x 3 5/16 in. (148:84 mm)
References: Bartsch 30
Provenance: Bresler Gallery, 1926
Gift of Herschel V. Jones, 1926 (P.10,996)

This perplexing image was probably conceived as a bookplate for Willibald Pirckheimer (1470–1530), a prominent humanist and scholar and Albrecht Dürer's best friend. The learned Pirckheimer educated Dürer in classical iconography and likely had a hand in the more complex symbolism in his prints. This print, awash in allegory and classical elements, is based on a drawing reputedly sketched by Dürer.[1] At the center are the figures of Hope, Tribulation, Envy, and Tolerance. While the reclining figure of Tolerance waits patiently, Tribulation beats on the anvil with a three-headed hammer, Envy casts a disdainful glance, and Hope looks up to see soothing drops fall on the flaming heart. The iconography points to the idea that patience in the face of hardship brings grace.[2] This undoubtedly reflected Pirckheimer's own philosophy, as he was ill when the engraving was made and died the following year. The birch tree on the anvil is his personal emblem.[3]

Master I.B. was no stranger to allegorical personification. His engravings are full of gods, myths, and virtues, indicating a broad knowledge of the Italian Renaissance. He evidently developed his elegant style in the 1520s in Nuremberg, then the artistic center of Germany.[4] Master I.B.'s virtuosic handling of minute detail—many of his prints are the size of a calling card—places him in the company of the Little Masters. These artists were followers of Dürer and were celebrated for their unconventional subject matter and intimate scale, qualities that appealed to private collectors. Despite much speculation, this master's identity has never been conclusively established.

M.J.K.

Notes
1. Stephen H. Goddard, ed., *The World in Miniature: Engravings by the German Little Masters, 1500–1550* (Lawrence: Spencer Museum of Art, University of Kansas, 1988), 75, 224.
2. Susan Dackerman, *Painted Prints: The Revelation of Color in Northern Renaissance and Baroque Engravings, Etchings, and Woodcuts* (Baltimore: Baltimore Museum of Art; University Park: Pennsylvania State University Press, 2002), 164.
3. Goddard, *World in Miniature*, 76.
4. Jeffrey Chipps Smith, *Nuremberg: A Renaissance City, 1500–1618* (Austin: University of Texas Press, 1983), 3–4.

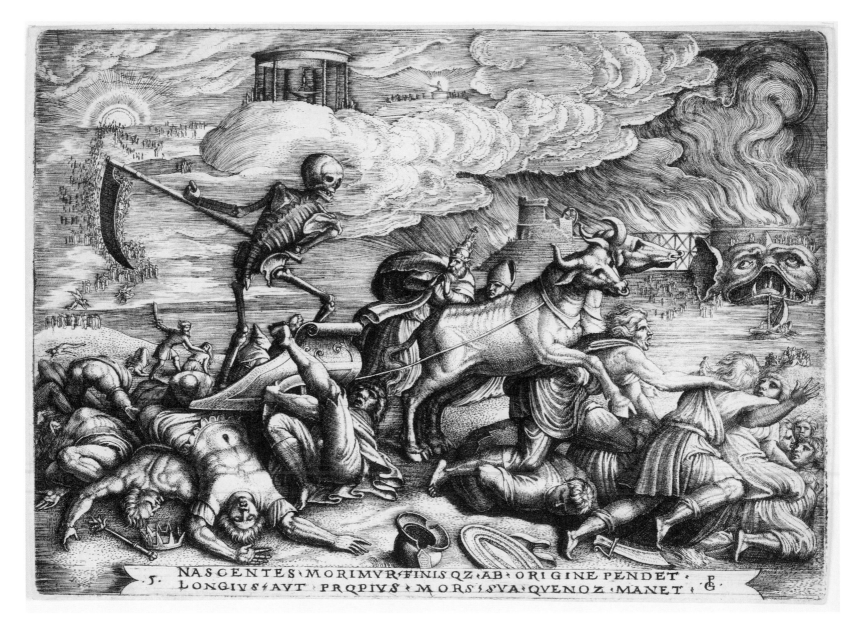

NASCENTES·MORIMVR·FINISQZ·AB·ORIGINE·PENDET·
·5· LONGIVS·AVT·PROPIVS·MORS·SVA·QVENQZ·MANET· P·G

Georg Pencz

Active in Germany, c. 1500–1550

Triumph of Death, c. 1539
From *The Triumphs of Petrarch*, c. 1539

Engraving
5 ⅞ x 8 ¼ in. (149:209 mm)
References: Landau 120; Bartsch 121
Provenance: C. Buckingham (L. 497); Albert Roullier, 1920
Gift of Herschel V. Jones, 1926 (P. 10,933)

Georg Pencz's six engravings for *The Triumphs of Petrarch* are based on fourteenth-century Florentine poet Francesco Petrarch's reflections on life. Some of the poems are autobiographical; he wrote the *Triumph of Death* after his great love, Laura, died in 1348, the year of the Black Death.[1] Like other northern artists, Pencz viewed trips to Italy as a requisite part of his training, and it appears that he may have engraved his *Triumphs* in Rome.[2] Of the six engravings in the series, all of which are in the Herschel V. Jones Collection, the *Triumph of Death* is the most chilling. As Death cuts down ruck and royalty alike, the damned are ferried across the River Styx on the right. The ominous inscription reads: "Being born, we die, and the end hangs from the beginning; Farther or nearer, his death awaits every man."[3]

Pencz worked in Albrecht Dürer's circle in Nuremberg as one of the eminent Little Masters, so named because of their small, intricate prints. This engraving is an excellent example of how well Pencz combined the northern manner with Italian Renaissance influences. The antique theme was common to Italian art, evident in the chariot and weaponry, but the crowded foreground and attention to humanity were characteristically northern.[4]

Pencz was greatly troubled by the brutal treatment of the peasants during Germany's Peasant War of 1525.[5] For his sympathies, he and fellow artists Barthel and Sebald Beham were called before the Nuremberg Rathaus. Found guilty of atheism and flouting authority, they were expelled from the city and became known as the "three godless painters." Eventually Pencz made his way back to respectability and in 1532 was named official painter of his adopted city of Nuremberg. His radicalism didn't leave him completely, however. He continued to find an outlet in the woodcuts he made to accompany poet Hans Sachs's moralizing broadsheets. And in the allegorical *Triumph of Death*, it seems that Pencz couldn't resist giving some of the victims the round-faced aspect of the peasantry.
M.J.K.

Notes
1. Clifton C. Olds, Ralph G. Williams, and William R. Levin, *Images of Love and Death in Late Medieval and Renaissance Art* (Ann Arbor: University of Michigan Museum of Art, [1976]), 32.
2. David Landau, *Catalogo completo dell'opera grafica di Georg Pencz*, trans. Anthony Paul (Milan: Salamon & Agustoni, 1978), 42.
3. Olds et al., *Images of Love and Death*, 92.
4. Katharine Jordan Lochnan, *Master Prints from the Presgrave Collection* (Toronto: Art Gallery of Ontario, 1980), 20.
5. Landau, *Catalogo completo*, 8.

Hans Baldung (Grien)

German, 1484/85–1545

Bewitched Groom, c. 1544

Woodcut
13 ³⁄₁₆ x 7 ¹³⁄₁₆ in. (336:199 mm)
Watermark: Unidentified (appears to be a bird)
References: Hollstein 237 ii/ii
Provenance: Bernard Hausman (L. 377); Frederick Keppel, 1925
Gift of Herschel V. Jones, 1926 (P.10,618)

Hans Baldung's famous woodcut, with its marvelous display of foreshortening, is considered to be the artist's spiritual self-portrait.[1] A convincing interpretation has been proposed by Baldung scholar Linda C. Hults, who views *Bewitched Groom* as an allegory for the moral dangers of too much imagination.[2] Under the spell of the "devil-horse" and the witch at the window, Baldung's groom has been struck senseless or dead. Sixteenth-century Germans readily knew the meaning of these images: the witch stood for rampant sexuality and the horse, lust. Artists prone to excess imagination or fantasy—or in sixteenth-century terms, an overactive melancholic temperament—were liable to lose control and succumb to "morally precarious" sensual appetites,[3] an idea underscored by the focus on the groom's codpiece and the horse's rear.[4] The prostrate groom is surrounded by impeccably ordered lines, while the horse and hag wave tail and torch above him, as if sprung from his imagination.[5] Filled with frenzied fantasy, the artist loses touch with reason and reality, and collapses.

The print includes a number of self-references. First, witches and horses made frequent appearances in Baldung's prints. More tellingly, the groom is thought to resemble him, the pitchfork points to his monogram, and his family coat of arms hangs on the stable wall.[6] Unlike his more rational friend and teacher Albrecht Dürer, Baldung was an idiosyncratic personality who sought to express an essentially dark inner vision. He may indeed have possessed a melancholic spirit, and it is perhaps significant that he died just a year after making this print.[7]

Raised in a family of doctors and lawyers, Baldung may have acquired the nickname "Grien" to distinguish him from other artists named Hans in Dürer's workshop.[8] Although he achieved his own renown, Baldung so venerated Dürer that when the master died Baldung requested, and received, a lock of his hair.[9]

M.J.K.

Notes

1. James H. Marrow and Alan Shestack, eds., *Hans Baldung Grien: Prints and Drawings* (New Haven: Yale University Art Gallery, 1981), 275.
2. Linda C. Hults, "Baldung's Bewitched Groom Revisited: Artistic Temperament, Fantasy, and the 'Dream of Reason,'" *Sixteenth-Century Journal* 15 (Autumn 1984): 264, 277.
3. Ibid., 264.
4. H. Diane Russell with Bernadine Barnes, *Eva/Ave: Woman in Renaissance and Baroque Prints* (Washington, D.C.: National Gallery of Art; New York: Feminist Press at the City University of New York, 1990), 169.
5. Hults, "Baldung's Bewitched Groom Revisited," 273.
6. Ibid., 262.
7. Ibid., 264.
8. These are Hans von Kulmbach, Hans Schäufelein, and Dürer's brother Hans Dürer.
9. Jeffrey Chipps Smith, *Nuremberg: A Renaissance City, 1500–1618* (Austin: University of Texas Press, 1983), 45.

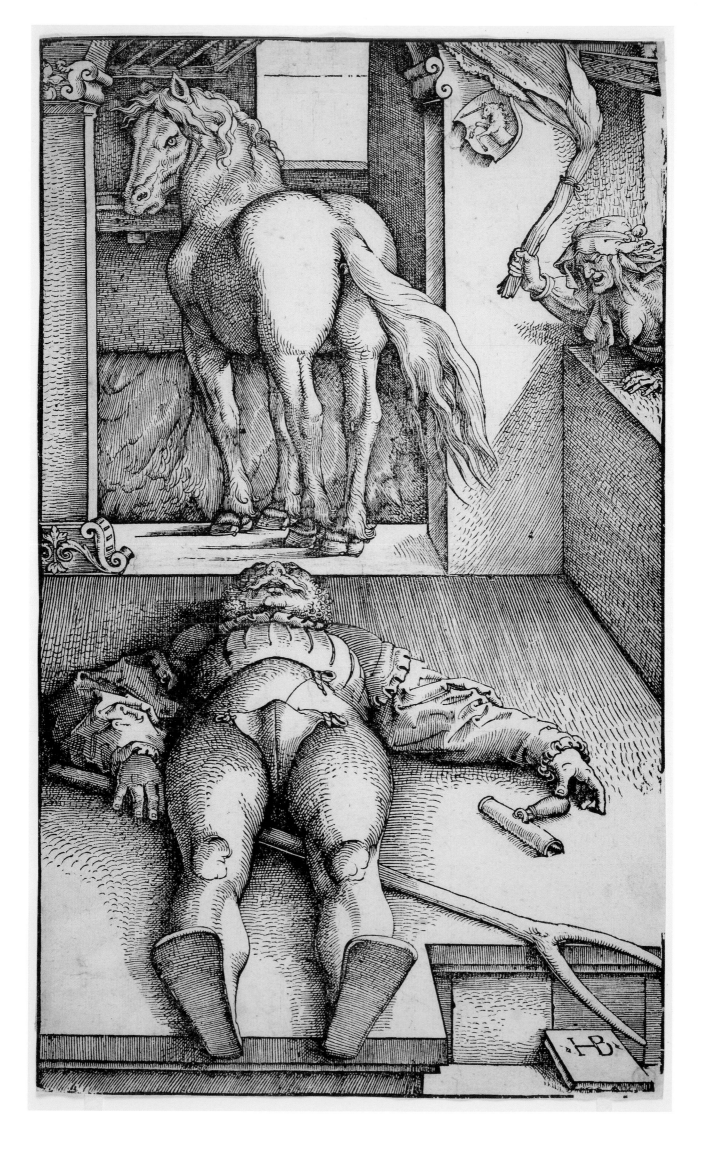

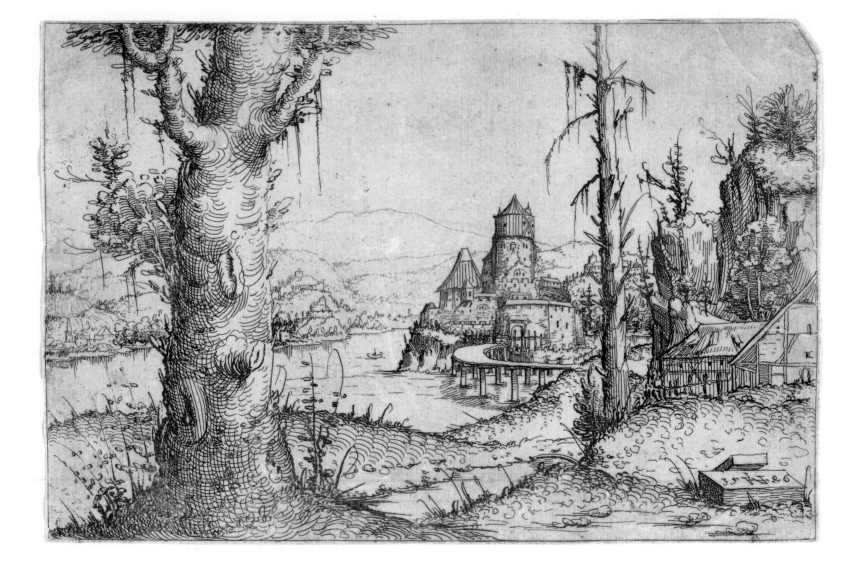

Augustin Hirschvogel

German, 1503–1553

Large Tree and Castle on a Lake, 1546

Etching
5 ⅝ x 8 ¼ in. (143:214 mm)
Watermark: Double eagle in shield with cross and letter *M*
References: Schwarz 73; Hollstein 46 ii/ii
Provenance: Albertina duplicate (L. 5g); Colnaghi;
 Knoedler & Co., 1925
Bequest of Herschel V. Jones, 1968 (P.68.183)

Until just before 1520, pure landscape was an unknown subject in printmaking. It had found legitimacy only as a backdrop for some form of narrative. Then an unorthodox group dubbed the Danube School—because its early practitioners lived along the Danube River—put landscape center stage in a series of remarkable etchings largely devoid of figures. The new genre helped cultivate a growing sense of German national identity and at the same time let artists explore a secular subject unlikely to rile religious reformers.

Augustin Hirschvogel, the son of a prominent Nuremberg glass painter, is the most famous of the second-generation Danube School artists and was central to carrying on the school's legacy. He took advantage of etching's special capacity to convey the wildness of the natural world. The personality in *Large Tree and Castle on a Lake* belongs to the muscular tree, and here Hirschvogel displayed an inspired immediacy, as if he'd just been on a sketching trip. The freedom of his etching needle and his mannered approach to the tree contrast with the carefully detailed setting on the right, revealing two sides of his professional life. Hirschvogel was not only an artist but also a cartographer and mathematician who invented the modern trigonometric system of surveying. In the 1530s and 1540s he mapped parts of Austria and Slovenia, as well as the Turkish borders, for the city council of Nuremberg.[1] For him the exploration of landscape etching, then, was tied in part to the Renaissance fascination with world geography.[2]

Most of Hirschvogel's thirty-five landscape etchings date to the 1540s, when he traveled through the Danube region; he eventually settled in Vienna. Many of his favorite motifs merge in *Large Tree and Castle on a Lake:* drooping moss, spiky vegetation, winding bridge, and, of course, a river. M.J.K.

Notes
1. Alan Shestack and Charles Talbot, *Prints and Drawings of the Danube School* (New Haven: [Yale University Art Gallery, 1969]), 88.
2. David Landau and Peter Parshall, *The Renaissance Print, 1470–1550* (New Haven: Yale University Press, 1994), 244.

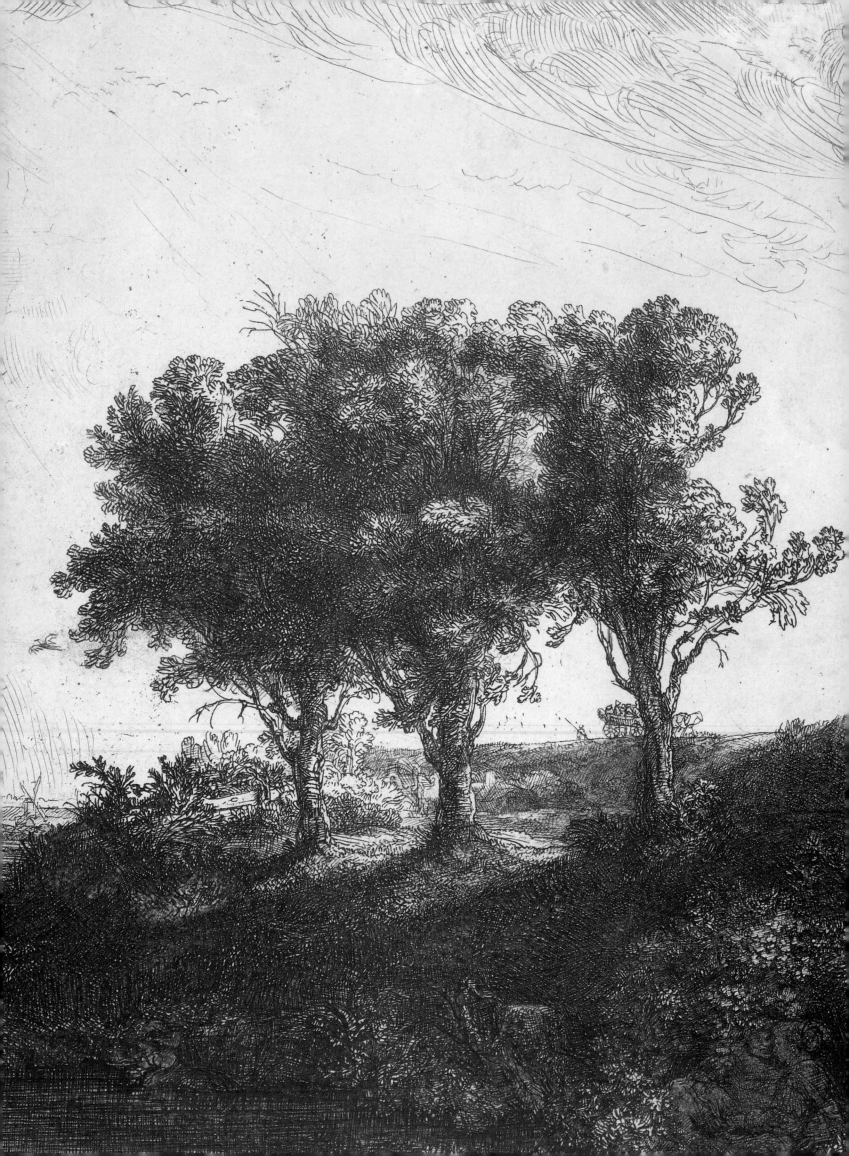

Printmaking in the
Seventeenth and Eighteenth Centuries

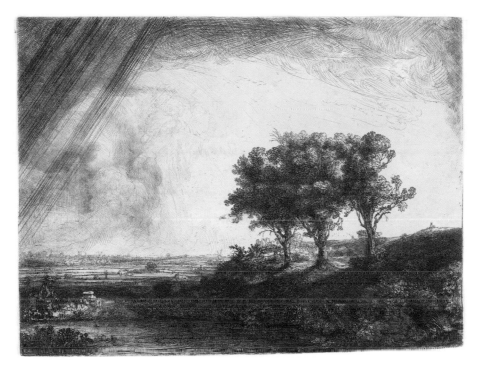

Rembrandt van Rijn, *The Three Trees,* 1643, etching and
drypoint, 8 1/16 x 10 7/8 in. (205:277 mm), P. 1,307

Hendrick Goltzius

Dutch, 1558–1617

Frederik de Vries, 1597

Engraving
14 3/16 x 10 1/2 in. (362:267 mm)
References: Strauss 311 ii/iii; Hollstein 218 ii/iii
Provenance: Frederick Keppel; William M. Ladd
Gift of Herschel V. Jones, 1916 (P. 590)

Giving a child his own true-to-life portrait was virtually unheard of in the sixteenth and seventeenth centuries, but such was the fortune of young Frederik de Vries. This engraving, one of the rarest and most prized of Goltzius's prints, was made as a gift to the artist's good friend Dirck de Vries, father of Frederik. The boy lived with Goltzius for many years while his father worked as a painter in Venice, and perhaps Frederik was still in Goltzius's care when he died prematurely in 1613. The dog is the artist's own beloved spaniel, whose likeness is captured just as affectionately and faithfully as Frederik's. The pet, in fact, may have slightly higher billing. Boy and dog take on the heroic pose of a falconer and his steed, with a dove serving as the raptor.[1] Goltzius hints at his meaning in the inscription, which reads in part, "Simplicity seeks and loves fidelity. The faithful dog and the simple boy, whom Goltzius has brought to life in copper with a skillful hand." The artist may be likening himself to the animal in his safeguarding of Frederik's welfare.[2]

Goltzius's own childhood was not so idyllic. As the artist's biographer and champion Karel van Mander recounted, at about a year old Goltzius fell into a fire and burned his hands over the coals.[3] To ease his pain, a know-it-all neighbor suggested that Goltzius's mother bind his right hand in cloth. The hand became deformed, and he was never able to open it fully. His achievements are therefore all the more remarkable. He is the unsurpassed genius of Netherlandish art in the second half of the sixteenth century and one of the first artists after the High Renaissance to carve out his own distinctive style. Indeed, an ever-present theme in Goltzius's work is his own virtuosity,[4] apparent here in the endlessly varied burin strokes creating the illusion of fur. His famously swelling and tapering lines, often interspersed with dots, are especially artful in Frederik's stockings and the tree trunk. Different as this print is from Goltzius's more typical Mannerist works, it too makes a heroic claim for his incomparable skill.

M.J.K.

Notes

1. Huigen Leeflang et al., *Hendrick Goltzius (1558–1617): Drawings, Prints, and Paintings* (Zwolle: Waanders; Amsterdam: Rijksmuseum; New York: Metropolitan Museum of Art; Toledo, Ohio: Toledo Museum of Art, 2003), 165.
2. Ibid.
3. Van Mander, cited ibid., 244.
4. Walter Melion, "Hendrick Goltzius's Project of Reproductive Engraving," *Art History* 13 (December 1990): 479.

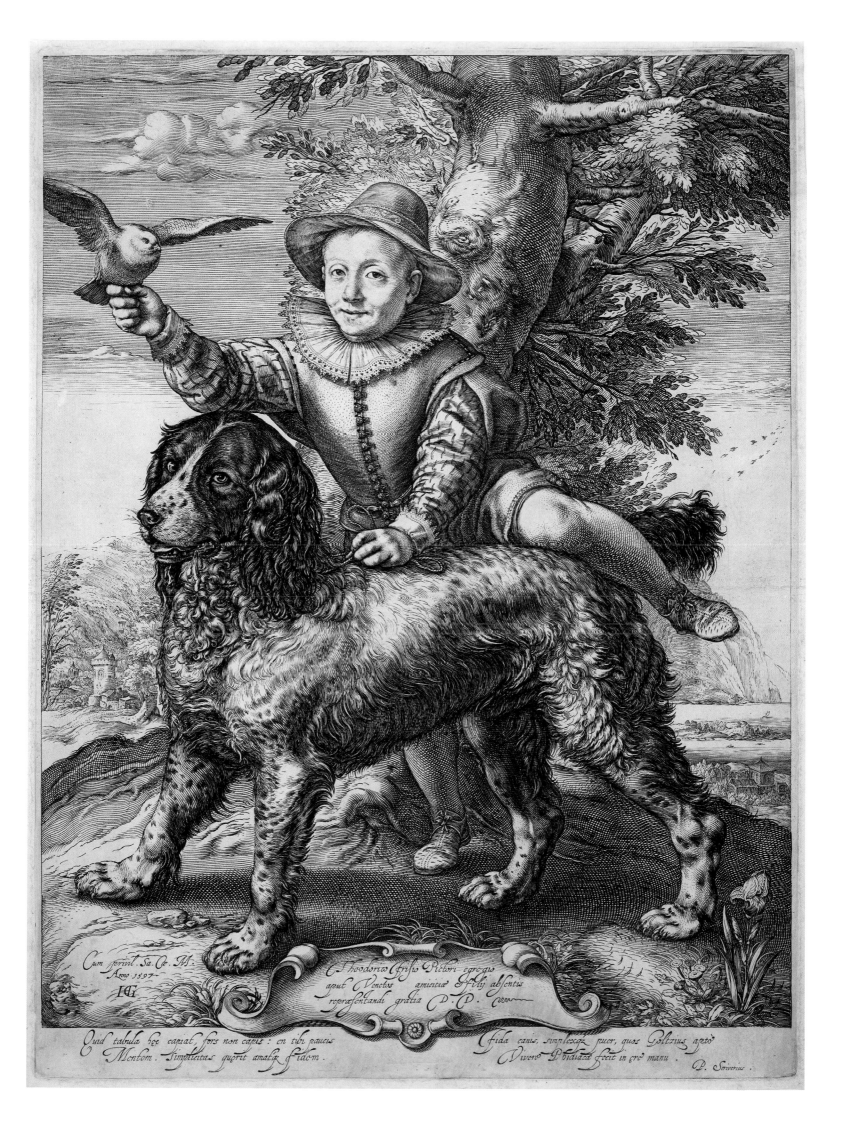

Cum privil. Sa. Cæ. M.
Anno 1597.
HG

Theodorico Crisio Pictori egregio
apud Venetos amicitiæ & sui absentis
repræsentandi gratia P. P.

Quid tabula hæc capiat, fors non capis: en tibi præuis
Montem. Simplicitas quærit amalæ fidem.

Fida canis, simplexgᵗ puer, quos Goltzius ætatͦ
Viuoᵗ Phidiaca fecit in ære manu.

P. Scriverius.

Jusepe de Ribera (Lo Spagnoletto)

Spanish, c. 1590–1652

The Poet, c. 1620–21

Etching
6 3/16 x 4 1/2 in. (158:121 mm)
References: Bartsch 10; Brown 3
Provenance: Pierre Mariette, 1667 and 1668 (see L. 1787);
 John Barnard (L. 1419); St. John Dent (L. 2373); William M. Ladd
Gift of Herschel V. Jones, 1916 (P. 463)

Scholars have proposed several identities for the subject of *The Poet*, including Virgil and Dante. But no one disputes that the figure represents a type that was very much a part of Renaissance iconography: the melancholy individual with the telltale shadowed face, ruminating expression, and head resting on hand. It is a theme that reached its apex in Albrecht Dürer's masterwork *Melencolia I* (fig. 42a), another celebrated print in the Jones Collection.[1] Unlike Dürer, however, Jusepe de Ribera chose to portray his brooding figure as a laurel-crowned poet, standing in a pose apparently inspired by that of the philosopher Heraclitus in Raphael's fresco *The School of Athens*.[2]

In allegorical tradition, Melancholy was one of the Four Temperaments, along with Sanguine, Choleric, and Phlegmatic. Artistic geniuses were thought to tend toward melancholy due to an excess of black bile, a state of imbalance that led to despondency and worse. The melancholic was believed capable of almost divine brilliance but at the same time sadly bound by his or her earthly limitations. Ultimately our poet is as weighted down as the stone block he leans upon. In another interpretation of *The Poet*, it has been proposed that the stone block was meant to hold lettering and that the print was intended as the title page for a pattern book that Ribera had begun in the early 1620s. As evidence for this theory, Ribera, an accomplished draftsman, had etched studies of eyes, noses and mouths, and ears just after completing *The Poet*, but his instruction manual was never finished.[3]

Including these pattern sheets, Ribera made some eighteen prints. His intense but temporary involvement with etching may have been prompted by a desire to publicize his painting skills after arriving in Naples in 1616, as several prints correspond to earlier oils. *The Poet* has no precedent, however.[4] Known by the nickname Lo Spagnoletto, Ribera was a favorite of the Spanish viceroys who ruled Naples, working for no fewer than eleven of them.[5] He became the leading figure of Neapolitan painting, depicting apostles, martyrs, allegorical figures, and philosophers in works that, like *The Poet*, deal with the somber realities of the human condition.

M.J.K.

Notes
1. Wolfgang Stechow, "A Note on 'The Poet' by Ribera," *Allen Memorial Art Museum Bulletin* 15, no. 2 (1957): 69.
2. Selma Holo, cited in Jonathan Brown, *Jusepe de Ribera: Prints and Drawings* (Princeton: Princeton University Press, 1973), 66.
3. Mark P. McDonald, "The Graphic Context of Jusepe de Ribera's 'The Poet,'" *Art Bulletin of Victoria*, no. 32 (1991): 52–53.
4. Jonathan Brown, "The Prints and Drawings of Ribera," in *Jusepe de Ribera, lo Spagnoletto, 1591–1652*, ed. Craig Felton and William B. Jordan (Fort Worth: Kimbell Art Museum, 1982), 77–78.
5. Alfonso E. Pérez Sánchez and Nicola Spinoza, eds., *Jusepe de Ribera, 1591–1652* (New York: Metropolitan Museum of Art, 1992), 171.

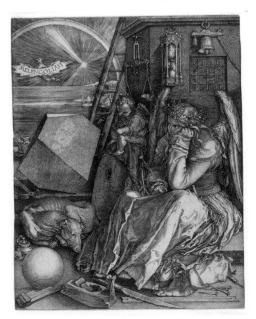

Figure 42a
Albrecht Dürer, *Melencolia I*, 1514, engraving, 9 3/8 x 7 5/16 in. (238:186 mm), P. 167

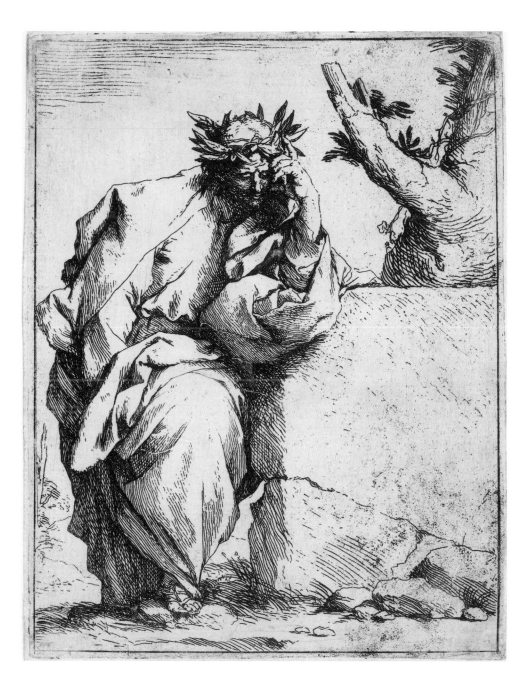

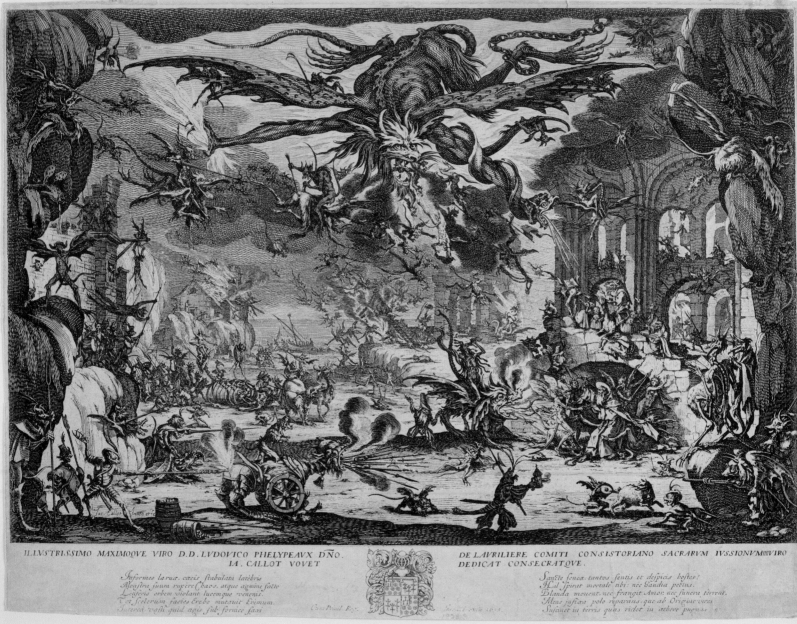

ILLVSTRISSIMO MAXIMOQVE VIRO D.D. LVDOVICO PHELYPEAVX DÑO. DE LAVRILIERE COMITI CONSISTORIANO SACRARVM IVSSIONVMⅢⅠVIRO
 IA. CALLOT VOVET DEDICAT CONSECRATQVE.

Informes laruæ. cæcis stabulata latebris Sanέte senex. tantos sentis et despicis hostes?
Monstra suum rupére Chaos. atque agmine facto Hil spirat mortale tibi: nec Gaudia pestus.
Leucferis orbem violant lucemque venenis. Blanda mouent. nec frangit Amor. nec funera terrent.
Et scelerum fæces Erebo mutauit Eremum. Aleas justixa polo reparans.que ab Origine vires
Interea rogas quid agis sub fornice saxi Sufanet in terris quas ridet in æthere pugnus.

 Came Priuil. Reg. Sima Lexch 1625.

Jacques Callot

French, 1592–1635

The Temptation of Saint Antony, 1635

Etching
14 x 18⅜₆ in. (356:465 mm)
References: Lieure 1416 v/v; Meaume 139 iii/iv
Provenance: William M. Ladd
Gift of Herschel V. Jones, 1916 (P.1,352)

Jacques Callot spent eight years in the Florentine court of Cosimo II de' Medici, where his job included making etchings to document the grand duke's elaborate theatrical productions.[1] Callot's interpretation of Saint Antony's travails, although made long after the artist left Florence to return to his native city of Nancy, carries the very look of a stage set. Antony was a third-century Egyptian who gave his possessions to the poor and went to lead a life of denial and seclusion in the desert. During his meditations he was tormented by evil and erotic visions, which he struggled to resist, making him a model of Christian discipline in the face of temptation.[2] Callot, however, was much more interested in the ascetic saint's horrific hallucinations, relegating Antony to a small, shallow cave on the right. A magnificent devil spews serpents aloft, while other monstrosities charge at Antony with swords, fire, and hurtling snakes.

This etching, which is more hellish than Callot's earlier *Temptation of Saint Antony* (1617), was completed the year he died and may sum up his own miseries. The duchy of Lorraine, where he lived, had been embroiled in war, and Callot had seen Nancy invaded by France in 1633.[3] In addition, Saint Antony was called on to ward off the plague, and Callot's father had died of the plague in about 1631. Still, the artist lets us have a distanced view of this nightmarish onslaught by setting it in a theatrical framework—and by chaining the devil so he can't get loose. Indeed, the piece has also been viewed as a parody of Cosimo II's vain extravaganzas.[4]

The brilliant lines in *The Temptation of Saint Antony* demonstrate Callot's incalculable contributions to the field of etching. To approximate the sophisticated look of engraving, he began using a hard ground made of lute maker's varnish and a special oval etching needle called an *échoppe*, which enabled him to vary line width with great precision. He also exploited multiple biting, a technique of varying lines according to how long the acid is allowed to bite certain areas of the plate. This accounts for the atmospheric depth in *The Temptation of Saint Antony*, with the faint, lightly bitten areas receding into the distance and the dark, deeply bitten lines looming in the foreground. Of the more than 1,400 prints in Callot's oeuvre, this one is said to best exemplify his facility for creating atmosphere.[5]

M.J.K.

Notes
1. Sue Welsh Reed and Richard Wallace, *Italian Etchers of the Renaissance and Baroque* (Boston: Museum of Fine Arts, 1989), 222.
2. Linda C. Hults, *The Print in the Western World* (Madison: University of Wisconsin Press, 1996), 53.
3. H. Diane Russell, *Jacques Callot: Prints and Related Drawings* (Washington, D.C.: National Gallery of Art, 1975), xix.
4. Ibid., 159.
5. Ibid., 160.

Wenceslaus Hollar

Bohemian, 1607–1677

A Group of Muffs, 1647

Etching with drypoint and burin
4 ⅜ x 8 ¹⁄₁₆ in. (111:205 mm)
References. Pennington 1951
Provenance: William M. Ladd
Gift of Herschel V. Jones, 1916 (P. 236)

Prague-born Wenceslaus Hollar was an etcher in the northern tradition who literally wore his love of surface detail on his sleeve. His meticulously described muffs are among his best-loved etchings, and they helped launch still life as a new printmaking genre. In *A Group of Muffs* we see the seventeenth-century interest in a particular object standing in for the whole. The landscapelike arrangement of muffs, kerchief, gauntlets, feather whisk, mask, pincushion, and fan suggest their absent owner and the social milieu in which she travels. Through Hollar's almost obsessive artistry, everyday objects take on a life of their own; free of context, they invite us to attach our own stories to them.

With his impossibly exacting etching needle, Hollar mapped his age. During an unsettled life that took him to Germany, England, and the Netherlands, he chronicled topographical views, landmarks, ships, and historic events. Later he took his factual bent into the scientific realm with important studies of seashells and insects. Yet over his fifty-year career—during which he averaged fifty-five plates a year—women's costume was a singular delight.[1] He could have made the drawing for *A Group of Muffs* while in service to the London art collector Thomas Howard, earl of Arundel.[2] Hollar's archiving impulse was given freer rein later under the patronage of the great antiquarian Sir William Dugdale. His etchings for Dugdale of the old Saint Paul's Cathedral and other medieval and ancient sites typify the seventeenth-century fascination with relics of the past and today provide an invaluable record of those places. For Hollar, England's history resided in such buildings, just as the Englishwoman somehow resided in her muffs.

M.J.K.

Notes

1. Richard Pennington, *A Descriptive Catalogue of the Etched Work of Wenceslaus Hollar, 1607–1677* (Cambridge: Cambridge University Press, 1982), xxxi.
2. Richard T. Godfrey, *Wenceslaus Hollar: A Bohemian Artist in England* (New Haven: Yale University Press, 1994), 10, and ibid., xxviii.

Claude Mellan

French, 1598–1688

The Sudarium of Saint Veronica, 1649

Engraving
16⅞ x 12⅜ in. (429:314 mm)
References: Montaiglon 25
Provenance: William M. Ladd
Gift of Herschel V. Jones, 1916 (P. 1,535)

Paris was slower than other European cities to develop its own tradition of etching and engraving. When the city finally embraced intaglio printmaking fully in the 1600s, engraver Claude Mellan was essential to its success.[1] Born into a family of coppersmiths, he received his most important training in Rome, where he learned from artists Simon Vouet and Gian Lorenzo Bernini. When he returned to Paris in 1636, after twelve years in Italy, he brought with him an individual new style marked by clarity and purity.

The Sudarium is an extraordinary technical achievement, the print with which Mellan declared his virtuosity. The image of Christ is made from a single engraved line that starts freehand at the center of his nose and spirals outward, swelling and tapering by turns to effect a marvelous curiosity. Mellan made only slight adjustments to line width.[2] He worked against the reproductive style then prevalent in Europe by displaying a very personal albeit contrived technique consisting solely of parallel lines. *The Sudarium* is a miraculous feat that mirrors the very image it represents— the miracle of Christ's face imprinted on Veronica's cloth when she wiped it on his ascent to Calvary. In their way, both Mellan's line and the Holy Face symbolize the same

thing: uniqueness.[3] The artist proclaimed as much in his inscription, which translates as: "It is formed by one and no other."

This masterpiece caused such a sensation that art students were assigned to copy it to learn engraving techniques. Mellan's originality got him noticed at court, and he was made engraver to Louis XIV. The artist lived out his life in lodgings at the Galeries du Louvre in Paris.
M. J. K.

Notes
1. Sue Welsh Reed, *French Prints from the Age of the Musketeers* (Boston: Museum of Fine Arts, 1998), 8.
2. Ibid., 178.
3. Martin Kemp, "Coming into Line: Graphic Demonstrations of Skill in Renaissance and Baroque Engravings," in *Sight and Insight: Essays on Art and Culture in Honour of E. H. Gombrich at Eighty-five*, ed. John Onians (London: Phaidon, 1994), 241–42.

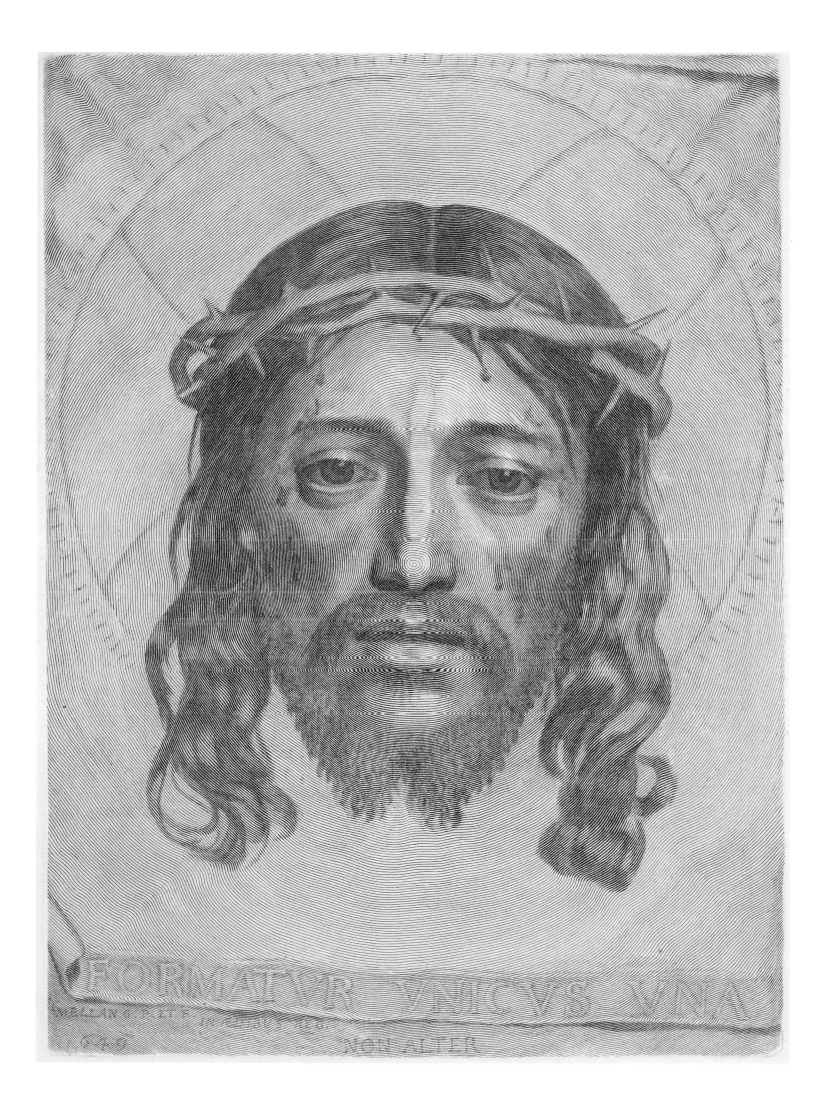

FORMATVR VNICVS VERA

MELLANVS ET F. NON ALTER

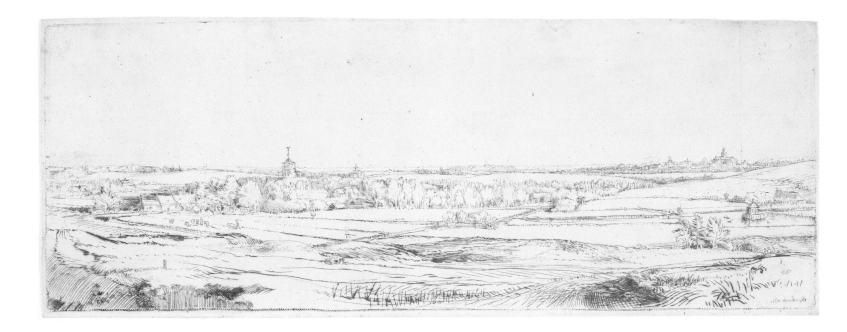

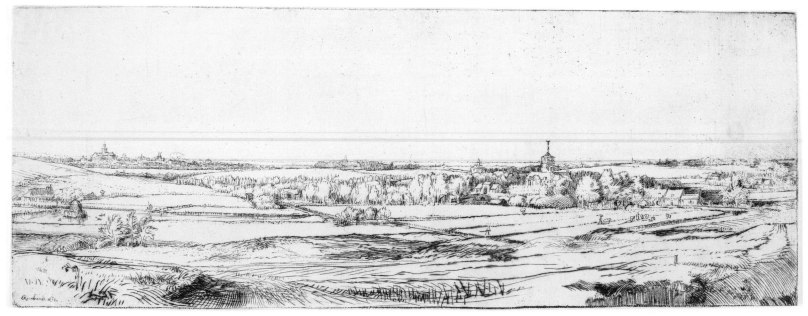

Figure 46a **Rembrandt van Rijn**, *The Goldweigher's Field*, 1651, etching and drypoint, 4¾ x 12⅜ in. (120:321 mm), Bequest of Herschel
V. Jones by exchange, the Putnam Dana McMillan Fund, the Edith and Norman Garmezy Prints and Drawings Acquisitions Fund, and gift
of funds from the Print and Drawing Council, P.95.14

Rembrandt van Rijn

Dutch, 1606–1669

The Goldweigher's Field, 1651

Etching and drypoint (counterproof)
4¾ x 12⅝ in. (120:321 mm)
Watermark: Strasbourg Lily
References: Hollstein 234; Hind 249
Provenance: Earl of Aylesford (L. 58); T. Wilson (L. 2580);
 Duke of Buccleuch (L. 402); William M. Ladd
Gift of Herschel V. Jones, 1916 (P.1,312)

The Goldweigher's Field is one of Rembrandt van Rijn's most far-ranging views of the Dutch landscape. For many years the etching was thought to represent the estate of Jan Uytenbogaert, the receiver-general of Amsterdam, whom Rembrandt had depicted as a gold weigher twelve years earlier. When the scene is viewed in reverse, as it is in this rare counterproof, its true identity is revealed as Saxenburg, the summer estate of Christoffel Thijsz. near Haarlem.[1] Thijsz. sold Rembrandt his home in Amsterdam in 1639, and in 1651 the artist still owed him money for it. It is quite possible that the etching was a commissioned portrait of the estate that was done to offset the debt.[2]

Rembrandt took a bird's-eye view of the countryside from a vantage point on the dunes outside Haarlem. His expansive vista comprises everything from Haarlem's Church of Saint Bavo in the distance to the linen-bleaching fields near Thijsz.'s home. Because the linen industry was so important to Haarlem's economy, Thijsz. may have requested the inclusion of the fields and the workers tending the cloth.[3]

The Institute's impression of The Goldweigher's Field is a counterproof; it differs from the traditional version (fig. 46a) in that it is printed in reverse. To create this work, Rembrandt would have taken a freshly printed impression and run it through the press again with another sheet of paper. The resulting print was of the same orientation as the copper plate. He could use this as a working proof for making changes or corrections, or to see the image as he had drawn it on the plate. This counterproof must have been printed from an incredibly lush early impression because it retains much of the rich, dark drypoint work that enlivens the composition and leads the viewer so artfully through the panorama.

L.D.M.

Notes
1. J. Q. van Regteren-Altena made this discovery and allowed W. R. Valentiner to publish his findings in "Shorter Notes: Rembrandt's Landscape with a Country House," *Art Quarterly* 14 (Winter 1951): 341–42.
2. Linda A. Stone-Ferrier, "Views of Haarlem: A Reconsideration of Ruisdael and Rembrandt," *Art Bulletin* 67 (September 1985): 432–33.
3. Ibid., 430–31.

Rembrandt van Rijn

Dutch, 1606–1669

The Blindness of Tobit: The Larger Plate, 1651

Etching with touches of drypoint
6 ¼ x 5 ¹⁄₁₆ in. (158:129 mm)
References: Hollstein 42 ii/ii; Hind 252 (only state)
Provenance: William M. Ladd
Gift of Herschel V. Jones, 1916 (P.1,241)

Rembrandt had a lifelong preoccupation with blindness, believing that truth lies in what cannot be seen. Again and again he used his art to explore the inadequacy of sight alone, an idea rooted in the Protestant mistrust of church spectacle, which in its severest form led to iconoclasm. It was believed that salvation comes not from praying to images but through deep faith and the Word of God. The focus of Rembrandt's poignant *Blindness of Tobit*, then, is not only sight but also hearing.

In the Book of Tobit, this scene follows the one etched by Giovanni Benedetto Castiglione a year earlier (cat. no. 50). After burying a poor soul one night, Tobit was blinded by sparrow droppings that fell onto his eyes from a nest as he slept outdoors.[1] His wife, Anna, turned to spinning to bring in money. In time Tobit sent his son, Tobias, and a companion (the archangel Raphael in disguise) on an errand to collect a debt. They were delayed when Tobias was first accosted by a magical fish and then decided to marry. When the boy's dog rushed in to announce his return at last, old Tobit hurried from his chair. Unknown to him, Tobias brought a potion from the fish that would cure blindness, a detail foreshadowed by the fish strung on the hearth.[2] In his haste to greet Tobias, Tobit knocked over his wife's spinning wheel and missed the door, so that he confronted not his son, but his own shadow. Having suggested a mood of great anticipation, Rembrandt asks us to use our own vision to reflect on Tobit's depth of feeling and imagine the reunion to follow.

Rembrandt liked the apocryphal Book of Tobit so well that he executed forty-four paintings, drawings, and prints on the subject.[3] For *The Blindness of Tobit* he used the simple lines characteristic of his later prints, and his clean parallel strokes suggest the clarity of Tobit's inner vision.

M.J.K.

Notes
1. Julius S. Held, *Rembrandt and the Book of Tobit* (Northampton, Mass.: Gehenna Press, 1964), 7–8.
2. Clifford S. Ackley et al., *Rembrandt's Journey: Painter, Draftsman, Etcher* (Boston: MFA Publications, 2003), 203.
3. Hilliard T. Goldfarb, *A Humanist Vision: The Adolph Weil, Jr. Collection of Rembrandt Prints.* (Hanover, N.H.: Hood Museum of Art, Dartmouth College, 1988), 136.

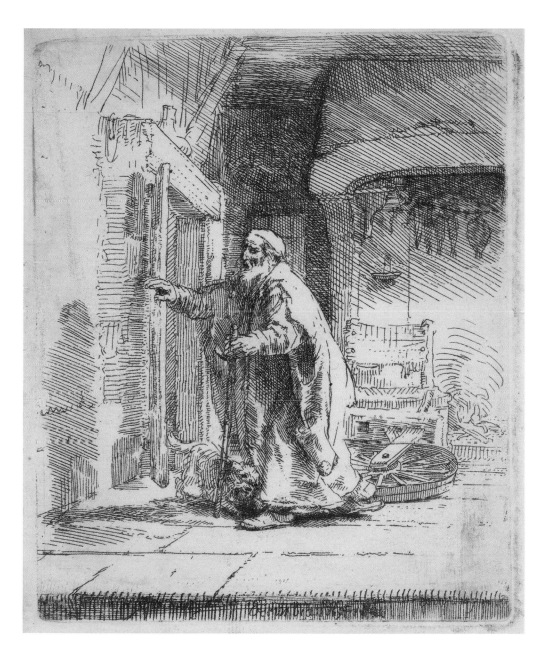

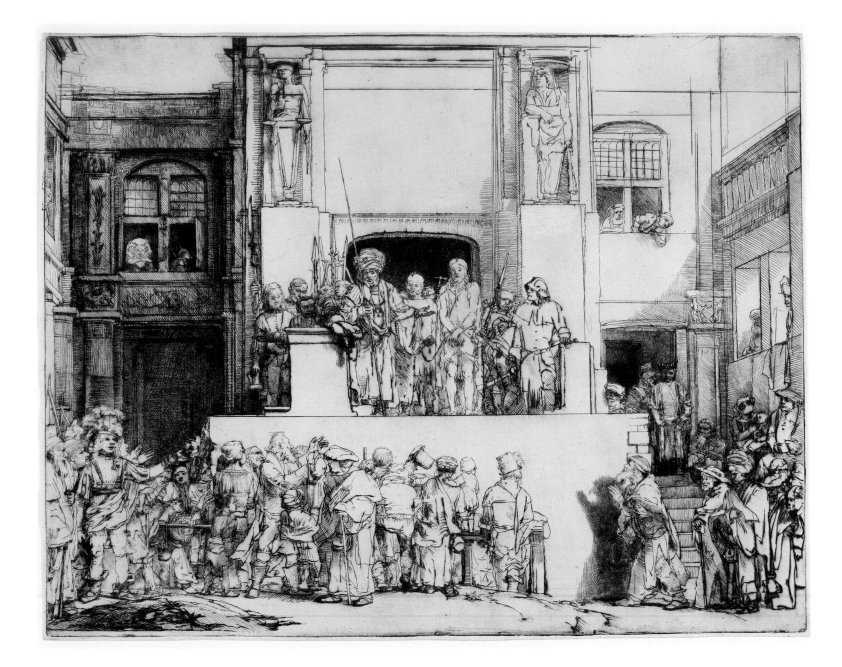

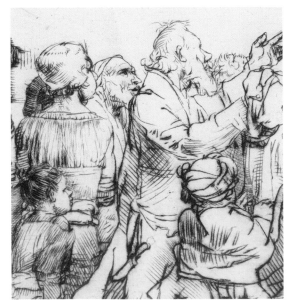

Rembrandt van Rijn

Dutch, 1606–1669

Christ Presented to the People (Ecce Homo), 1655

Drypoint with pen additions
14⅛ x 17¹³⁄₁₆ in. (357:452 mm)
References: Hollstein B76 v/viii; Hind 271 iii/vii
Provenance: John Barnard, 1747 (L. 219);
 Rev. R. Burleigh James (L. 1425); Bresler Gallery, 1924
Bequest of Herschel V. Jones, 1968 (P.68.408)

Christ Presented to the People is one of the rare prints that Rembrandt executed in pure drypoint, a feat unheard of at this monumental scale.[1] In contrast to the intimate, isolated drama he portrayed in *The Blindness of Tobit* (cat. no. 47), here Rembrandt treated the very public moment when Pilate, urged by his wife, gives in to the crowd's wishes and sheds responsibility for Jesus' fate: "Take ye him and crucify him, for I find no fault in him" (John 19.6). Jesus stands on the platform, roped to Barabbas on the left, the prisoner whom the crowd decides to free instead of Christ. The overbearing architecture, adorned by the figures of blind Justice and Fortitude, is modeled after an actual building in Amsterdam where criminals were displayed for ridicule and punishment.[2] Rembrandt also included other details of contemporary Dutch life, such as the wimple worn by the woman in the upper left window, believed to be Pilate's wife.

Rembrandt was famously experimental, working and reworking his plates so that there is the sense that they were never finished. *Christ Presented to the People* underwent a dramatic transformation as he worked through the print's spiritual meaning. In the fourth state, he made the structure less towering by slicing a strip off the top of the print, thereby focusing more tightly on the platform.[3] The Institute's impression is a unique working proof of the fifth state in which Rembrandt indicated several areas of shading in the crowd with brown pen and ink. These changes were never realized in succeeding states, and in fact he made the momentous decision in the sixth state to burnish out the central mob scene completely, effectively putting the viewer in the place of judgment. In keeping with the Protestant tradition of private devotion, Rembrandt helped the viewer to experience Christ's persecution at an increasingly personal level as he continued to rework the print. In this impression, the strong drypoint visible in the crowd at the right and in the servant holding the basin at the left of Pilate serves to activate the naysayers, adding force to their cries for crucifixion.

M.J.K.

Notes
1. Clifford S. Ackley et al., *Rembrandt's Journey: Painter, Draftsman, Etcher* (Boston: MFA Publications, 2003), 255.
2. Mariët Westermann, *Rembrandt* (London: Phaidon, 2000), 279.
3. Ackley et al., *Rembrandt's Journey*, 258.

Jacob van Ruisdael

Dutch, 1628/29–1682

The Great Beech with Two Men and a Dog, c. 1650–55

Etching
7 ¹¹/₁₆ x 11 ¹/₁₆ in. (195:280 mm)
References: Slive E11 ii/ii
Provenance: Frederick Keppel; William M. Ladd
Gift of Herschel V. Jones, 1916 (P. 883)

One of the outstanding Dutch landscapists of all time, Jacob van Ruisdael had an early taste of painting thanks to his father, a frame maker and art dealer in Haarlem. As with other artists discussed in this catalogue whose fame rests primarily on painting or sculpture, Ruisdael's brief excursion into printmaking produced some astonishing results. We know of thirteen etchings, most done when the artist was in his twenties. *The Great Beech with Two Men and a Dog* dates to the period in the 1650s when he was incorporating an elaborate *l* into his signature.[1]

Aware that Dutch collectors were attracted to the novelty of foreign landscapes, Ruisdael set off with friend Nicolaes Berchem around 1650, in the midst of his etching phase, to the rugged German border country in search of new inspiration. What seems to have impressed Ruisdael profoundly, judging from his works, is erosion. Here his mighty beech keeps a tenuous grip on the bank while its wild branches fill the print's right side. In a mannerist fashion borrowed from earlier in the century, Ruisdael animates his tree with exaggerated curves and thick dead wood that lunges strangely from the top. In the words of one writer, he was "the master of the ruined tree."[2]

Ruisdael's tree symbolizes the relentless cycle of exuberant growth and withering decay.[3] Like the pair of dwarfed travelers, we are meant to contemplate the power of untamed nature and life's impermanence, which Ruisdael further emphasized with the fallen tree in the foreground and weathered cottage in the distance. He resisted the classicizing trends of the day and instead sought to express deeper truths about the natural world, a transient world that he, through his art, was able to freeze in time.
M.J.K.

Notes
1. E. John Walford, *Jacob van Ruisdael and the Perception of Landscape* (New Haven: Yale University Press, 1991), 81–82.
2. Walter S. Gibson, *Pleasant Places: The Rustic Landscape from Bruegel to Ruisdael* (Berkeley: University of California Press, 2000), 166.
3. Walford, *Jacob van Ruisdael*, 81.

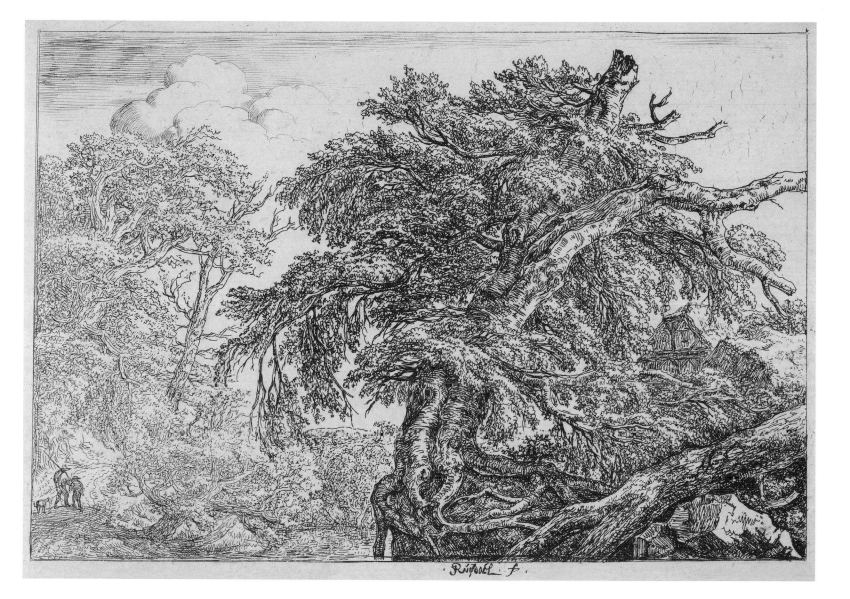

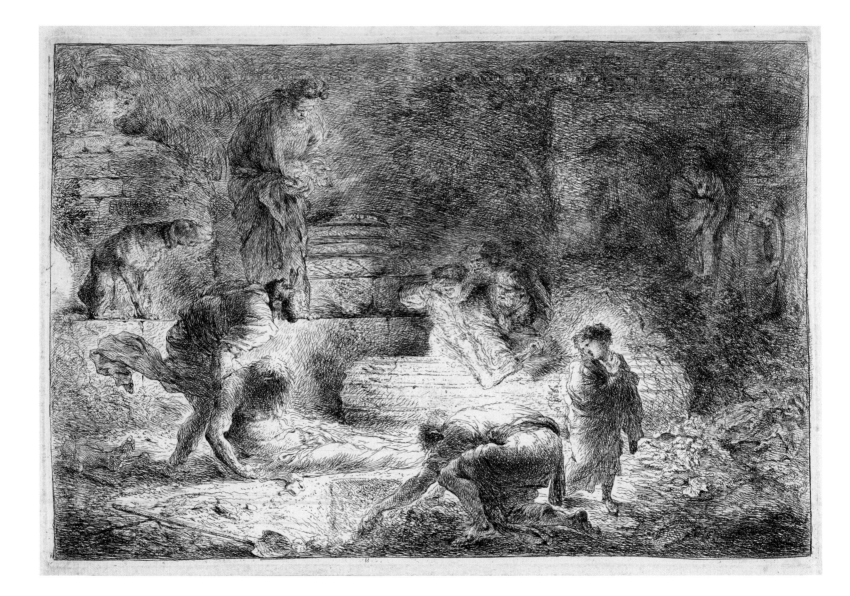

Giovanni Benedetto Castiglione

Italian, 1609 or earlier–1664

Tobit Burying the Dead, c. 1650

Etching
8 ⅟₁₆ x 11 ⅞ in. (205:302 mm)
References: Percy E20
Provenance: William M. Ladd
Gift of Herschel V. Jones, 1916 (P. 444)

Giovanni Benedetto Castiglione was a highly original artist whose dazzling draftsmanship and technical skill are among the great achievements of Baroque art. Inspired by the strong chiaroscuro and freedom of line he encountered in Rembrandt's etchings, Castiglione built his narratives from an accumulation of febrile marks. Through assorted squiggles, scallops, curves, hatches, flecks, and crisscrosses, he created an environment full of mood and mystery.

The Genoese artist etched *Tobit Burying the Dead*—along with two other nocturnal scenes in the museum's collection, *The Raising of Lazarus* and *The Bodies of Saints Peter and Paul Hidden in the Catacombs* (fig. 50a)—while living in Rome around 1647–51.[1] In each print Castiglione challenged himself with illuminating a sepulchral scene solely with

torchlight. In the Tobit story, which originates in an apocryphal book of the Old Testament, Tobit was exiled to Nineveh when the Assyrians entered the Kingdom of Israel. Determined to keep Jewish law even in hardship, Tobit continued to aid and comfort those around him, even helping by burying the dead.[2] Castiglione's emphasis on the onlookers' emotional responses—the man covering his face with his hand, the horrified woman turning away but unable to resist another glance—involves us in the clandestine drama. The feet visible on the left edge of the print signal that there is more to come.

The dead man's slumped body resembles the way Christ is commonly depicted in pictures of the entombment, suggesting a parallel between the two. Both the torch and the figures' stares direct our attention toward the fallen body in a dramatic reminder of Christ's suffering. Working in Italy during the Counter-Reformation, Castiglione guided his viewers to rediscover their devotion to God. The broken pillar and statuary, symbols of a decayed civilization, underscore the transience of life.

M.J.K.

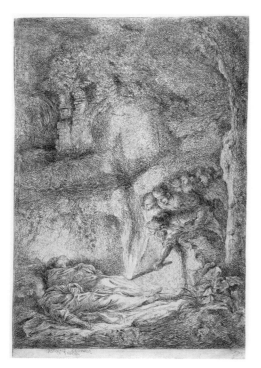

Figure 50a
Giovanni Benedetto Castiglione,
The Bodies of Saints Peter and Paul Hidden in the Catacombs,
c. 1650, etching,
11 ⁵⁄₁₆ x 7 ¹⁵⁄₁₆ in.
(287:202 mm),
P. 446

Notes
1. Ann Percy, *Giovanni Benedetto Castiglione: Master Draughtsman of the Italian Baroque* (Philadelphia: Philadelphia Museum of Art, 1971), 21, 34.
2. Julius S. Held, *Rembrandt and the Book of Tobit* (Northampton, Mass.: Gehenna Press, 1964), 7.

Salvator Rosa

Italian, 1615–1673

The Dream of Aeneas, c. 1663–64

Etching
13⅞ x 9³⁄₁₆ in. (345:237 mm)
Watermark: Fleur-de-lis in a circle
References: Bartsch 23; Rotili 108
Provenance: G. J. Morant (L. 1823); William M. Ladd
Gift of Herschel V. Jones, 1916 (P. 466)

Some say that Salvator Rosa's major creation may have been his own turbulent personality. The intractable Neapolitan was exceedingly conscious of fashioning his artistic persona, and he resisted having his "extravagant genius" caged in by traditional commissions.[1] Instead he preferred to work from his own inspiration. Eager to escape the label of landscape artist, an early specialty that he felt too easily appealed to the popular taste, Rosa worked hard to promote his abilities as a figure painter, which is to say a painter of serious narratives. He even appears to have created figure etchings specifically to advertise the kind of subjects he could paint.[2]

The Dream of Aeneas is drawn from the eighth book of Virgil's *Aeneid*, in which the warrior Aeneas, in Italy at last, falls asleep on the riverbank. The river god Tiber appears, his hair covered with reeds, to give Aeneas advice and predict that he will find lasting peace. Working in the tradition of the Roman Baroque, Rosa made repeated use of diagonals, which add an impassioned energy to his oneiric scene—note the angle of Tiber's gesturing arm and his flowing drapery. Also an actor and satiric playwright, Rosa seems to have taken special delight in rendering the shield, with its theatrical Gorgon's head.

The artist's rebellion and frustrated fervor often put him at odds with society, and he spoke more than once of his longing for a solitary existence of the kind expressed in this print.[3] The melodrama in his life and art would later make him a favorite of eighteenth- and nineteenth-century English romantics.

M.J.K.

Notes
1. Marjorie B. Cohn, *A Noble Collection: The Spencer Albums of Old Master Prints* (Cambridge: Fogg Art Museum, Harvard University Art Museums, 1992), 219.
2. Richard W. Wallace, *Salvator Rosa in America* (Wellesley, Mass.: Wellesley College Museum, Jewett Arts Center, 1979), 40.
3. Ibid., 21.

VEDUTA DELL'ANFITEATRO FLA-
VIO DETTO IL COLOSSEO
A. Massiccio i Gradi, e le Sostruzioni B. che reggeva-
no i detti Gradi.
C. Manca la Volta, sopra cui vi era il Podio, ove or-
dinavano i Consoli, il Senate, i Sacerdoti, e le Vergi-
ni Vestali, le quali stavano dirimpetto al Pretorio.
D. Sedeva l'Ordine Equestre.
E. Manica la Loggia, e Pulvinare per l'Imd. e sua Cob.
Y. Gradi, il Devi sormon a l'Imp. Tito Dalle sue Terme.

G. I Soldati Pretoriani stavano qui Seguiti e nei passaggi.
H. Saliva la Gioventù nobile co' loro Pedagoghi, ed al-
tri attinenti ai Collegi e Persone N. range.
K. Salivano le Donne.
L. Scali per salir sopra a legar i Canapi per situar
la Tenda.
M. Cappellette, o Croce nel mezzo, e Chiesa moderna.
N. Manca la Circonferenza esterna.
O. Avanzi Pi Stucchi lavorati, e grottesco.

Cav. Piranesi F.

Giovanni Battista Piranesi
Italian, 1720–1778

View of Flavian Amphitheater, called the *Colosseum*, 1776
From *Views of Rome*, c. 1746–78

Etching and engraving
19 ⅜ x 27 ⅝ in. (494:702 mm)
References: Hind 126 i/iv; Wilton-Ely 259
Provenance: William M. Ladd
Gift of Herschel V. Jones, 1916 (P. 493)

Giovanni Battista Piranesi was passionate about Rome's ancient past, driven to glorify the city in hundreds of etchings throughout his career. Trained as an architect, he believed that Rome's greatness lay in its buildings and monuments, and he expressed that conviction with an etching needle. Among his most famous series is *Views of Rome*, 135 ambitious, large-scale etchings completed over a thirty-year span. He etched Rome's ancient and modern sights: fountains, bridges, arches, palaces, churches, tombs, and, at least four times, the Colosseum. It was Piranesi's hope that his views of Roman antiquity would help counter the growing evidence during the eighteenth century that Greece may in fact have been the superior civilization.

The dramatic angle Piranesi chose for this work would have strongly appealed to the tourists whom he counted on to buy his *Views*. These prints were his "bread-and-butter" project, which he sold by subscription or in single sheets to travelers stopping in Rome on the Grand Tour.[1] For an artist in love with ruins, the Colosseum was perhaps the quintessential Roman ruin. In it, many of Piranesi's past experiences seem to converge: his father's training as a stonemason, his

uncle's job in the Venetian waterworks (the Colosseum, also called the Flavian Amphitheater, used to be flooded for staging sea battles), and the artist's probable contact with Venetian stage designers. To emphasize the structure's monumental scale, Piranesi sprinkled the interior and perimeter with tiny figures and lit it sharply from the left. At the center, though difficult to decipher because it is angled so severely, is a crucifix, a reference to earlier Christian uses of the space.

Although Piranesi's projects existed almost exclusively on paper, he did work on at least one actual building, the reconstruction of Santa Maria del Priorato in Rome in the 1760s. Pope Clement XIII knighted him for his efforts, which is why this plate is signed *Cavalier Piranesi F.*[2]
M.J.K.

Notes
1. Malcolm Campbell et al., *Piranesi: Rome Recorded: A Complete Edition of Giovanni Battista Piranesi's "Vedute di Roma" from the Collection of the Arthur Ross Foundation* (London: Royal Institute of British Architects, 1991), 9.
2. A. Hyatt Mayor, *Giovanni Battista Piranesi* (New York: H. Bittner & Co., 1952), 17–19.

Valentine Green

English, 1739–1813

The Air Pump, 1769
After Joseph Wright of Derby

Mezzotint
18½ x 23 in. (472:586 mm)
References: Whitman 167 iii/iii
Provenance: William M. Ladd
Gift of Herschel V. Jones, 1916 (P. 3,391)

Mezzotint enabled artists to render delicate gradations of light and shadow, a quality ideally suited to reproducing oil paintings. In the eighteenth century, artists could earn a living by making engraved versions of significant paintings, and mezzotint was the best means available for accurately capturing the fine shades and rich textures of oil on canvas.[1] Valentine Green was a gifted mezzotinter who created his first print in 1767, only two years before executing this remarkable work. His prints are notable for their soft, velvety quality and their refined detail. Such technical excellence earned him the appointment of mezzotint engraver to King George III in 1773, and the following year Green was elected one of six associate engravers of the Royal Academy.[2]

Mezzotint was used primarily to translate portrait paintings into prints, but *The Air Pump* represents another type of popular subject—the candlelit scene. Joseph Wright of Derby popularized this type of painting, and Green effectively rendered the suggestive lighting and dramatic chiaroscuro of Wright's work. In the center of a room illuminated by a lone candle, a family watches a philosopher's experiment with an air pump. The woman and young girl on the right cannot bear to look at the parrot that has fallen to the bottom of the glass container due to the exhaust; the man next to them meanwhile points out the bird's revival. Wright was known to have provided scaled-down, monochromatic oil sketches for engravers, but in the case of *The Air Pump*, Green is credited as being both the copyist and the engraver.[3] The print's tonal variety—from deepest black to pristine white—reveals his mastery of the medium and shows why he was such a popular printmaker in his day.

Mezzotint is an extremely labor-intensive medium that results in relatively few impressions due to the delicacy of the printing plates. Although it produces a dazzling range of blacks, whites, and grays, it fell out of favor in the second half of the nineteenth century with the advent of new printing processes, especially photography. Photo-generated reproductions freed publishers from having to pay the engraver and had the advantage, of course, of unlimited duplication.[4]
L. D. M.

Notes
1. Jane Bayard, *Darkness into Light: The Early Mezzotint* (New Haven: Yale University Art Gallery, 1976), 1.
2. Alfred Whitman, *British Mezzotinters: Valentine Green* (London: A. H. Bullen, 1902), 4.
3. Carol Wax, *The Mezzotint: History and Technique* (New York: Harry N. Abrams, 1990), 56.
4. Ibid., 138–39.

Joseph Wright pinxit.

J. Boydell excudit 1769.

Valentine Green del & fecit.

A PHILOSOPHER SHEWING AN EXPERIMENT ON THE AIR PUMP.

From the Original Picture Painted by Mr. Joseph Wright.

Published June 24, 1769.

LOUIS SEIZE

ROI DES FRANÇAIS, RESTAURATEUR DE LA LIBERTÉ.

PRÉSENTÉ AU ROI et à L'ASSEMBLÉE NATIONALE. Par l'Auteur.

Charles-Clément Bervic

French, 1756–1822

Louis XVI, 1790

After Antoine-François Callet

Engraving and etching
27⅜ x 20⅞ in. (702:530 mm)
References: Portalis/Béraldi 11 iv/v
Provenance: Frederick Keppel; William M. Ladd
Gift of Herschel V. Jones, 1916 (P.1,750)

As king of France from 1774 to 1792, Louis XVI presided over the sumptuous quarters and gardens at Versailles and married the extravagant Marie Antoinette. In Charles-Clément Bervic's print, Louis is labeled "Restorer of Liberty," a theme repeated in the balanced scales of justice seen in the background relief. The king's reign only served to foment misery and discontent among the French people, however, as evidenced by the Revolution of 1789–92. Unfortunately for Bervic, this print appeared shortly before Louis XVI was found guilty of treason and guillotined.

Bervic worked slowly on very large plates, producing only fifteen engravings in the course of a career spanning fifty years. This portrait, finished in 1790, shows Louis as a proud and powerful leader. He is portrayed draped in a lavish cloak lined with ermine and patterned with fleurs-de-lis, the symbol of the French monarchy. Official portraiture in the eighteenth century was dominated by the *portrait d'apparat*, in which the sitter's opulent attire and paraphernalia of office were as important as the actual personage.[1] Bervic proved himself to be a meticulous and exacting engraver in the way he skillfully duplicated the textures and tonalities of the royal setting.

This impression of *Louis XVI* is a rare early state before the plate was broken under mysterious circumstances. Some believe that Bervic was carried away by revolutionary fervor and broke the plate in two with his own hands before it was published and that he also tore in half all the proofs still in his possession. Others believe that he was surprised in his atelier by agents of the Assembly before he could hide his plate and that it was the agents who caused the damage.[2] After the revolution the plate was patched together, and a new edition was printed with a white bar running across the middle.
L. D. M.

Notes

1. Richard Campbell, "The Portrait Print: Traditions and Transformations," in *Regency to Empire: French Printmaking, 1715–1814*, organized by Victor I. Carlson and John W. Ittmann (Baltimore: Baltimore Museum of Art; Minneapolis: Minneapolis Institute of Arts, 1984), 30.
2. T. H. Thomas, *French Portrait Engraving of the Seventeenth and Eighteenth Centuries* (London: G. Bell & Sons, 1910), 128.

Thomas Gainsborough

British, 1727–1788

Wooded Landscape with Cows at a Watering Place, Figures and Cottage, c. 1785

Aquatint printed in brown
7 ⅛ x 9 ⁷⁄₁₆ in. (181:240 mm)
References: Hayes 17 (only known impression)
Provenance: William Esdaile, 1833 (L. 2617); William M. Ladd
Gift of Herschel V. Jones, 1916 (P.3,564)

Aquatint was a relatively new invention in the 1770s, when Thomas Gainsborough made his first attempts with this tonal printing method. Jean-Baptiste le Prince claimed to have discovered the technique in 1768, but others, including Alexandre Charpentier and the Abbé de Saint-Non, conducted important early experiments with it.[1] Gainsborough was a popular and well-respected landscape and portrait painter known for his adventurous approach to both oil and works on paper. He used any tool at his disposal, including household implements and, in one case, a set of tea tongs to hold his lump of whiting.[2] The same spirit was evident in his groundbreaking approach to aquatint.

Wooded Landscape with Cows at a Watering Place, Figures and Cottage is a confident work from the mid-1780s, when the artist created many of his best aquatints. His graphic works all focus on the scenery and vistas of his native East Suffolk; *Wooded Landscape*, with its charming pastoral scene, is no exception. Gainsborough's use of the sugar-lift process allowed for a painterly effect, particularly effective in the subtle tonal variations in the rolling hills and expressive sky. He captured the brilliant reflection of light on the pond, trees, and ground cover with an inspired use of stopping out. To add a bit of textural variety, he utilized the roulette to make miniscule dots in the weeds surrounding the lower edge of the pond.

The Institute's sheet is the only known impression of this aquatint, which Gainsborough chose to print in warm brown ink. It is doubtful that the artist owned his own printing press, and where he worked is still a mystery.[3] Because so few impressions were pulled from his plates, it is assumed that he used a friend's equipment, quite possibly that of Paul Sandby, who was also making sugar-lift aquatints at about this time.[4] The rarity of good examples of Gainsborough's historic investigations into aquatint makes this gentle landscape one of the treasures of the museum's collection.

L. D. M.

Notes
1. For an early history of the medium, see Antony Griffiths, "Notes on Early Aquatint in England and France," *Print Quarterly* 4 (September 1987): 255–70.
2. John Hayes, *Gainsborough as Printmaker* (New Haven: Yale University Press, 1972), 1.
3. Ibid., 24.
4. Griffiths, "Notes on Early Aquatint," 263–64.

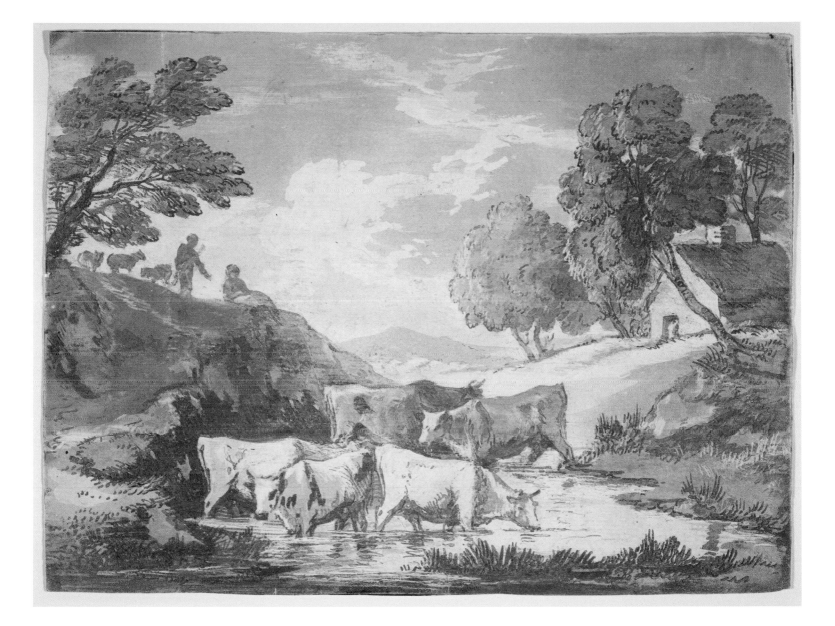

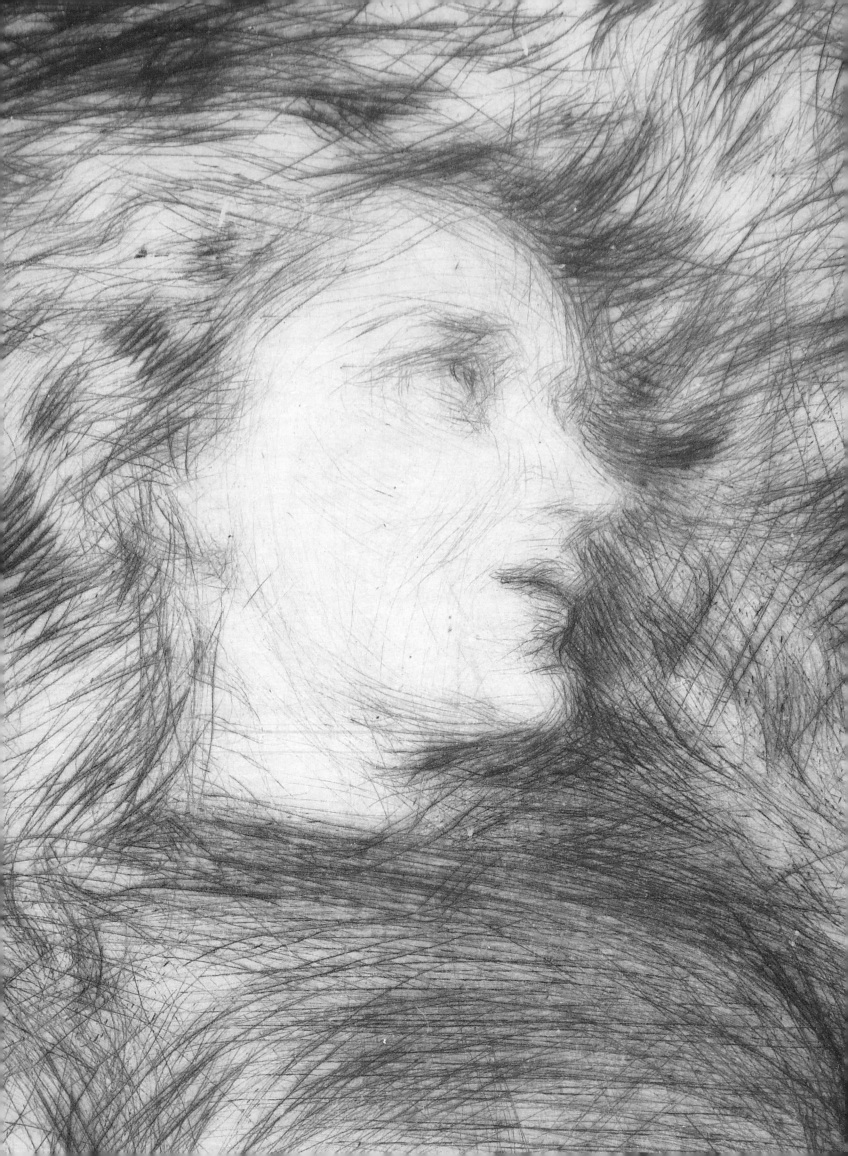

Printmaking in the Modern Era

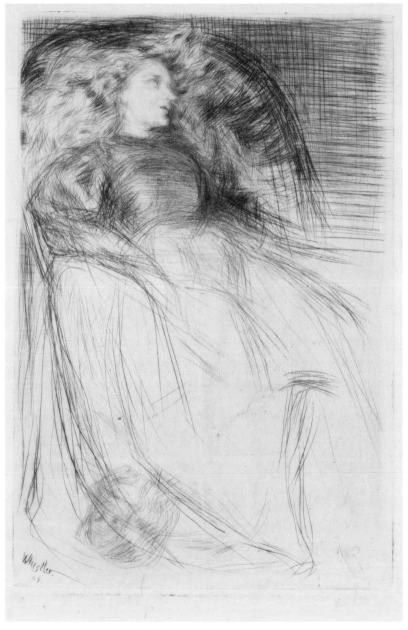

James McNeill Whistler, *Weary,* 1863, etching and drypoint, 7¾ x 5⅛ in. (197:130 mm), P. 4,559

Charles-Emile Jacque

French, 1813–1894

The Mill, 1848

Drypoint with roulette and plate tone on chine collé
4 $\frac{7}{16}$ x 3 $\frac{15}{16}$ in. (113:100 mm)
References: Guiffrey 266
Provenance: William M. Ladd
Gift of Herschel V. Jones, 1916 (P. 2,492)

Charles-Emile Jacque was one of the pioneers of the nineteenth-century etching revival. He not only encouraged his contemporaries to work in the medium, but he also invigorated the movement by resurrecting forgotten processes.[1] He created nearly 500 etchings and lithographs over his sixty-year career, gaining renown for his images of swine and poultry. Known as the "Raphael of pigs,"[2] he also raised chickens for profit and wrote a book on indigenous and exotic poultry.[3] Jacque's base of operation was the small village of Barbizon, thirty miles southeast of Paris, on the edge of the Fountainebleau Forest. He and fellow Barbizon artists rejected academic tradition and introduced a new way of examining nature by recording seasonal and atmospheric effects and by working directly in front of their subjects. As this print demonstrates, the majority of Jacque's etching plates were small enough to fit into his pocket, so he could carry them easily while working outside.

Of the nearly 250 Jacque prints that William M. Ladd owned, The Mill is one of the few without farm animals, showing just a lonely miller walking the land. The small, evocative drypoint has a palpable richness, an effect helped along by the thin sheet of China paper that Jacque placed on a larger sheet just before printing. The China paper takes a drypoint image more easily than a thicker sheet and gives a richer impression. By intentionally leaving a thin veil of ink, or plate tone, on the surface of the plate, Jacque was able to add delicate areas of tone without scratching additional lines. The only part of the plate that he wiped clean is the lantern that lights the miller's way. We know that Jacque studied Rembrandt's prints, and The Mill recalls the master's expert combining of drypoint and plate tone.[4] Jacque's use of bygone techniques was not wasted on his contemporaries, and his influence is apparent in such works as James McNeill Whistler's Nocturne: Palaces (cat. no. 62).

L. D. M.

Notes
1. Gladys Engel Lang and Kurt Lang, Etched in Memory: The Building and Survival of Artistic Reputation (Chapel Hill: University of North Carolina Press, 1990), 24–25.
2. Robert J. Wickendon, "Charles Jacque," Print Collector's Quarterly 2 (1912): 87.
3. Jacque's book Le poulailler: Monographie des poules indigènes et exotiques was published in 1858; see Gabriel P. Weisberg, Millet and His Barbizon Contemporaries (Tokyo: Art Life, 1985), unpaginated.
4. Alison McQueen, The Rise of the Cult of Rembrandt: Reinventing an Old Master in Nineteenth-Century France (Amsterdam: Amsterdam University Press, 2003), 208–9.

Félix Bracquemond

French, 1833–1914

The Upper Part of a Door Panel, 1852–65

Etching
12 x 15 ½ in. (305:400 mm)
References: Béraldi 110 v/v; Bouillon Ac1
Provenance: William M. Ladd
Gift of Herschel V. Jones, 1916 (P.1,809)

The Upper Part of a Door Panel brought Félix Bracquemond his first critical attention as a graphic artist when it appeared at the Universal Exposition in Paris in 1855. It was considered daring for its realism, clarity, unprepossessing subject manner, and large size.[1] The etching depicts a group of dead winged creatures—crow, horned owl, small bat, and sparrow hawk—nailed to a door panel. The legend tacked to the lower edge of the door reads:

> Here you see sadly suspended
> Birds predatory and lustful . . .
> For their equals it is to learn
> That flying and plundering are different . . .[2]

The words seem to suggest that the artist wanted to impart a lesson related to the predators around us as well as to those taking flight.[3] We know from his numerous pen and ink studies (fig. 57a) that Bracquemond took great care to observe his subjects and describe them accurately. Because the legend was not added until the fourth state, scholars believe that the work is as much a naturalistic study as a moral lesson.

Bracquemond was instrumental to the etching renaissance in France. He was a member and ardent supporter of the Société des Aquafortistes, which sought to encourage the creation, sale, and dissemination of original etchings. From 1862 to 1867 he organized and consulted on the 300 etchings that the group published.[4] In 1865 the Société reprinted *The Upper Part of a Door Panel* in one of its albums.

Despite the technical clarity and naturalistic precision of his etchings, Bracquemond's most important contribution to the graphic arts may have been his discovery of Katsushika Hokusai's *Manga* (Sketches) at Auguste Delâtre's print studio in 1856. The Japanese woodblock prints had been used as packing material in a shipment of porcelain.[5] Bracquemond became a devoted collector and advocate of Japanese art and worked to bring its aesthetic to the attention of other artists and critics working in Paris in the 1860s.
L. D. M.

Notes
1. Michel Melot, *The Impressionist Print*, trans. Caroline Beamish (New Haven: Yale University Press), 29.
2. Translated in Jean-Paul Bouillon, *Félix Bracquemond: Le réalisme absolu: Oeuvre gravé, 1849–1859: Catalogue raisonné* (Geneva: Editions d'Art Albert Skira, 1987), 76.
3. Robert H. Getscher, *Félix Bracquemond and the Etching Process* (Wooster, Ohio: College of Wooster, 1974), 22.
4. Melot, *Impressionist Print*, 49.
5. Colta Feller Ives, *The Great Wave: The Influence of Japanese Woodcuts on French Prints* (New York: Metropolitan Museum of Art, 1974), 12.

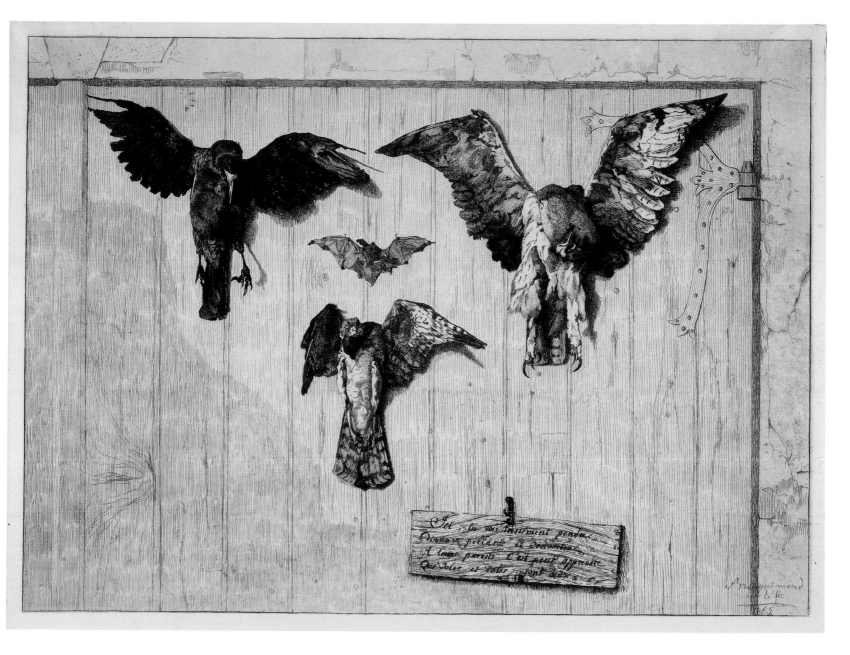

Figure 57a **Félix Bracquemond**, *Bird*, 1852, brown ink, 6⅜ x 6¹³⁄₁₆ in. (162:173 mm), John DeLaittre Memorial Collection, gift of funds from Mrs. Horace Ropes, 23.50.5

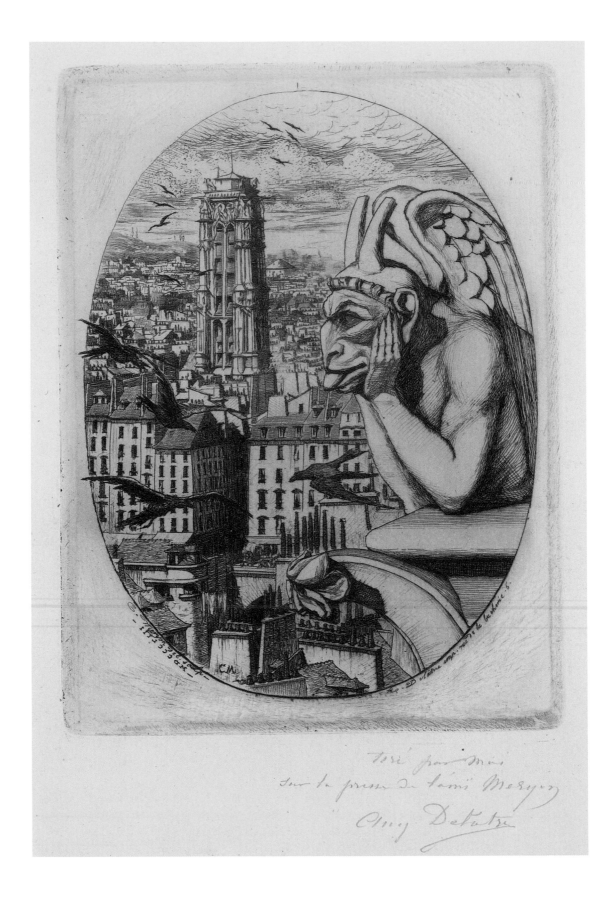

tiré par moi
sur la presse de Charles Meryon
Chez Delâtre

Charles Meryon

French, 1821–1868

The Vampire, 1853
From *Etchings of Paris*, 1850–54

Etching printed in brown with plate tone
6 13/16 x 5 1/8 in. (173:130 mm)
Watermark: C&W Comp
References: Delteil 23 v/viii
Provenance: William M. Ladd
Gift of Herschel V. Jones, 1916 (P. 3,007)

In the 1850s Paris swelled with new arrivals from the countryside, and the streets were crowded and dangerous. The neighborhood of Ile de la Cité, now fashionable, was a dark and decaying ghetto with sewage seeping into the streets and the River Seine.[1] Soon after becoming France's new emperor in 1852, Louis-Napoléon chose Baron Georges-Eugène Haussmann to modernize Paris and make it the cultural center of both the country and all of Europe. Haussmann demolished the tenements; created new sewage and water systems; built more than 4,000 acres of parks, gardens, and squares; and oversaw vast building projects.[2] In his suite *Etchings of Paris*, Charles Meryon captured the medieval spirit of the city being forever altered by Haussmann's crusade.

The Vampire gives us a bird's-eye view of Paris from the second-level gallery of the Cathedral of Notre-Dame. From his elevated perch, a creature the artist referred to as an "insatiable Vampire" surveys the city, lusting after its blood.[3] For Meryon, this monstrous figure symbolized stupidity, cruelty, lust, and hypocrisy.[4] Interestingly, the gargoyle was not an original feature of the building but a sculpture added by architect Eugène-Emmanuel Viollet-le-Duc during a twenty-year restoration of the cathedral begun in 1844.

Although this etching appears at first glance to be a precise rendition of a vanishing area of old Paris, it is in fact a deeply personal interpretation in which Meryon rearranged and accentuated certain monuments to suit his artistic needs. Figuring prominently in the background is the refurbished square steeple of the tower of Saint-Jacques. Meryon relocated the tower closer to Notre-Dame and increased its size and significance.[5] At the same time, he imbued the scene with a sense of mystery and foreboding: this is not the "city of light," but a place where ominous black birds hover over shadowy streets and darkened buildings.

Meryon's perception of Paris was clouded by a severe mental illness that eventually took his life. Sadly, he declined just as his etchings were receiving serious attention and favorable reviews. He was one of the first artists to devote his entire career to printmaking and is a forerunner of the etching renaissance of the 1860s. Many view Meryon as one of the most important etchers since Rembrandt because of his mastery of the craft and his singular artistic vision. L.D.M.

Notes
1. William U. Eiland, "Reflections on a Gilded City: The Paris of Napoleon III, Meryon, and Millet," in *Charles Meryon and Jean-François Millet: Etchings of Urban and Rural Nineteenth-Century France*, ed. Patricia Phagan (Athens: Georgia Museum of Art, University of Georgia, 1993), 14.
2. Ibid., 15.
3. Meryon included an inscription on earlier states of *The Vampire* that was removed for the final state. For an accounting of the various translations of this inscription, see ibid., 38.
4. Frederick Wedmore, *Méryon and Méryon's Paris* (London: Deprez & Gutekunst, 1892), 44–45.
5. Phillip Dennis Cate, "Meryon's Paris," *Print Collector's Newsletter* 2 (September–October 1971): 77–78.

Charles-François Daubigny

French, 1817–1878

The Hydraulic Engine, 1862

Cliché-verre
8 ¼ x 13 ⅞ in. (209:342 mm)
References: Delteil 147 (inverse proof)
Provenance: William M. Ladd
Gift of Herschel V. Jones, 1916 (P. 2,111)

In essence, a cliché-verre is a photograph made from a hand-drawn negative. The process was invented in 1839 and enjoyed a brief period of popularity among the Barbizon artists before falling into near obscurity.[1] The technique did not involve a printing press, chemical baths, or engraving skill, yet few artists embraced the medium. To create a cliché-verre, the artist scratches a design with an etching needle or other sharp instrument on a piece of glass that has been covered with a ground. The glass plate is then placed facedown on a piece of light-sensitive paper, and the ensemble is exposed to the sun. Light passing through the exposed areas of the glass causes black lines to appear on the sensitized paper. Because no ink is impressed on the paper, clichés-verre are characteristically flat and textureless, as opposed to the deep grooves and velvety richness of an etching or drypoint.

Charles-François Daubigny created eighteen clichés-verre in a relatively short period of time in 1862. He approached them with the same love of experimentation and variation as he did his etchings.[2] He used a variety of effects to alter his clichés-verre and often printed each plate in a number of ways. *The Hydraulic Engine* is a rare inverse print in which Daubigny flipped the glass plate to produce a mirror image of the way he had normally printed this scene. In doing so, he caused the light to travel through an extra layer of glass, resulting in an image that is not as sharp or clear as those printed in the standard manner, with the glass facedown. It is doubtful that Daubigny worked directly from nature because the prepared glass plates were fragile and could not take much handling.[3] In *The Hydraulic Engine*, however, he was able to capture the variant effects of the sun. In the far distance, the hydraulic engine is barely visible, sketched in with only a few lines to replicate the way bright sunlight causes a shiny object to flicker and disappear.

Partly because clichés-verre could not be neatly classified as either prints or photographs, they never became popular with nineteenth-century collectors. Even so, important scholars such as William M. Ivins Jr. believed that the clichés-verre of this era were "some of the most thoroughly original and indubitably artistic prints of the century."[4] In 1921 thirty-six plates by Jean-Baptiste-Camille Corot, Jean-François Millet, Pierre-Etienne-Théodore Rousseau, Eugène Delacroix, and Daubigny were discovered and reprinted to bring the works to a wider audience.[5] That William M. Ladd acquired an example each by Corot and Millet as well as four clichés-verre by Daubigny before this portfolio came to light is a testament to his insight as a collector.

L. D. M.

Notes

1. Elizabeth Glassman, "Cliché-verre in the Nineteenth Century," in *Cliché-verre: Hand-Drawn, Light-Printed: A Survey of the Medium from 1839 to the Present* (Detroit: Detroit Institute of Arts, 1980), 29–30.
2. Ibid., 40–41.
3. *Daubigny, Corot, and the Cliché-verre* (Johannesburg: Johannesburg Art Gallery, 1978), 4.
4. William M. Ivins Jr., *Prints and Visual Communication*, 2nd ed. (Cambridge: MIT Press, 1968), 114–15.
5. Maurice Le Garrec issued the portfolio *Quarante clichés-glace* in 1921; see Brenda D. Rix, *The Clichés-verre of the Barbizon School* (Toronto: Art Gallery of Ontario, 1983), 3.

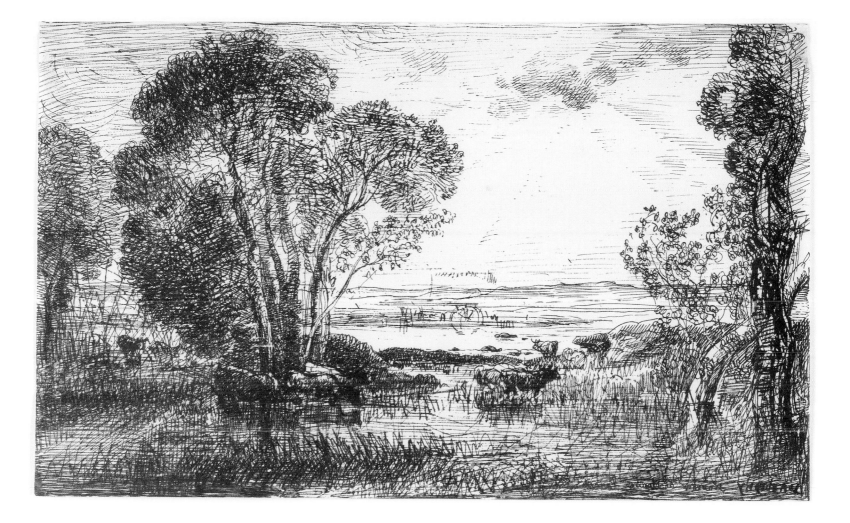

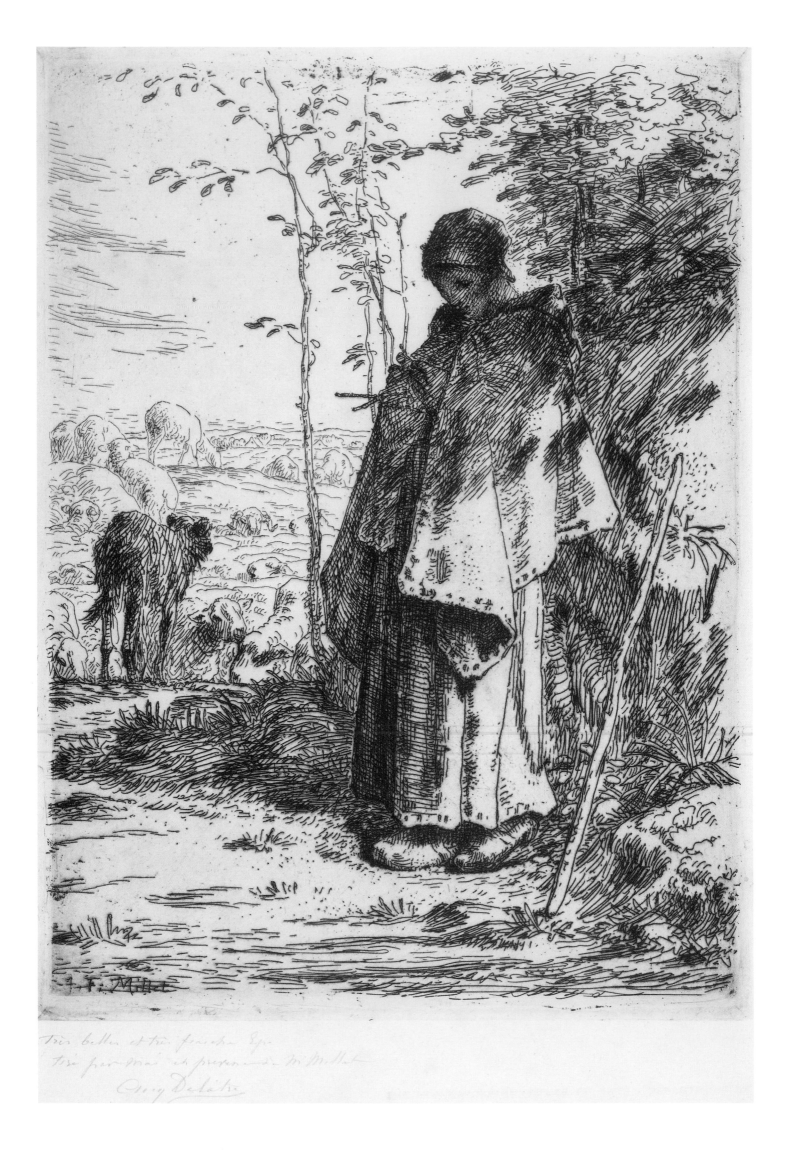

J. F. Millet

Jean-François Millet

French, 1814–1875

The Shepherdess Knitting (La Grande Bergère), 1862

Etching
12⅜ x 9⅛ in. (319:232 mm)
References: Delteil 18
Provenance: Frederick Keppel; William M. Ladd
Gift of Herschel V. Jones, 1916 (P. 3,048)

Born of peasant stock, Jean-François Millet liked watching workers tend the small flocks of sheep that grazed near his home in rural Barbizon. Millet scholar Alexandra R. Murphy contrasts the shepherdess serenely absorbed in her knitting with the flighty or helpless "barefoot shepherdess" that had been in vogue in French imagery.[1] Working in the Barbizon countryside, where he had settled in 1849 with his friend Charles-Emile Jacque (cat. no. 56) to escape the political unease and cholera then prevalent in nearby Paris, Millet built an oeuvre around the daily existence of French peasants, shunning the elevated subjects of the academy. He sketched figures churning butter, sowing seeds, shearing sheep, spinning wool, watering cows, gathering wood, gleaning stray stalks of wheat, and much more. Sometimes his heroines are knitting to fill the time—an activity that Millet, who had six daughters, probably knew well.

Millet's realistic, ennobling treatment of such rustic scenes upset the critics, who believed that paintings of common laborers had no place in Salon exhibitions.[2] The late 1850s were a particularly trying time, and in 1855 Millet followed Jacque's lead and took up etching as a new, faster way to earn money.[3] The shepherdess was a favorite motif, one that Millet explored in paintings, pastels, and drawings. In *The Shepherdess Knitting*, he dignifies his subject by placing her monumental form prominently before us, enveloped in a contemplative mood heightened by strong shadows. In her darkened face we are asked to read the "expressions of a heroic mind and soul."[4] The Jones impression of this etching, also called *La Grande Bergère* because of its large size, is a superior print inscribed by the esteemed Parisian printer Auguste Delâtre, a seminal figure in the etching renaissance.
M.J.K.

Notes
1. Alexandra R. Murphy et al., *Jean-François Millet: Drawn into the Light* (Williamstown, Mass.: Sterling and Francine Clark Art Institute; New Haven: Yale University Press, 1999), 54.
2. Ibid., 11, 15–16.
3. Alexandra R. Murphy, *Jean-François Millet* (Boston: Museum of Fine Arts, 1984), 97.
4. S. William Pelletier, "Charles Meryon and Jean-François Millet: Two French Printmakers of the Second Empire," in *Charles Meryon and Jean-François Millet: Etchings of Urban and Rural Nineteenth-Century France*, ed. Patricia Phagan (Athens: Georgia Museum of Art, University of Georgia, 1993), 51.

Samuel Palmer

English, 1805–1881

The Lonely Tower, 1879

Etching
7 ⅝ x 10 ¹⁄₁₆ in. (194:256 mm)
References: Lister E12 vi/vii
Provenance: Frederick Keppel; William Kingston Vickery;
 William M. Ladd
Gift of Herschel V. Jones, 1916 (P. 4,194)

Samuel Palmer's poetically infused etchings are rooted in his childhood, when his nurse quoted John Milton to him. At age nineteen Palmer met William Blake, whose wood engravings affected him deeply with their ability to kindle "the inmost soul."[1] It was in an atmosphere of literature, music, and spiritual musings in the English countryside that the youthful Palmer nurtured his vision of nature's profound consonance and mystical perfection, and he tried to recapture this vision later in life when he executed *The Lonely Tower*, one of his finest etchings.

The print, which grew out of a project to illustrate some of Milton's poems, is based on a passage from *Il Penseroso*: "let my Lamp at midnight hour, / Be seen in some high lonely Towr, / Where I may oft out-watch the *Bear*, / With thrice-great *Hermes*." Palmer was in the habit of reading Milton—along with Shakespeare and Keats—under the moon near his cottage in Shoreham, and the moon remained a common symbol in his work. Lit by moonlight and one of the constellations mentioned in Milton's poem, the figures in *The Lonely Tower* yearn to reach the distant tower, some closing in on it, others arrested on the opposite side of a deep chasm.

To achieve the proper depth of feeling, Palmer worked the plate tirelessly and at length, subjecting *The Lonely Tower* to fourteen separate bitings, or soakings in an acid bath, to etch the lines just so. His painstaking approach enabled him to capture, in the words of Richard T. Godfrey, "a last glowing ember of romanticism."[2] Although Palmer was primarily a painter, etching turned out to be ideally suited to his dreamy vision. Still, he completed just thirteen plates in his lifetime. Writing about his etchings inspired by Milton, such as *The Lonely Tower*, the rhapsodic Palmer said he hoped they would live on "when I am with the fallen leaves."[3] M.J.K.

Notes
1. Raymond Lister, *Samuel Palmer: His Life and Art* (Cambridge: Cambridge University Press, 1987), 25.
2. Richard T. Godfrey, *Printmaking in Britain: A General History from Its Beginnings to the Present Day* (New York: New York University Press, 1978), 103.
3. Lister, *Samuel Palmer*, 222.

James McNeill Whistler

American, 1834–1903

Nocturne: Palaces, 1879–80
From *Twenty-six Etchings*, 1886

Etching and drypoint with plate tone
11 ½ x 7 ¾ in. (292:197 mm)
References: Kennedy 202 viii/ix
Provenance: William M. Ladd
Gift of Herschel V. Jones, 1916 (P. 4,584)

The late 1870s were difficult years for James McNeill Whistler. In 1878 the gifted yet flamboyant and outspoken artist sued respected art critic John Ruskin over a review of one of his paintings. Although Whistler won the highly publicized court case, he was awarded only a farthing in damages and was plunged more deeply into debt.[1] As a result of bad press after the trial, his painting commissions dried up, and the artist was forced to declare bankruptcy in 1879. His world falling apart, Whistler jumped at the chance to leave later that year, when the Fine Art Society of London commissioned a set of twelve etchings of Venice. He intended to stay for only a few months but was so inspired by the Venetian atmosphere that he remained for more than a year and completed twelve paintings, nearly 100 pastels, and forty additional etchings, including *Nocturne: Palaces*.

Whistler's experimental approach to the Venice etchings yielded some of the most revolutionary works of his career. His novel artistic printing methods broke new ground, and each impression of *Nocturne: Palaces* evokes a different mood, atmosphere, and quality of light. Traditionally the surface of a plate is wiped clean after ink is forced into the etched lines. Whistler would instead intentionally leave ink on the plate and manipulate it to produce the effect of shadow and tone. Since his wiping varied with each printing, every impression of *Nocturne: Palaces* is unique.[2] The Institute's etching is thick with humidity and shimmering moonlight, with only a scant flicker coming from the lantern between the buildings, while others printed from the same plate shine with reflected light or descend into deep darkness.

With the Venice etchings, Whistler began the practice of signing his prints with a butterfly insignia set in a small tab projecting beyond the trimmed edge of the paper. Whistler authority Katherine A. Lochnan associates the artist's use of the pencil-drawn butterfly and the abbreviation *imp* with inaugurating the tradition of signing impressions by hand, which would become common practice by the end of the nineteenth century.[3] Whistler considered the placement of the tab and signature to be integral to his composition. Trimming the paper was another important aspect of the design; he placed the etching on a sheet of glass and carefully cut along the platemark. He was fiercely proud of his Venice etchings, claiming that his printing methods produced work that "vibrated and was full of color."[4]

L. D. M.

Notes

1. For a complete account of the trial, see Linda Merrill, *A Pot of Paint: Aesthetics on Trial in Whistler versus Ruskin* (Washington, D.C.: Smithsonian Institution Press in collaboration with the Freer Gallery of Art, 1992).

2. Katherine A. Lochnan, *The Etchings of James McNeill Whistler* (New Haven and London: Yale University Press, 1984), 196.

3. Ibid., 213.

4. John Siewert, *Whistler: Prosaic Views, Poetic Vision: Works on Paper from the University of Michigan Museum of Art* (New York: Thames & Hudson, 1994), 91.

Jacques-Joseph Tissot, called James Tissot

French, 1836–1902

A Winter's Walk, 1880

Etching and drypoint printed in black and red
22 ⅛ x 10 ⅜ in. (564:262 mm)
References: Wentworth 48 ii/iii
Provenance: Frederick Keppel; William M. Ladd
Gift of Herschel V. Jones, 1916 (P. 3,320)

The story goes that Jacques-Joseph Tissot changed his name to James as a tribute to his friend James McNeill Whistler, but he no doubt surmised that an anglicized moniker would also help his success in England. Tissot moved to London in 1871 to escape the disastrous effects of the Paris Commune. Thanks to the efforts of Francis Seymour Haden and Whistler, the city had become a hotbed of etching activity.[1] In London, Tissot settled in the stylish neighborhood of St. John's Wood and excelled at recording the elegant society of Victorian England, with all its sumptuous textures and ravishing beauties. His works are more than just decorative reminders of this era, however, because they reveal a keen insight into the underlying psychological drama of its social settings.[2]

Tissot's model for A Winter's Walk was the beautiful Kathleen Newton (1854–1882). He most likely met the young divorcée in 1875 or 1876, and she soon appeared in many of his prints and paintings. She was probably already suffering from tuberculosis when they began their relationship, and by the time this etching was completed in 1880, she was quite ill. Tissot's tender rendering of her sorrowful expression may reflect the couple's knowledge of her impending death. In this print Newton is personified as winter, but the addition of John Keats's couplet—"She will bring in spite of frost / Beauties that the earth hath lost"—seems to suggest that her grace and loveliness could cancel out the bleakness of the season.[3]

Sales of Tissot's etchings were brisk enough to support an opulent lifestyle in London.[4] Like his friend Whistler (cat. no. 62), Tissot added a pencil signature to the impressions he regarded as superior; the Institute's impression is signed and also marked with the artist's red studio stamp in the lower right-hand corner. One of Tissot's largest prints, A Winter's Walk highlights his technical prowess with both etching and drypoint. The rich texture of Newton's fur collar and muff contrasts beautifully with her lace cuff and the snowy pine boughs of the garden in the background.

Newton died of tuberculosis in November 1882, at the age of twenty-eight. Tissot immediately abandoned his life in London and moved back to Paris. He struggled for several years but finally resurrected his career after undergoing a religious conversion in 1886. After turning to biblical themes, he once again found great financial and critical success.

L. D. M.

Notes
1. Haden also lured the master printer Auguste Delâtre to London in 1871. Delâtre trained Frederick Goulding, who would print the majority of Tissot's prints (Michael Justin Wentworth, *James Tissot: Catalogue Raisonné of His Prints* [Minneapolis: Minneapolis Institute of Arts, 1978], 13).
2. *James Tissot, 1836–1902: An Exhibition of Etchings* (London, William Weston Gallery, 1984), unpaginated.
3. Tissot borrowed lines 29 and 30 from Keats's poem "Fancy," written in December 1818 and published in 1820. See Willard E. Misfeldt, *J. J. Tissot: Prints from the Gotlieb Collection* (Alexandria, Va.: Art Services International, 1991), 110.
4. Tissot's income was so high that he was in the top 1 percent of the working population in Britain at the time (ibid., 19).

She will bring in spite of frost
Beauties that the earth hath lost. Keats.

Auguste Rodin

French, 1840–1917

La Ronde, c. 1883/1884

Drypoint printed in green
9 x 7 in. (230:178 mm)
References: Delteil 5 i/iii; Thorson 19 i/iii
Provenance: William M. Ladd
Gift of Herschel V. Jones, 1916 (P. 3,308)

When Auguste Rodin attempted his first drypoint engraving, he had taken a job decorating vases at the Sèvres porcelain factory to earn money so that he could afford to keep making sculpture. The feel of the incising tools at Sèvres seems to have prompted him to experiment with drypoint, for which he felt an immediate affinity.[1] He was guided by Alphonse Legros (fig. 8), an old classmate whom Rodin was visiting in London in 1881 (and an artist well represented in William M. Ladd's collection); Rodin made his earliest drypoint on the back of a copper plate Legros had used.[2]

The sculptor's foray into printmaking, confined largely to the period between 1881 and 1888, yielded twelve spectacularly innovative drypoints. *La Ronde* is exceptional not only because Rodin inked some impressions in green—just the kind of novelty that a collector such as Ladd coveted—but also because few if any artists had depicted a circle of seven dancers who all were nude men.[3] More figures pose on either side, resolutely uninvolved in the romp. Unlike some other Rodin drypoints, this one is not connected with a sculpture, but it is sculptural nonetheless, with its vigorous contours, bold musculature, and three-dimensional modeling.

Brilliantly, Rodin used the medium's blurry quality to heighten the sense of movement, an effect that is especially dramatic in this rich, fresh impression.

Far from the lyrical scenes Rodin was designing at Sèvres, the mood of *La Ronde* is insistently sober, leading scholars to look for themes in Dante's *Divine Comedy*, which had consumed Rodin around the time of this print's inception.[4] Just a few years earlier he had begun his famous sculpture *The Gates of Hell* (1880–c. 1900), with its subtext of unbridled passions. Among other interpretations, the circle of dancers could also allude to the Dance of Death motif so prevalent in the Middle Ages.[5]

M.J.K.

Notes
1. Victoria Thorson, *Rodin Graphics: A Catalogue Raisonné of Drypoints and Book Illustrations* (San Francisco: Fine Arts Museums of San Francisco, 1975), 13.
2. Ibid., 18.
3. Albert Elsen, "Rodin's 'La Ronde,'" *Burlington Magazine* 107 (June 1965): 294, 297.
4. Ibid., 297.
5. Ibid.

65

Félix Buhot

French, 1847–1898

Funeral Procession on the Boulevard de Clichy, 1887

Photomechanical reproduction, etching, aquatint, roulette,
 drypoint, lift ground, soft ground, stop-out, and engraving,
 printed in black and blue
11⅜ x 15⅝ in. (295:398 mm)
References: Bourcard/Goodfriend 159 iii/iii
 (with additional work in drypoint and roulette)
Provenance: William M. Ladd
Gift of Herschel V. Jones, 1916 (P. 1,954)

Félix Buhot's unique working method has led scholars to describe him as a "multi-state" etcher.[1] His prints often evolved through many stages, and he frequently printed single impressions or even small editions each time he altered the plate, changed the ink color or paper type, or devised new ways to modify the outcome of his work. In the case of *Funeral Procession on the Boulevard de Clichy*, Buhot began by making a photomechanical reproduction of one of his drawings. He then added margins and layered multiple intaglio processes—including etching, aquatint, drypoint, and engraving—onto the plate. Each plate was then inked by hand (*à la poupée*), so that every impression displays a different color balance and overall effect.[2] In the end, *Funeral Procession* has more in common with a monotype than with a traditional editioned print.

Buhot lived at 71, boulevard de Clichy in Paris from 1876 to 1889 and was intimately familiar with the scene represented in this print.[3] The verse in the lower left corner indicates that the funeral is for an undertaker's mute, who "used to take pleasure in seeing, against Parisian skies of blue, gray or rose, two or three hearses, silhouetted in black." One of the more inventive aspects of Buhot's work was his use of ancillary images in the margins. He referred to these as "symphonic" when they were evocative or musical in nature and as "anecdotal" when they showed events specific to the main subject.[4] The symphonic margins of *Funeral Procession* have a Japanese flair in the asymmetrical arrangement of swans and flower blossoms.

Shortly after completing this print in 1887, Buhot decided to leave Paris and wrote to New York art dealer Frederick Keppel asking him to purchase his entire studio, including all his proofs and plates. Keppel responded by mounting the first retrospective of Buhot's paintings, prints, and drawings at his gallery the following year.[5] Unfortunately, soon after this successful showing, Buhot fell into a deep depression that severely limited his artistic output. He quit making etchings after 1891, and although he made a few lithographs, mental illness overtook him, and he died in 1898, at age fifty-one.

L. D. M.

Notes
1. Gustave Bourcard, with additions and revisions by James Goodfriend, introduction to *Félix Buhot: Catalogue descriptif de son oeuvre gravé* (New York: Martin Gordon, 1979), unpaginated.
2. For the variety of impressions, see Jay McKean Fisher and Colles Baxter, *Félix Buhot, Peintre-Graveur: Prints, Drawings, and Paintings* (Baltimore: Baltimore Museum of Art, 1983), nos. 85a–e.
3. Ibid., 84.
4. Baxter, "Some Notes on Margins: Format, Sources, Meanings," ibid., 53.
5. Fisher, "Biography and Printmaking Chronology," ibid., 21–22.

Innocent Flaneur, ennemi des Chloroses
Ce croquemort defunt trouvait plaisant de voir
Sur des ciels Parisiens aux tons bleus gris ou roses
Deux ou trois corbillards se detacher en noir
 Felix Buhot 1887

P. 1888.
Ev. VAN MUYDEN.

Salon 1889 1er état de la planche tiré à 5 planche détruite E. van Muyden

Evert van Muyden

Swiss, 1853–1922

Lioness Seated and Three Cubs, 1888

Etching
15 13/16 x 12 3/16 in. (402:310 mm)
References: Curtis 58 i/iii
Provenance: Frederick Keppel; William M. Ladd
Gift of Herschel V. Jones, 1916 (P. 3,087)

Evert van Muyden made his mark as a skillful if some-what romantic interpreter of animals—their movements and habits, even their moods. His favorite subjects were large cats, which he visited often at the zoo at the Jardin des Plantes in Paris.[1] Through steady observation, he gained great insight into their behavior. In *Lioness Seated and Three Cubs*, he portrayed both the sleepy, playful nature of the cubs and the watchful and alert demeanor of the mother. Van Muyden could just as readily depict animals' feral impulses and did not hesitate to show a lioness attacking and devouring her prey.

The artist studied at the Ecole des Beaux-Arts in Paris under Jean-Léon Gérôme but was completely self-taught as an etcher. By 1885 it was his preferred medium. William M. Ladd was a great admirer, acquiring more than 150 of van Muyden's etchings and lithographs and even a few of his drawings. The artist pulled extremely small editions of his prints and promptly destroyed the plates even when demand was high.[2] This version of *Lioness Seated*, for example, is one of only five impressions of the first state. In the more plentiful published edition, van Muyden added more small lionesses

to the upper margin. The lower margin, which depicts a lioness running, seems almost photographic in the way it captures the different poses of a cat in motion.[3]

Except on rare occasions when he was commissioned by friends to represent a specific animal, van Muyden avoided photography to aid his drawing, believing that it would compromise the artistic spirit of his images.[4] He preferred to complete his sketches from life in order to fully capture the animal's true essence.

L. D. M.

Notes
1. Atherton Curtis, *Catalogue of the Etched Work of Evert van Muyden* (New York: Frederick Keppel & Co., 1894), 11.
2. Frederick Keppel, *The Golden Age of Engraving: A Specialist's Story about Fine Prints* (New York: Baker & Taylor Company, 1910), 217.
3. Eadweard Muybridge's photographs of horses in motion were completed in 1874, and he lectured on his discoveries in Paris in 1881. It is not known whether van Muyden saw Muybridge speak or knew of his photographs, but the similarity is provocative.
4. Curtis, *Catalogue*, 11–12.

Francis Seymour Haden

English, 1818–1910

A Likely Place for a Salmon, 1889

Etching and drypoint with black and white chalk additions
4 ³⁄₁₆ x 10 ³⁄₁₆ in. (106:259 mm)
References. Harrington 141 (trial proof a)
Provenance: Francis Seymour Haden (L. 1049);
 William M. Ladd
Gift of Herschel V. Jones, 1916 (P. 3,891)

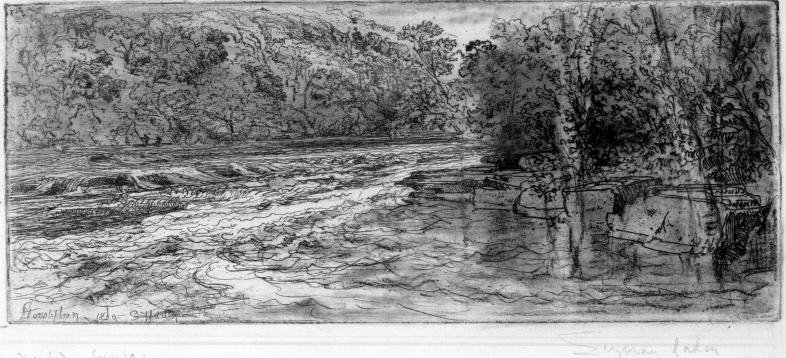

Francis Seymour Haden was not a professional artist but rather a renowned surgeon with a thriving London practice. He took his first classes in drawing and etching while studying medicine at the Sorbonne in Paris to "better train the hand and eye for surgery."[1] Shortly after establishing his medical practice in London, he began collecting etchings and even became something of an authority on Rembrandt van Rijn.[2] Haden had a press installed in his home and started to print his own work. His collections and self-made etchings would have a lasting influence on his brother-in-law James McNeill Whistler (cat. no. 62).

Haden's *Shere Mill Pond* (fig. 3) was the first print purchased by William M. Ladd, and his interest in Haden's work only increased over the years, to the point that he eventually owned more than 260 of the artist's prints. Ladd secured many prize examples, including two different states of *A Likely Place for a Salmon:* an early trial proof and the later published version. The trial proof, which he acquired from the artist's own collection, was a working proof on which Haden had made significant revisions in black and

A Likely Place for a Salmon, 1889

Etching and drypoint
4 3/16 x 10 3/16 in. (106:259 mm)
Watermark: Horn (unidentified)
References: Harrington 141 v/vi
Provenance: William M. Ladd
Gift of Herschel V. Jones, 1916 (P. 3,892)

white chalk. Such notations on proof impressions, which a printmaker will make to check progress of a print, can provide valuable insight into the creative process. In the case of *A Likely Place for a Salmon*, we can see Haden working out issues in the water and shoreline and even the placement of the fisherman on the near bank. Haden was a passionate angler, and thus this subject was near to his heart; he would have had many experiences to draw on when creating this image.[3]

L. D. M.

Notes
1. Katherine A. Lochnan, *The Etchings of James McNeill Whistler* (Toronto: Art Gallery of Ontario, 1984), 4.
2. Haden owned 129 etchings by Rembrandt and wrote *The Etched Work of Rembrandt* (London: Privately printed, 1877), in which the prints were organized according to date, rather than subject matter, and many long-accepted works by the artist were rejected as works by other artists.
3. Frederick Keppel, "Personal Characteristics of Sir Seymour Haden, P.R.E., Part I," *Print Collector's Quarterly* 1, no. 3 (1911): 308.

Henri-Charles Guérard

French, 1846–1897

The Racehorse, after Manet, c. 1888

Etching and aquatint
13 ⅜ x 5 ¹⁵⁄₁₆ in. (340:150 mm)
Watermark: Arches
References: Béraldi 255; Bertin 562
Provenance: Henri-Charles Guérard (L. 1157);
 A. Barrior (L. 76); Vickery, Atkins & Torrey; William M. Ladd
Gift of Herschel V. Jones, 1916 (P. 2,230)

Although unknown to most Americans, Henri-Charles Guérard was one of the most prolific French printmakers of the nineteenth century. In addition to hundreds of book illustrations and reproductive prints, he created nearly 500 original works, the majority of which were never published and remained in his studio for years after his death.[1] Guérard was enthralled by all forms of printmaking and experimented with etching, aquatint, mezzotint, lithography, woodcut, and numerous color processes.

A member of the Parisian avant-garde in the 1870s and 1880s, he was a close associate of the painter Edouard Manet. In fact, Guérard's wife, Eva Gonzalès, whom he married in 1879, was Manet's student. At the end of Manet's life, when he was sick and paralyzed, it was Guérard who printed the elder artist's plates. Sadly, Guérard was dealt a double blow in the spring of 1883, when both Gonzalès and Manet died.[2] Five years later, no doubt still struggling to recover from his loss, he acknowledged his debt to his colleague with *The Racehorse, after Manet.* In this dynamic print, Guérard isolated a single horse from the pack in Manet's lithograph *The Races* (fig. 69a). Manet's revolutionary composition was the first work in the history of art to depict a racing scene with the horses coming directly toward a viewer, who is positioned on the racetrack itself.[3] Guérard adopted a similarly dramatic viewpoint; the horse and rider seem poised to race off the page and into our space.

The tall, narrow format of *The Racehorse* reveals the influence of Japanese prints on Guérard's work. In 1883 he contributed eleven etchings and 220 drawings of Japanese objects for Louis Gonse's important book *L'art japonais.*[4] This project allowed Guérard access to extraordinary collections of Japanese art and established his prominence as a reproductive printmaker capable of accurately recording what he saw.[5] In his own prints, Guérard was highly imaginative and quite playful. His assimilation of the Japanese aesthetic was highly original and can be seen in the daring composition and bold outlines of this work.
L. D. M.

Figure 69a **Edouard Manet,** *The Races,* c. 1869, lithograph, 15 x 20 ⅛ in. (381:511 mm), gift of Bruce B. Dayton, by exchange, P. 86.28

Notes

1. Michel Melot, *The Impressionist Print,* trans. Caroline Beamish (New Haven: Yale University Press, 1996), 120.
2. Gabriel P. Weisberg, *Henri-Charles Guérard (1846–1897): 108 Original Prints* (Chicago: Merrill Chase Galleries, 1981), iv.
3. *Master Prints of Five Centuries: The Alan and Marianne Schwartz Collection* (Detroit: Detroit Institute of Arts, 1990), 170.
4. Marie-Caroline Sainsaulieu, *Henri Guérard (1846–1897)* (Paris: Galerie Antoine Laurentin, 1999), 8.
5. Weisberg, *Henri-Charles Guérard,* vi.

Paul-César Helleu

French, 1859–1927

Woman Looking at Watteau Drawings in the Louvre, c. 1895

Drypoint printed in black and sepia
11¾ x 15¾ in. (298:401 mm)
Watermark: Van Gelder Zonen
References: Montesquiou-Fézensac 56
Provenance: William M. Ladd
Gift of Herschel V. Jones, 1916 (P. 2,260)

Paul-César Helleu epitomized the elegance of fin-de-siècle Paris. He knew many of the leading artists, critics, and writers of the day and in fact was the model for Elstir, the aesthete and painter at the center of Marcel Proust's novel *Remembrance of Things Past*. Elstir and Helleu shared an admiration for the French Rococo artist Jean-Antoine Watteau. Helleu was a serious collector of Watteau's drawings and even made several drypoints in his style.[1] In *Woman Looking at Watteau Drawings in the Louvre*, Helleu paid tribute to his favorite artist by depicting his wife examining his work.

Helleu was in demand as a portraitist, and his clientele included the most important and beautiful society women of the day. Even though he could have had any one of them as his muse, his preferred model throughout his career was his wife. Helleu first met the fourteen-year-old Alice Guérin when he was commissioned to paint her portrait in 1884. The two fell madly in love but were not allowed to marry until she reached age sixteen, and even then they were obliged to spend their first two years of marriage living with her parents.[2] Helleu's happy domestic life with Alice and their children—Ellen, Jean, and Paulette—was a constant source of subject matter.

Helleu exploited every aspect of the drypoint technique. In a drypoint, the artist scratches the line into a copper plate with a sharp tool. The resulting burr, or furrow of metal that is displaced, holds onto the ink to create a soft, dark line when printed. Helleu was encouraged to pursue drypoint by James Tissot (cat. no. 63); in fact, it was Tissot who gave him the diamond-tipped tool that he used to produce his signature strokes.[3] Helleu worked quickly on his plates and was a master at varying the intensity of line. In *Woman Looking at Watteau Drawings in the Louvre*, heavy drypoint draws the viewer's eye to Alice's hair and the framed drawings. Because of the fragile nature of the drypoint line, the artist published his prints in small editions, often of fewer than twenty.

Helleu was also popular outside his native France, repeatedly traveling to England and the United States. In 1912 he painted the ceiling of New York's Grand Central Station with a panorama of the nighttime sky. By the time he returned to New York in 1920, his elegant sense of style, once eagerly sought out by the leading beauties of the day, had gone out of fashion, and he decided to retire. Upon his return to France he destroyed his copper printing plates and retreated into family life.

L. D. M.

Notes

1. Helen O. Borowitz, "The Watteau and Chardin of Marcel Proust," *Bulletin of the Cleveland Museum of Art* 69, no. 1 (1982): 21.
2. M. Quennell, "Paul Helleu: A Revaluation," *Apollo* 117 (February 1983): 115.
3. Jane Abdy, "Tissot: His London Friends and Visitors," in *James Tissot*, ed. Krystyna Matyjaszkiewicz (New York: Abbeville Press, 1985), 52.

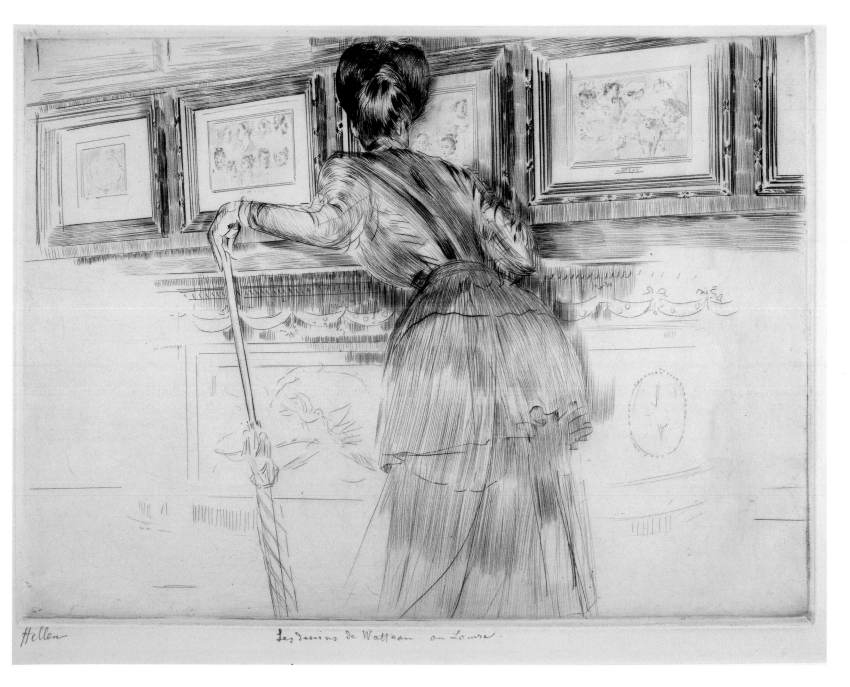

Helleu Les dessins de Watteau au Louvre.

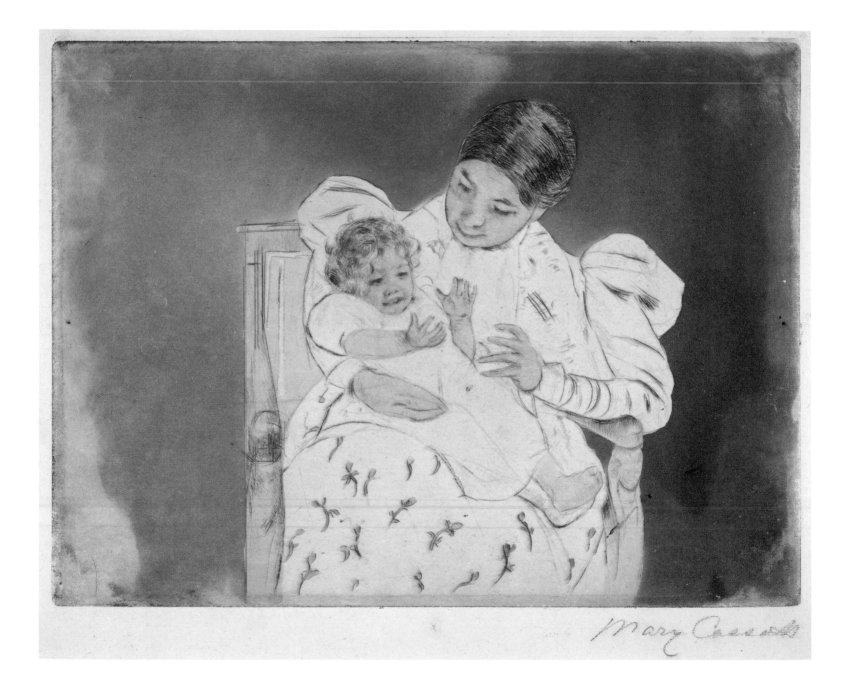

Mary Cassatt

Mary Cassatt

American, 1844–1926

The Barefooted Child, c. 1896–97

Drypoint and aquatint printed in black, gray, and yellow
9½ x 12⅜ in. (241:316 mm)
References: Mathews/Shapiro 22 iv/v (only known impression)
Watermark: Crowned shield with the letter *B*
Provenance: Frederick Keppel; William M. Ladd
Gift of Herschel V. Jones, 1916 (P. 4,957)

Mary Cassatt was astonished by the huge exhibition of Japanese prints that she saw at the Ecole des Beaux-Arts in Paris in the spring of 1890.[1] Although she had seen Japanese art before in the collections of her friends Edgar Degas and Félix Bracquemond (cat. no. 57), the exhibition's nearly 1,000 ukiyo-e color woodblock prints made such an impression that she set out to imitate them in color prints of her own. In 1891 her series of ten color aquatints was exhibited in Paris and offered for sale at Frederick Keppel's gallery in New York.[2] She returned to color aquatint during a very productive period in 1896–97, when she completed *The Barefooted Child* and three other maternal scenes with the same dark-haired mother and blond, curly-haired child.

In the earlier color prints, Cassatt had emphasized outline and large, flat areas of color and pattern. In *The Barefooted Child,* she used a distinctive drypoint technique and relied more heavily on hatching to achieve three-dimensional modeling.[3] This hatching is especially evident in the face and hands of the figures as they engage in a game of patty-cake. When this second group of color aquatints was shown in New York, they were viewed as masterful, but unfortunately Cassatt's Paris dealers, the Durand-Ruels, told her that there was no market for these works and that she should abandon color prints and return to pastel.[4]

This particular impression of *The Barefooted Child* is the only known example of the fourth state of this print. In the fifth and final state (fig. 71a), Cassatt evened out the aquatint in the background and incorporated a more vivid color scheme than the subtle gray and yellow of the Jones sheet.
L. D. M.

Notes
1. Colta Feller Ives, *The Great Wave: The Influence of Japanese Woodcuts on French Prints* (New York: Metropolitan Museum of Art, 1974), 45.
2. Nancy Mowll Mathews, "The Color Prints in the Context of Mary Cassatt's Art," in Nancy Mowll Mathews and Barbara Stern Shapiro, *Mary Cassatt: The Color Prints* (New York: Harry N. Abrams; [Williamstown, Mass.]: Williams College Museum of Art, 1989), 48.
3. Mathews, "Color Prints," 52.
4. Ibid., 53.

Figure 71a **Mary Cassatt,** *The Barefooted Child,* c. 1896–97, color aquatint and drypoint, 9½ x 12⅜ in. (241:316 mm), gift of Kenneth and Lillian Smith, P. 93.21.5

Anders Zorn

Swedish, 1860–1920

Miss Maud Cassel (Mrs. Ashley), 1898

Etching
7 x 5 ⅟₁₆ in. (178:129 mm)
References: Asplund 138 iii/iii (unique proof)
Provenance: William M. Ladd
Gift of Herschel V. Jones, 1916 (P. 5,385)

Maud Cassel was the daughter of industrialist Sir Ernest Cassel and thus typical of the social and political elite from which Anders Zorn drew his subjects. As a leading portraitist during the late nineteenth-century Belle Epoque, working in both Europe and the United States, Zorn immortalized poets and princes alike. (The year after Zorn etched Maud, President Grover Cleveland sat for him.) Ernest Cassel was a devoted patron, enlisting Zorn to make likenesses of himself, his sister, and his niece in addition to his only daughter, Maud. Zorn painted her first as a young girl and later as a debutante, and the latter painting formed the basis for this etching.[1] He shows her amid the comforts of her privileged life—the family's London home was adorned with 800 tons of Carrara marble—and attended by her pets.[2] It was a world that fascinated Zorn, whose own parents met while working in an Uppsala brewery.

By the late 1880s Zorn was depicting subjects in their natural setting, the better to reveal their personality. His handling had also grown more impressionistic. Here his pulsating lines convey the liveliness of the moment—in this case Maud's arrival in society. She looks directly at us with a determined gaze matched by the equally decisive slashes of Zorn's etching needle. It was indeed a successful coming out; Amalia Mary Maud Cassel went on to marry Colonel Wilfred William Ashley in 1901, and their daughter Edwina married Earl Mountbatten of Burma.

Sweden's most famous etcher, Zorn is represented in the Jones Collection with twenty-three prints. *Miss Maud Cassel (Mrs. Ashley)* is special because it is a unique proof, the only impression in which the artist added work on the dog and other areas. With characteristic dynamism he took his lines right to the edge of the plate, and he had to burnish the bottom edge to make space for his etched signature. Even though Zorn kept a studio in Paris, the French saw few of his prints because Americans snapped them up so quickly.[3] Dealer Frederick Keppel exhibited them in 1893, 1899, and 1907, which may be how William M. Ladd acquired the Zorn prints now in the Institute's collection.

M.J.K.

Notes
1. Elizabeth Broun, *The Prints of Anders Zorn* (Lawrence: Spencer Museum of Art, University of Kansas, 1979), 65.
2. Douglas K. S. Hyland and Hans Henrik Brummer, *Zorn: Paintings, Graphics, and Sculpture* (Birmingham, Ala.: Birmingham Museum of Art, 1986), 74.
3. Ibid., 44.

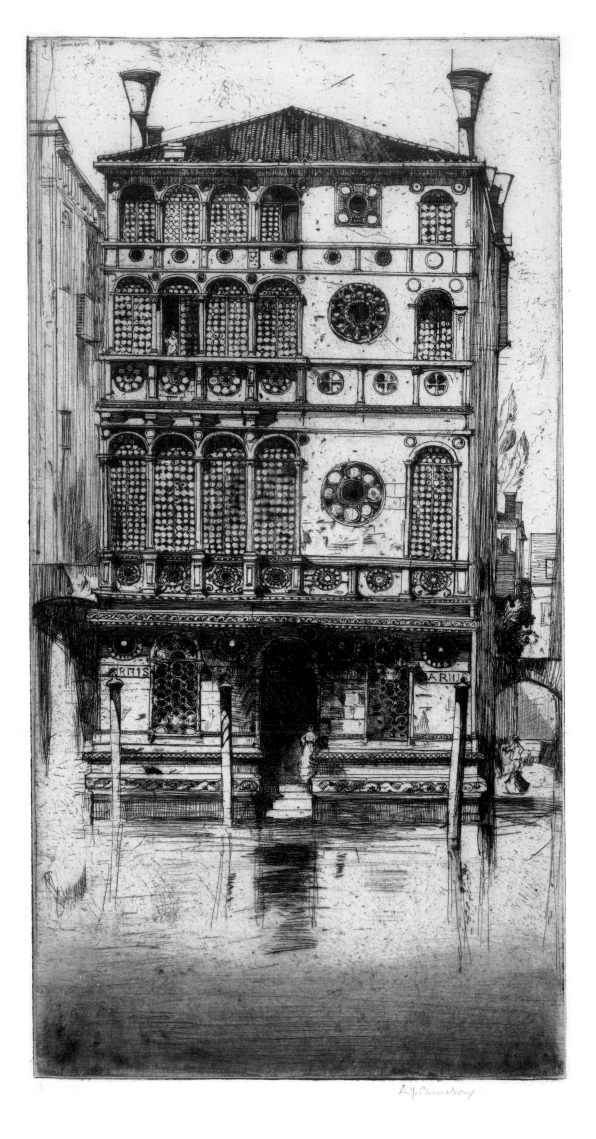

D. Y. Cameron

Scottish, 1865–1945

Joannis Darius, 1900

Etching and drypoint
12⅜ x 6½ in. (322:165 mm)
Watermark: Crown (unidentified)
References: Rinder 309 ii/ii
Provenance: Frederick Keppel; William M. Ladd
Gift of Herschel V. Jones, 1916 (P. 3,674)

The industrious D. Y. Cameron was something of an etching purist who completed more than 500 plates between 1887 and 1932. A native of Glasgow, Cameron first began etching while living in Edinburgh and studying at an art school there. The somber beauty of his native Scotland is reflected in the dark, rich tone of his etchings, even when he was depicting other locales, such as Venice. Cameron had talent as both a printmaker and painter, and he exhibited successfully in both mediums. As an etcher, he put great care into the choice of papers and inks; throughout his career he searched for old papers in London, Edinburgh, Amsterdam, Paris, and Florence.[1] He did not believe in excessive use of plate tone or artistic wiping of the plate, and thus his interpretation here of a site in Venice produced a very different effect than that of his contemporary James McNeill Whistler (cat. no. 62).

Cameron was inspired by the prints of many of the artists represented in William M. Ladd's collection, including Francis Seymour Haden (cat. nos. 67, 68), Charles Meryon (cat. no. 58), and Rembrandt van Rijn (cat. nos. 46–48),

whom Cameron considered the master of the medium. Cameron, who was knighted by George V in 1924, truly came into his own as an etcher of architectural scenes, as seen in *Joannis Darius*. The subject of this magnificent print is the Palazzo Dario, a famous Venetian landmark located on the Grand Canal. Venetians believe that a curse is attached to this jewel-like fifteenth-century palace, and it is hard to argue with the reports of strange diseases, ruined fortunes, suicides, and bizarre accidents that have befallen former residents. Yet the curse has not kept artists from portraying the striking asymmetrical façade, with its three floors of loggias and unique circular inlays. Cameron depicted the small palazzo twice and, as with all of his architectural scenes, attempted to evoke the spirit and mysterious appeal of the edifice and its site on the Grand Canal.

L. D. M.

Notes
1. Frank Rinder, *D. Y. Cameron: An Illustrated Catalogue of His Etched Work with Introductory Essay and Descriptive Notes on Each Plate* (Glasgow: J. Maclehose and Sons, 1912), xxix–xxx.

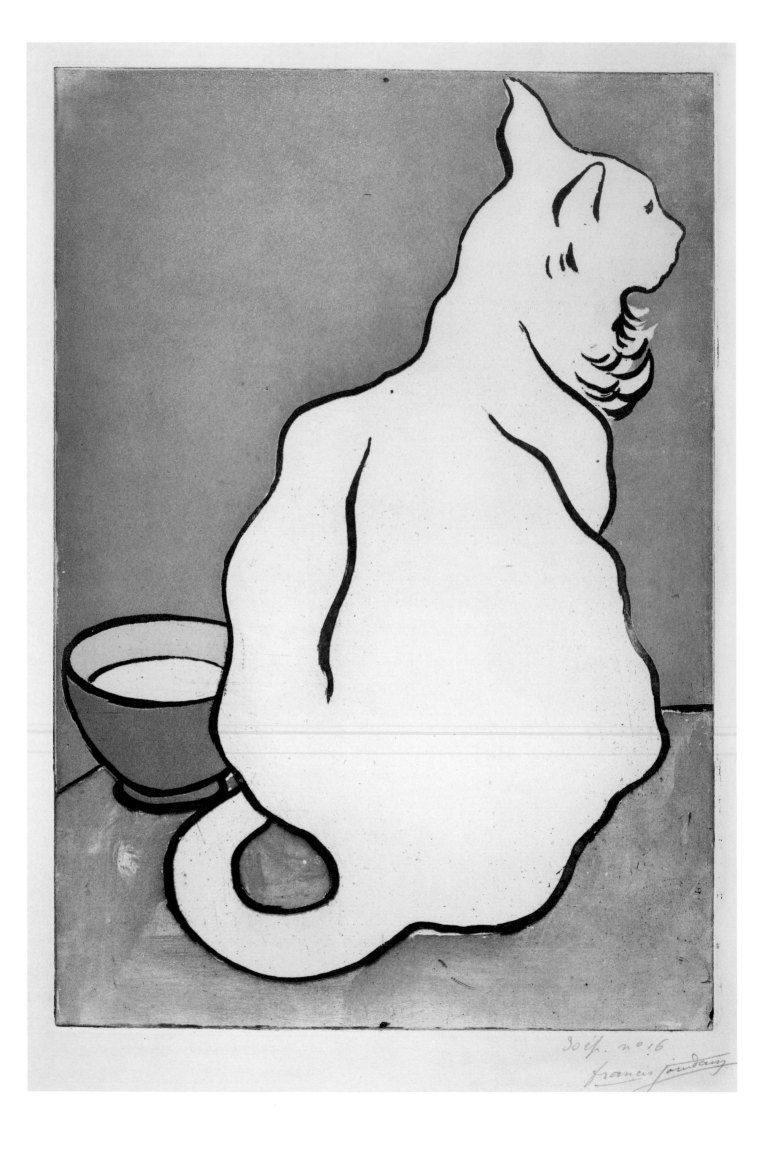

Francis Jourdain

French, 1876–1958

The White Cat, c. 1900

Color aquatint printed in rose, green, olive, dark blue,
 and light blue
14 1/16 x 9 11/16 in. (358:246 mm)
Provenance: William M. Ladd
Gift of Herschel V. Jones, 1916 (P. 2,606)

Francis Jourdain fiercely believed that furnishings and decorative objects should reflect the spirit of their age, not past traditions. He made it his lifelong mission to reform the applied arts in France by having them be based on purity, simplicity, and economy of means—all qualities evident in *The White Cat*.

The son of important Art Nouveau architect Frantz Jourdain, Francis was destined for a career in the arts. One of his first teachers was the painter Eugène Carrière, a close friend of his father's. In the late 1890s, while working as an assistant to another artist, Paul-Albert Besnard, the young Jourdain was introduced to color etching by the printer Eugène Delâtre.[1] Jourdain used his newfound medium to celebrate the stuff of everyday life. kites, a laundress, a cat. His printmaking activity lasted for about three years, until 1900, when he began painting and making furniture. Furniture eventually won out, and by 1913 he had dedicated himself to a career as an architect-decorator and to filling the Salons with his ideas for a more democratic form of design.

Jourdain fought to make good design available to the working classes, championing an aesthetic in which beauty was revealed through function rather than meaningless embellishment. During the height of his fame, from 1913 to 1939, he continually sought new ways to simplify urban interiors, creating compact built-ins and constructing furniture that could be reconfigured as needs changed. Although his interiors were too austere for some—one critic called him a coffin maker—Jourdain was one of the first to produce tasteful, rational designs that workers could afford.[2]

M.J.K.

Notes
1. Arlette Barré-Despond and Suzanne Tise, *Jourdain: Frantz 1847–1935, Francis 1876–1958, Frantz-Philippe 1906–1990* (New York: Rizzoli, 1991), 218.
2. Ibid., 251–54.

Käthe Kollwitz

German, 1867–1945

Working Woman with Blue Shawl, 1903

Color lithograph printed in blue, black, and light brown
12¾ x 9⅞ in. (323:251 mm)
Reference: Klipstein 68 i/iii (trial proof)
Provenance: William M. Ladd
Gift of Herschel V. Jones, 1916 (P. 359)

When she began her career at Berlin's School for Women Artists, Käthe Kollwitz hoped to become a painter. In 1890, however, she took up printmaking and abandoned oil and canvas for good. The following year she married Karl Kollwitz, a physician who practiced in a poor, working-class section of Berlin. His career exposed her to the suffering of those in the lowest echelons of society and provided her with subject matter for the next fifty years. From her vantage point in Germany she also witnessed the misery and pain caused by both World Wars. She tackled the plight of the poor and the atrocities of war in a bold, graphic style whether she was working in etching, lithography, or woodcut. Kollwitz was the first woman elected to the Prussian Academy of Arts and was director of graphic arts there from 1928 until her resignation in 1933, during the Nazi era.[1]

For a brief period at the turn of the century, Kollwitz experimented with color in her prints. She seems to have ultimately concluded that color was more properly associated with painting, and avoided it in her work after 1903.[2] In this rare trial proof of Working Woman with Blue Shawl, Kollwitz's talent for lithography is revealed in the subtle layering of blue, black, and brown inks and her expert use of the cream-colored paper for the highlights in the woman's face. William M. Ladd owned both this trial proof and the third state, published in a large edition by Die graphischen Künste, an Austrian art publication. Compared with the editioned print, the trial proof is remarkable for its delicate modeling and tonal variety, an effect that obviously could not be sustained over multiple printings. It is not only the technical virtuosity that draws the viewer to this work, however, but the respect and dignity with which Kollwitz approached her sitter.

L. D. M.

Notes
1. Rae Becker, "Käthe Kollwitz," in Ann Sutherland Harris and Linda Nochlin, Women Artists, 1550–1950 (Los Angeles: Los Angeles County Museum of Art, 1976), 263.
2. Elizabeth Prelinger, Käthe Kollwitz (Washington, D.C.: National Gallery of Art, 1992), 47.

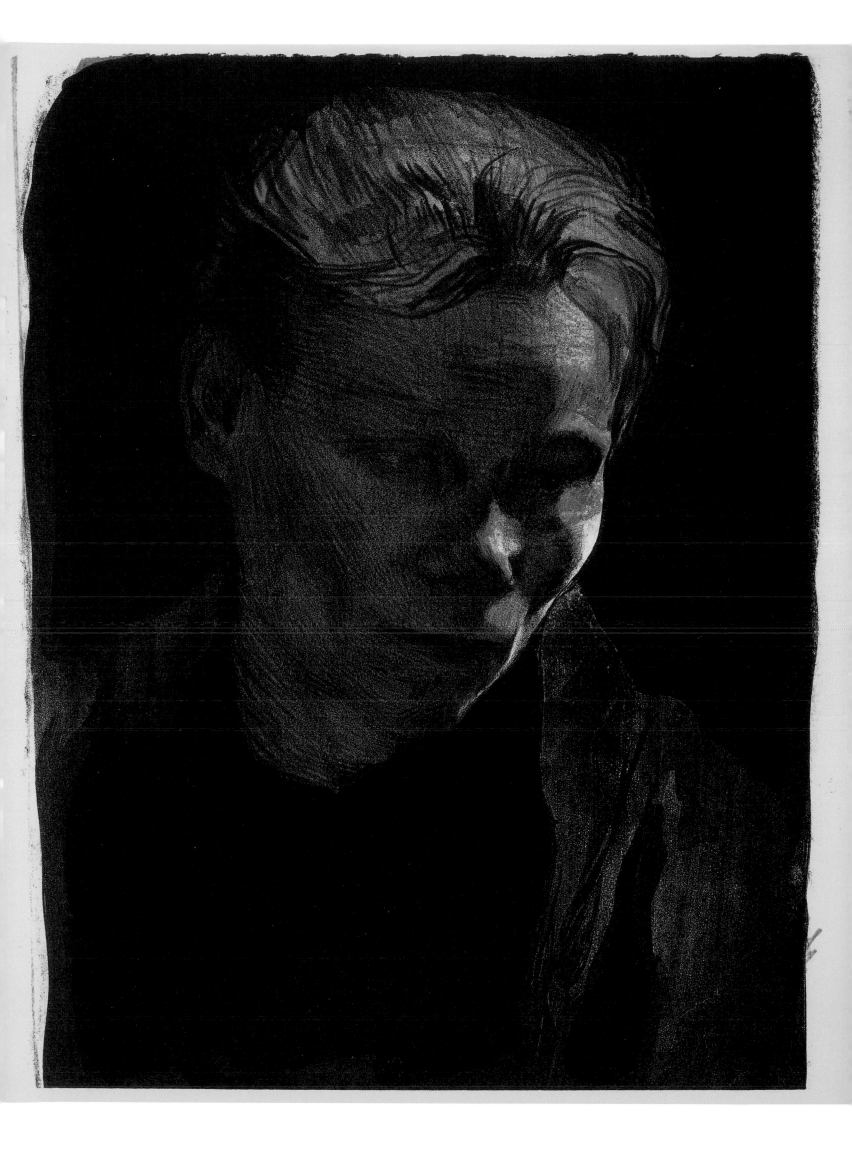

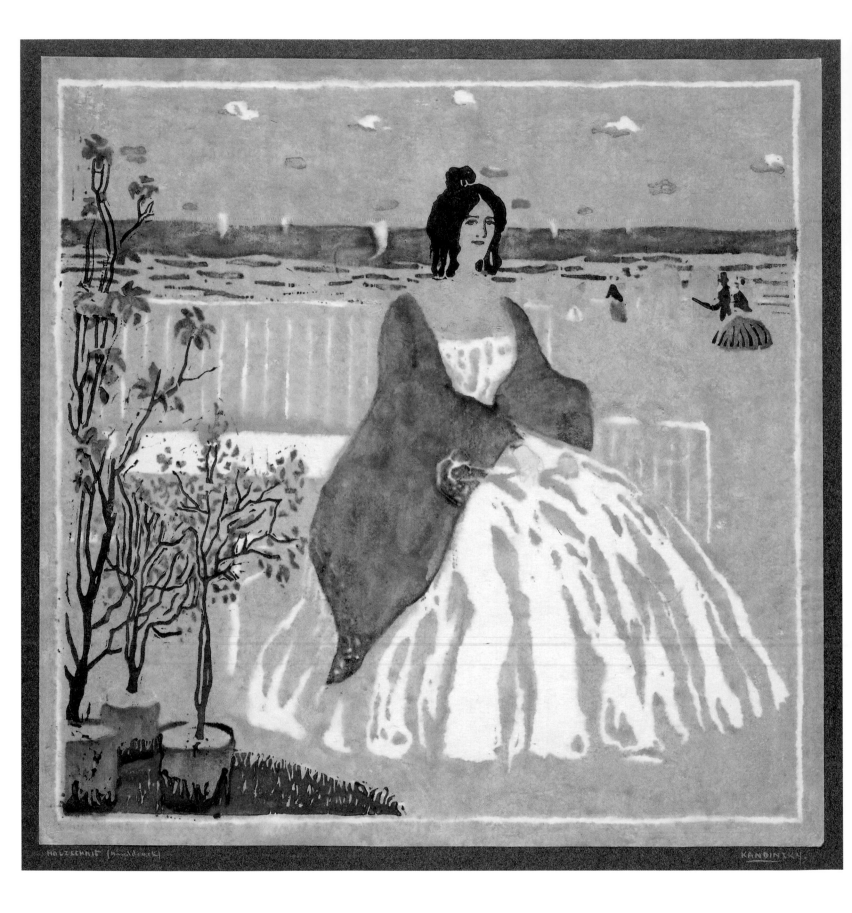

HOLZSCHNIT (Handwork) KANDINSKY.

Vasily Kandinsky

Russian, 1866–1944

On the Beach, 1903

Color woodcut printed from three blocks in blue, black,
 red, yellow, green, blue-green, and gray on a dark gray
 backing sheet
12¼ x 12¼ in. (311:311 mm)
References: Roethel 5
Provenance: William M. Ladd
Gift of Herschel V. Jones, 1916 (P. 353)

Because Vasily Kandinsky is universally regarded for his groundbreaking abstractions, it is hard to imagine a time when he was avidly making woodcuts of medieval knights and fairy-tale figures. A few years after earning a law degree from the University of Moscow, Kandinsky spent a seminal period in Munich, where he had moved in 1896 to learn to paint. The artist quickly became enamored of the Jugendstil movement afoot in Munich. Jugendstil was the German version of Art Nouveau, and the proponents of this highly ornamental style embraced craftsmanship, putting applied arts on an equal footing with painting and sculpture. Kandinsky designed embroidery, dresses, jewelry, vases, tables, and even locks and keys, but the area of craftwork that moved him most strongly was hand-printed woodcuts. Throughout the early 1900s he made them for hours on end and exhibited them widely, often calling on fanciful motifs from the real or imagined past. In 1904 he wrote to his lover Gabriele Münter that woodcuts were things he "simply *must* make."[1]

The year he made *On the Beach*, Kandinsky had spent the summer in the Bavarian town of Kallmünz. The print's romantic feel reflects the artist's mood at the time; Münter had joined him in Kallmünz, and he was falling more deeply in love with her.[2] For many of his early woodcuts, Kandinsky used one block for the color and another for the lines, working in the Japanese style. This print required three separate woodblocks, however. Instead of using oil-based ink, he applied watercolor to his blocks, resulting here in a softness that befits his courtly, exotically costumed figure.

Kandinsky made some forty-eight woodcuts between 1902 and 1904 alone.[3] These prints were crucial to his transition into abstraction. His color woodcuts necessitated flattening planes, disregarding perspective, and reducing forms to their essentials, in essence demanding "an abstraction from nature."[4] When translated into tempera and oil, this process had implications for the artist's later investigations into nonrepresentational art.

M.J.K.

Notes
1. Peg Weiss et al., *Kandinsky in Munich, 1896–1914* (New York: Solomon R. Guggenheim Foundation, 1982), 83.
2. Vivian Endicott Barnett; *Vasily Kandinsky: A Colorful Life: The Collection of the Lenbachhaus, Munich*, ed. Helmut Friedel (Cologne: DuMont, [1995]), 47, 95.
3. Peg Weiss, "Kandinsky and the 'Jugendstil' Arts and Crafts Movement," *Burlington Magazine* 117 (May 1975): 276.
4. Peg Weiss et al., *Kandinsky in Munich*, 51.

Louis-Auguste-Mathieu Legrand

French, 1863–1951

Four Dancers at the Bar, 1906

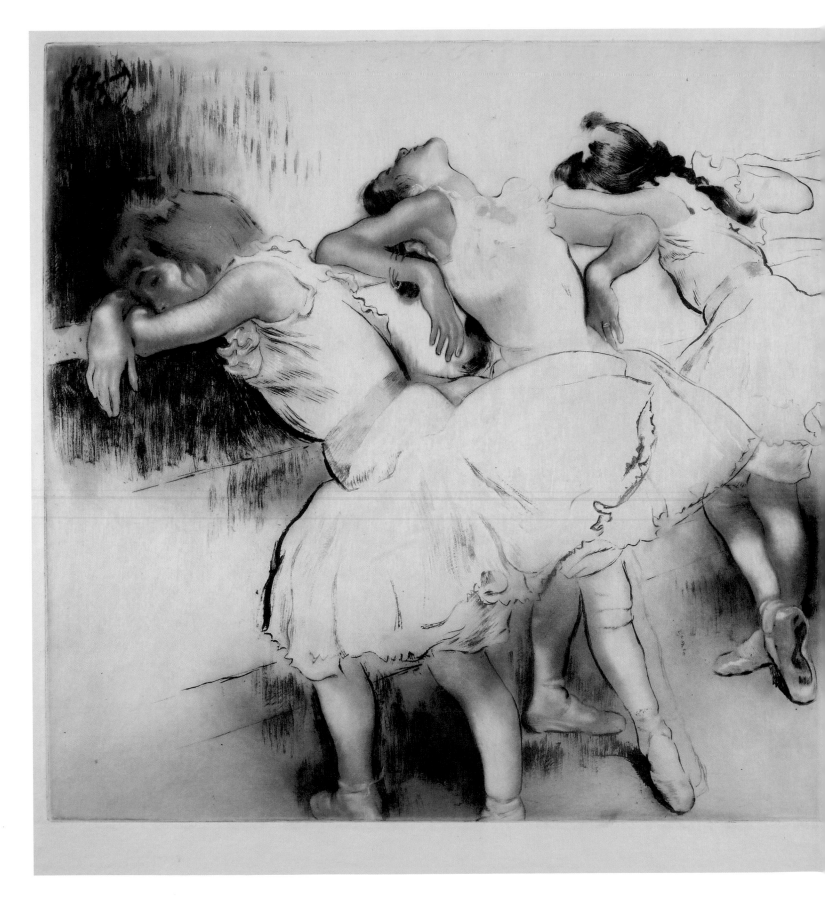

Aquatint and drypoint
14 ⅛ x 21 ⁵⁄₁₆ in. (359:541 mm)
Reference: Laran 135
Provenance: William M. Ladd
Gift of Herschel V. Jones, 1916 (P. 2,693)

Louis-Auguste-Mathieu Legrand found creative inspiration in the behind-the-scenes domain of the Parisian ballet. In *Four Dancers* we see him at his best, reveling in the grace and beauty of four young women resting on the ballet bar after a particularly challenging performance or practice. Legrand conveys their exhaustion as he skillfully alternates each pose to expose the front, back, and side of the figures. His expertise with aquatint is apparent in the calligraphic lines of the dancers' skirts and the impressive tonal range of the entire scene. To complete the effect, Legrand introduced subtle drypoint lines in the hair and costumes.

Legrand left his native Dijon for Paris in 1884 and at age twenty-one began contributing caricatures to various Parisian journals. In 1891 he gained instant celebrity when his watercolors of cancan dancers were reproduced in the periodical *Gil Blas illustré*. These immediately sold out in large numbers, prompting him to create eleven etchings on the same theme.[1] This series brought Legrand to the attention of the influential print publisher Gustave Pellet (1859–1919). Over the next three decades, Pellet published almost 300 of Legrand's etchings and drypoints. As an artist, Legrand was well regarded in his day and had a large solo exhibition of nearly 200 prints and drawings at Siegfried Bing's L'Art Nouveau gallery in 1896.[2] He received a silver medal at the 1900 Universal Exposition in Paris and two years later was awarded the prestigious Légion d'Honneur by the French government.
L. D. M.

Notes
1. *Louis Legrand, 1863–1951: Etchings and Drypoints* (London: William Weston Gallery, 1979), unpaginated.
2. Edwin Becker, "Les Salons de L'Art Nouveau: Perfect Harmony and Unpretentious Beauty," in *The Origins of L'Art Nouveau: The Bing Empire*, ed. Gabriel P. Weisberg, Edwin Becker, and Evelyne Possémé (Amsterdam: Van Gogh Museum, 2004), 142.

Donald Shaw MacLaughlan

American (born Canada), 1876–1938

The Pool, 1910

Etching
14⅝ x 9⅞ in. (374:250 mm)
References: Bruette 154 i/ii
Provenance: William M. Ladd
Gift of Herschel V. Jones, 1916 (P. 5,070)

Donald Shaw MacLaughlan discovered etching in 1899 while studying painting in Paris. He found immediate acclaim, and three of his earliest prints were exhibited at the Salon that year.[1] In his quest to improve his technique, MacLaughlan studied the Rembrandt etchings at the Bibliothèque nationale de France, attaining such mastery that the French government entrusted him with reprinting several of Rembrandt's plates.[2] In addition to researching past masters, MacLaughlan admired the prints of his contemporary James McNeill Whistler. MacLaughlan so idolized Whistler that he believed that the artist, who died in 1903, had contacted him during séances on at least three different occasions.[3] Like Whistler, MacLaughlan ground all his own inks and printed his own plates. He also searched throughout Europe for antique papers to use for his prints, often tearing blank sheets out of old Dutch and Italian books.[4]

MacLaughlan found his subjects in the Swiss and Italian countryside, as well as in the hustle and bustle of Paris and London. *The Pool* is from a group of etchings focusing on the River Thames. The tall, vertical composition catalogues the myriad watercraft that navigated the river each day. At the top of this crowded sheet, just beyond Tower Bridge, is a steamer heading out to sea. In the middle ground, sailing vessels battle for space while two other steamers are docked to the left. Fanning out in the immediate foreground are smaller barges loaded with cargo and sailors. MacLaughlan carefully named the smaller boats, possibly in recognition of family and friends. The print is packed with details but succeeds in relaying the teeming atmosphere of this working river.

William M. Ladd collected 119 prints by MacLaughlan before 1916 in an obvious effort to acquire a nearly complete catalogue of this artist's work. MacLaughlan's reputation peaked in the 1920s, and he has since been relegated to a lesser status among printmakers. Still, *The Pool* reveals the charm and energy that made his etchings so popular to audiences of the early twentieth century.

L. D. M.

Notes
1. Marie Bruette, *A Descriptive Catalogue of the Etched Work of Donald Shaw MacLaughlan* (Chicago: Albert Roullier Art Galleries, 1924), 7.
2. Katherine A. Lochnan, *Whistler and His Circle* (Toronto: Art Gallery of Ontario, 1986), 70.
3. Ibid.
4. Bruette, *Descriptive Catalogue*, 7–8.

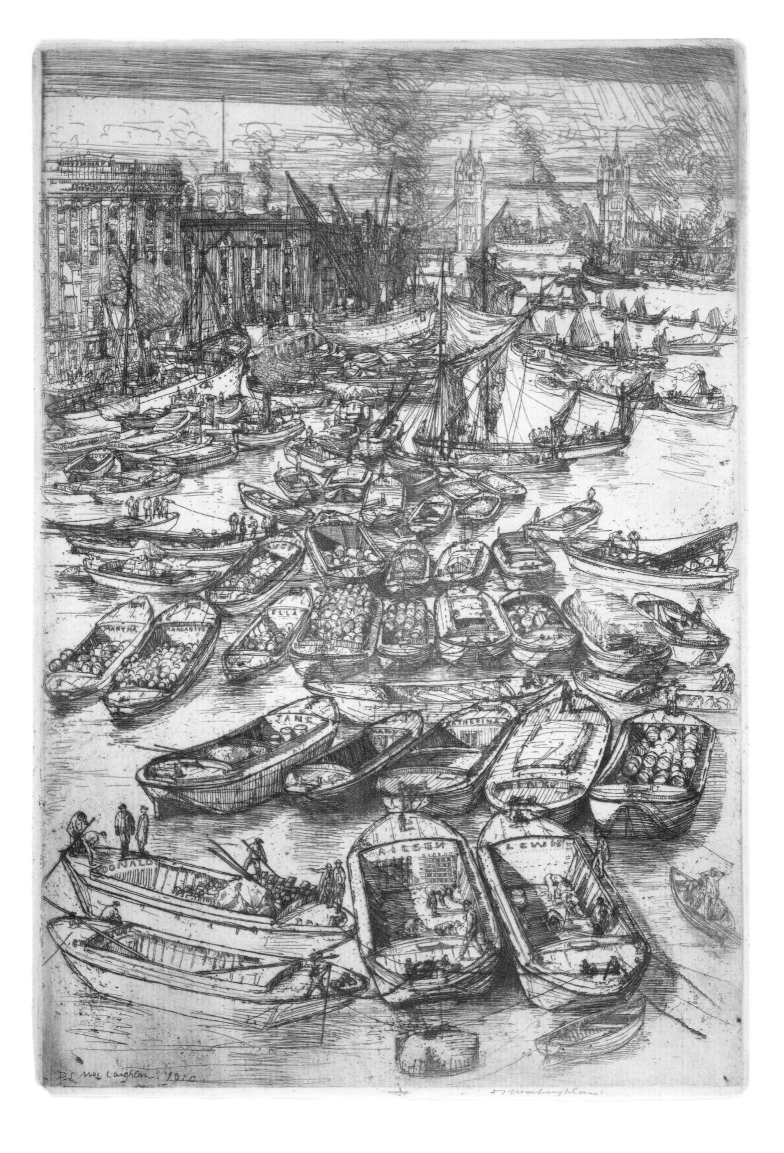

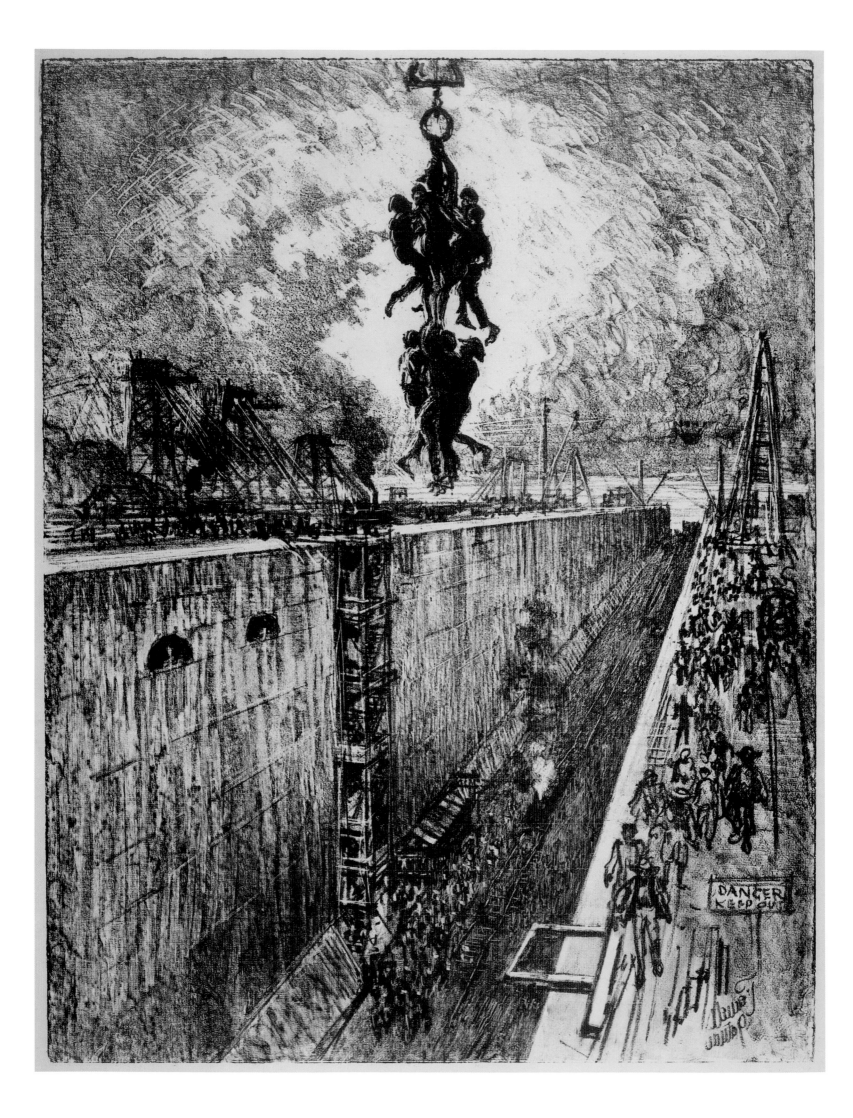

Joseph Pennell

American, 1860–1926

The End of the Day, Gatun Lock, 1912
From *Pictures of the Panama Canal*

Transfer lithograph
21⅞ x 16½ in. (555:425 mm)
Watermark: Fabriano
Reference: Wuerth 226
Provenance: William M. Ladd
Gift of Herschel V. Jones, 1916 (P.5,213)

Sometime magazine and book illustrator Joseph Pennell developed an instinct for the story. In the early 1900s the topic that seemed to excite him most was modern industry, particularly the great industrial behemoths puncturing the sky with their fearful geometry. In 1909 the Philadelphia-born Quaker gave his personal theme a title: "The Wonder of Work." He pursued his subjects across the United States and Europe, documenting hydroelectric power stations, skyscrapers, steelworks, blast furnaces, and coal breakers. But the project he dearly longed to record was the construction of the Panama Canal. After repeated pleas to his editor, he sailed for Panama in early 1912 and soon became a familiar sight among the machinery and scaffolding with his tweeds, campstool, and pocketful of pencils.

Gatun Lock, actually a series of three locks, was designed to raise ships eighty-five feet to Gatun Lake. *The End of the Day, Gatun Lock* captures the moment when the whistle signaled quitting time at the site. As Pennell described it: "From the depths a long chain rose and, clinging to the end of it, grouped as Cellini would have loved to group them, were a dozen men swinging up to the surface. . . . No one could imagine it—and I had only a minute to see it."[1] The reason Pennell was able to make a lithograph of such a fleeting scene was the special coated transfer paper he took with him to Panama in lieu of heavy lithographic stones. In all, he drew thirty scenes of the canal's progress, which he somehow managed to safeguard during the long trip by steamer back to Philadelphia. There he worked side by side with a printer at Ketterlinus Lithographic Manufacturing Company to transfer his drawings to stone.

Pennell once determined that 1912, the year he completed *Pictures of the Panama Canal*, was the busiest of his life.[2] There were other working trips that year to the Grand Canyon, Yosemite, Washington, D.C., and Philadelphia, but no other site was extolled quite like the Panama Canal, which Pennell termed "the most stupendous thing on God's earth."[3]
M.J.K.

Notes
1. Louis A. Wuerth, *Catalogue of the Lithographs of Joseph Pennell* (Boston: Little, Brown, 1931), 78.
2. Elizabeth Robins Pennell, *The Life and Letters of Joseph Pennell*, vol. 2 (Boston: Little, Brown, 1929), 101.
3. Ibid., 106.

Bibliography

Asplund, Karl. *Zorn's Engraved Work*. Translated by Edward Adams-Ray. 2 vols. Stockholm: A.-B. H. Bukowski's Konsthandel, 1920–21.

Bartsch, Adam. *Le Peintre Graveur*. 21 vols. Vienna: J. V. Degen, 1803–21.

Bellini, Paolo. *L'opera incisa di Adamo e Diana Scultori*. Vicenza: Neri Pozza Editore, 1991.

Béraldi, Henri. *Les graveurs du XIX^e siècle*. 12 vols. Paris: Librairie L. Conquet, 1885–92.

Bertin, Claudie. *Henri-Charles Guérard (1846–1897): L' oeuvre gravé*. Paris: Ecole du Louvre, 1975.

Bouillon, Jean-Paul. *Félix Bracquemond: Le réalisme absolu: Oeuvre gravé, 1849–1859: Catalogue raisonné*. Genève: Skira, 1987.

Bourcard, Gustave, and James Goodfriend. *Félix Buhot: Catalogue descriptif de son oeuvre gravé*. Paris: H. Floury, 1899; reprint, New York: M. Gordon, 1979.

Briquet, C. M. *Les filigranes: Dictionnaire historique des marques du papier dès leur apparition vers 1282 jusqu'en 1600, avec 39 figures dans le texte et 16,112 facsimilés de filigranes*. 2nd ed. 4 vols. Leipzig: K. W. Hiersemann, 1923.

Brown, Jonathan. *Jusepe de Ribera: Prints and Drawings*. Princeton: Princeton University Press, 1973.

Bruette, Marie. *A Descriptive Catalogue of the Etched Work of Donald Shaw MacLaughlan*. Chicago: Albert Roullier Art Galleries, 1924.

Curtis, Atherton. *Catalogue of the Etched Work of Evert van Muyden*. New York: Frederick Keppel & Co., 1894.

Delteil, Loys. *Le peintre-graveur illustré*. 31 vols. Paris: Privately printed, 1906–26; reprint, New York: Collectors Editions, Da Capo Press, 1969.

Guiffrey, J. J. *L'oeuvre de Ch. Jacque: Catalogue de ses eaux-fortes et pointes sèches*. Paris: Mlle Lemaire, 1866.

Harrington, H. Nazeby. *The Engraved Work of Sir Francis Seymour Haden, P.R.E*. Liverpool: H. Young & Sons, 1910.

Hayes, John. *Gainsborough as Printmaker*. New Haven: Yale University Press, 1972.

Hind, Arthur M. *A Catalogue of Rembrandt's Etchings, Chronologically Arranged and Completely Illustrated*. 2 vols. New York: Da Capo Press, 1967.

———. *Early Italian Engraving: A Critical Catalogue with Complete Reproduction of All the Prints Described*. 7 vols. London: Bernard Quaritch, 1938–48.

Hollstein, F. W. H. *Dutch and Flemish Etchings, Engravings, and Woodcuts, c. 1450–1700*. 60 vols. Amsterdam: Menno Hertzberger, 1949–2003.

———. *German Engravings, Etchings, and Woodcuts, c. 1400–1700*. 65 vols. Amsterdam: Menno Hertzberger, 1954–.

Kennedy, Edward G. *The Etched Work of Whistler*. New York: Da Capo Press, 1974.

Klipstein, August. *The Graphic Work of Käthe Kollwitz*. New York: Galerie St. Etienne, 1955.

Landau, David. *Catalogo completo dell'opera grafica di Georg Pencz*. Translated by Anthony Paul. Milan: Salamon & Agustoni, 1978.

Laran, Jean, et al. *Inventaire du fonds français après 1800*. 15 vols. Paris: Bibliothèque nationale, 1930–85.

Lehrs, Max. *Katalog der Kupferstiche Martin Schongauers*. Vienna: Gesellschaft für vervielfältigende Kunst, 1925.

Lewis, Michal, and R. E. Lewis. "Catalogue Raisonné" in *The Engravings of Giorgio Ghisi*. New York: Metropolitan Museum of Art, 1985.

Lieure, Jules. *Jacques Callot*. 8 vols. 1924–29; reprint, New York: Collectors Editions, 1969.

Lister, Raymond. *Catalogue Raisonné of the Works of Samuel Palmer*. New York: Cambridge University Press, 1988.

Lugt, Frits. *Les marques de collections de dessins et d'estampes; marques estampillées et écrites de collections particulières et publiques; marques de marchands, de monteurs et d'imprimeurs; cachets de vente d'artistes décédés; marques de graveurs apposées après le tirage des planches; timbres d'édition, etc., avec des notices historiques sur les collectionneurs, les collections, les ventes, les marchands et éditeurs, etc.* Amsterdam: Vereenigde drukkerijen, 1921; supplement, 1956.

Massari, Stefania. *Incisori mantovani del '500: Giovan Battista, Adamo, Diana Scultori e Giorgio Ghisi dalle collezioni del Gabinetto Nationale delle Stampe e della Calcografia Nazionale*. [Rome]: De Luca, [1981].

Mathews, Nancy Mowll, and Barbara Stern Shapiro. *Mary Cassatt: The Color Prints*. New York: Harry N. Abrams; [Williamstown, Mass.]: Williams College Museum of Art, 1989.

Meaume, Édouard. *Recherches sur la vie et les ouvrages de Jacques Callot, suite au peintre-graveur français de M. Robert-Dumesnil*. 2 vols. Paris: V. J. Renouard, 1860.

Meder, Joseph. *Dürer-Katalog: Ein Handbuch über Albrecht Dürers Stiche, Radierungen, Holzschnitte, deren Zustände, Ausgaben und Wasserzeichen*. Vienna: Gilhofer & Rauschburg, 1932.

Montaiglon, Anatole de. *Catalogue raisonné de l'oeuvre de Claude Mellan d'Abbeville*. Abbeville, France: P. Briez, 1856.

Montesquiou-Fézensac, Robert de. *Paul Helleu: Peintre et graveur*. Paris: H. Floury, 1913.

Nagler, Georg Kaspar. *Die Monogrammisten*. Continued by Andreas Andresen and Carl Clauss. 5 vols. Reprint, Nieuwkoop, Netherlands: B. de Graaf, 1966.

Pennington, Richard. *A Descriptive Catalogue of the Etched Work of Wenceslaus Hollar, 1607–1677*. Cambridge: Cambridge University Press, 1982.

Percy, Ann. *Giovanni Benedetto Castiglione: Master Draughtsman of the Italian Baroque*. Philadelphia: Philadelphia Museum of Art, 1971.

Portalis, Roger, and Henri Béraldi. *Les graveurs du dix-huitième siècle*. 6 vols. Paris: Morgand et Fatout, 1880–82.

Rinder, Frank. *D. Y. Cameron: An Illustrated Catalogue of His Etched Work with Introductory Essay and Descriptive Notes on Each Plate*. Glasgow: J. Maclehose and Sons, 1912.

Roethel, Hans Konrad. *Kandinsky: Das graphische Werk*. [Köln]: M. DuMont Schauberg, 1970.

Rotili, Mario. *Salvator Rosa incisore*. Naples: Società Editrice Napoletana, 1974.

Schreiber, Wilhelm Ludwig. *Handbuch der Holz- und Metallschnitte des XV. Jahrhunderts*. 8 vols. Leipzig: Karl W. Hiersemann, 1926–30.

Schwarz, Karl. *Augustin Hirschvogel*. 2 vols. 1917; reprint, New York: Collectors Editions, 1971.

Shoemaker, Innis H., and Elizabeth Broun. *The Engravings of Marcantonio Raimondi*. Lawrence: Spencer Museum of Art, University of Kansas; Chapel Hill: Ackland Art Museum, University of North Carolina, 1981.

Slive, Seymour. *Jacob van Ruisdael: A Complete Catalogue of His Paintings, Drawings, and Etchings*. New Haven: Yale University Press, 2001.

Strauss, Walter L. *The Complete Engravings, Etchings, and Drypoints of Albrecht Dürer*. New York: Dover, 1972.

———. *Hendrik Goltzius, 1558–1617: The Complete Engravings and Woodcuts*. 2 vols. New York: Abaris Books, 1977.

Thorson, Victoria. *Rodin Graphics: A Catalogue Raisonné of Drypoints and Book Illustrations*. San Francisco: Fine Arts Museums of San Francisco, 1975.

Wentworth, Michael Justin. *James Tissot: Catalogue Raisonné of His Prints*. Minneapolis: Minneapolis Institute of Arts, 1978.

Whitman, Alfred. *Valentine Green*. London: A. H. Bullen, 1902.

Wilton-Ely, John. *Giovanni Battista Piranesi: The Complete Etchings*. 2 vols. San Francisco: Alan Wofsy Fine Arts, 1994.

Wuerth, Louis A. *Catalogue of the Lithographs of Joseph Pennell*. Boston: Little, Brown, 1931.

Index of Artists

Numbers in the following index refer to catalogue entries.

Tiffany Studios, *The Herschel V. Jones Memorial Tablet*, 1929, cast bronze relief, 26⅜ x 60¼ x 1 in. (670.1,530.25 mm), gift of L. J. Bardwell, C. K. Blandin, Anson S. Brooks. Francis A. Chamberlain, Hovey C. Clarke, Edward W. Decker, George P. Douglas, H. F. Douglas, William A. Durst, Frank T. Heffelfinger, E. E. Mitchell, F. E. Murphy, Frank M. Prince, Arthur R. Rogers, John R. Van Derlip, Frederick B. Wells, Charles J. Winton, David N. Winton, and Theodore Wold, 30.9